Thunder Bay
P·R·E·S·S

COLORS OF AFRICA

DUNCAN CLARKE

Published in the United States by
Thunder Bay Press
An imprint of the Advantage Publishers Group
5880 Oberlin Drive
San Diego, CA 92121-4794
www.advantagebooksonline.com

Produced by PRC Publishing Ltd
Kiln House, 210 New Kings Road
London SW6 4NZ

© 2000 PRC Publishing Ltd

All notations of errors or omissions should be addressed to Thunder Bay Press,
editorial department, at the above address. All other correspondence (author inquiries,
permissions and rights) concerning the content of this book should be addressed to
PRC Publishing Ltd, Kiln House, 210 New Kings Road, London SW6 4NZ.

ISBN 1 57145 264 8

Library of Congress Cataloging-in-Publication Data available upon request.

Printed and bound in Hong Kong

1 2 3 4 5 00 01 02 03

CONTENTS

INTRODUCTION

Travelers in rural Africa often remark on the vivid intensity of colors glimpsed in what sometimes appear to be almost monochrome landscapes: a spray of shocking pink flowers on a single tree in an endless vista of dusty brown savannah, or the fleeting view of a flock of tiny yellow weaverbirds against the dark green of the forest. In urban areas, the rich colors of African dress excite similar comment. Colorful and apparently exotic practices, such as the beadwork and house painting of the Ndebele in South Africa, or the startlingly made-up faces of Wodaabe men at their annual dances are singled out by tourist agencies as typical African scenes, or appropriated in advertisements by multinational companies, coming to stand for a single, undifferentiated Africa to much of the world beyond. However, while it is clear to even the most casual observer that Africa is indeed a very colorful place, an exploration of the world of color in Africa should move beyond the clichés of vacation brochures to introduce at least a little of the complexity and diversity that has marked—and that continues to mark—indigenous ideas about color and color use in different regions of the African continent.

Beads, often imported from Europe and India, were one of many media through which ideas about color could be used to communicate a wide variety of concepts. In the ancient African kingdom of Benin, red beads and red metal, specifically coral beads and bronze regalia, were highly prized, and the rights to their use strictly regulated by the king. Red was a dangerous color, representing the deadly potency of the Oba, or king, who could kill with a look or a word. Royal control over these luxuries, notionally obtained from the god of the sea (although, in fact, bartered with the Portuguese merchants who first reached the area around 1480 C. E.), reinforced the king's status as ruler of the land. Unauthorized wearing of coral beads could be punished by death.

For the Zulu of South Africa on the other hand, beads could be used to send messages of love. As part of a complex of ideas

about the appropriate use of beads and beadwork that developed with the influx of large quantities of cheap, brightly colored trade beads from Europe early in the twentieth century, young Zulu women sent color-coded messages of love to their boyfriends working as migrant laborers via beaded neck bands, bracelets and necklaces. Here, depending on the context, an imported red-glass bead, called *umlilwane*, was likened to the flames of a fire and meant, "whenever I see you my heart leaps up in little flames." At the same time, colors and patterns of beadwork adornment came to signify wider issues, from place of origin, to marital status, to fashion, even to political allegiances.

Over the following pages, African perspectives on color and the meanings of colors will be explored and illustrated through accounts of the cultural activities by which people in various parts of Africa have acted to transform the resources provided both by nature and by trade into material artifacts that make up their distinctive cultures. These will include aspects of such traditions as architecture and mural painting, body decoration, beadwork and jewelry, textiles and dress, and performance in festivals and masquerades. Underlying these arts, however, are more abstract ideas about color and color use which also found expression in perhaps more surprising areas of African life such as medicinal practices and religious ritual.

Although the perception of color is a human universal, the specific responses to it evoke a multitude of complex cultural variations that are drawn from, but not always constrained by, the landscape and natural resources of the region. The Dinka people of southern Sudan are cattle-herding pastoralists whose ideas about color are drawn almost entirely from the diverse shades and patterns found on their prized cows. Like other nearby cattle-herding peoples speaking variant forms of the Nilotic language family, the Dinka have numerous terms that mostly do not apply to pure colors or shades but to patterns and permutations of such shades. In the 1930s, the British anthropologist Evans-Pritchard recorded thirty such terms

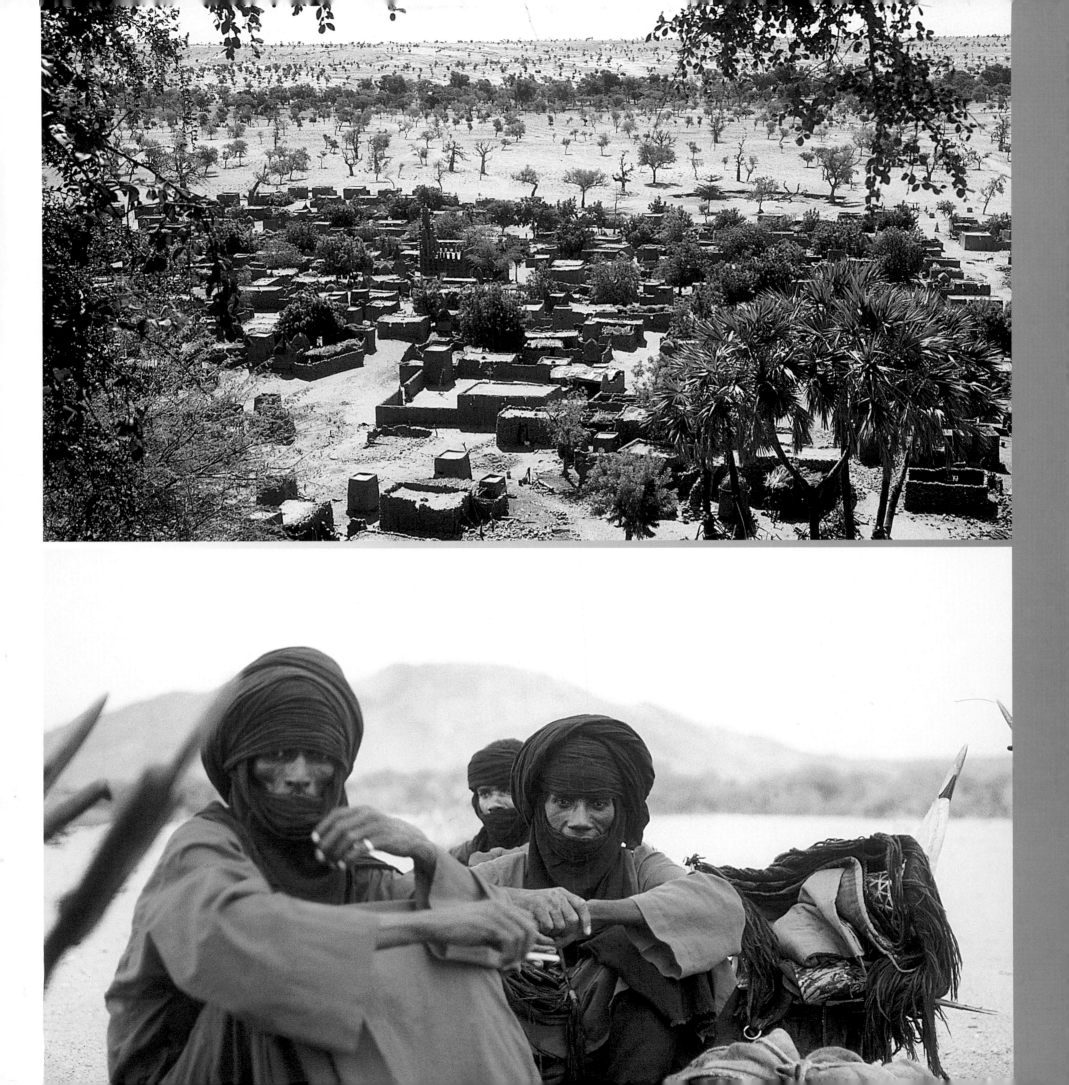

among one Dinka group, noting that hundreds of permutations could be obtained by relating ten principal color terms by twenty-seven combination terms. A male calf with a particularly distinctive and highly prized pattern of colors would be castrated and kept for display purposes, enhancing the prestige of the owner and his family at the expense of the future wealth that might have flowed from keeping it for stud purposes.

Talking about color and pattern in relation to cattle was a central feature of life for men among the Dinka, Nuer and their neighbors, with constant debate, dispute, and even conflict, centered on the precise categories that described a particular prized animal. Moreover, the color and sheen of oxen was a frequent topic for songs and poetry.

While this preoccupation with the color of cattle, which extended to describing other aspects of life in terms of cattle patterns and shades, is comprehensible when one understands the extent to which cattle keeping dominated the lives of these people, it is a comparatively unusual example. More commonly, it is the colors of the land that are significant, directly impacting on cultural life through the various pigments they provide for use in such diverse arts as textile dyeing, body painting, and house decoration. As will be seen in the following chapter, Basotho women revitalize the bleak landscape of the high veldt in Lesotho with vivid murals, based on the colors offered by earth paints, producing designs which are literally prayers invoking ancestral protection and the rain that will renew the fertility of the land. As elsewhere, an openness to external influences such as trade, and the accelerating pace of change over recent centuries have extended the range of colors available through commercial imports.

The contrast between the cattle-focused perspective of the Dinka men, and the role of earth pigments among Basotho women draws attention to the extraordinary diversity of lifestyles, ecological conditions and cultural practices that are a feature of African life. African people, like people elsewhere, live in a wide variety of environments. They have been, and continue to be, exposed to, and to participate in, historical changes, of which the colonial intervention of Europeans at the end of the nineteenth century, and the tragic trans-Atlantic and trans-Saharan slave trades which preceded it were perhaps among the most far-reaching, but certainly not the only, significant events.

Contrary to prejudiced stereotyping, which is still all too common, Africa was neither a land of undifferentiated harmony nor a dark unknown continent of war and suffering before a sudden European conquest ended thousands of years of isolation. Instead, it was a complex, varied continent on which great kingdoms and empires flourished, from the ancient

Right: Camels have been used for centuries to maintain trading routes across the Sahara. Further south in the arid Sahel they are a sign of wealth and prestige.

Ben Hunter

8

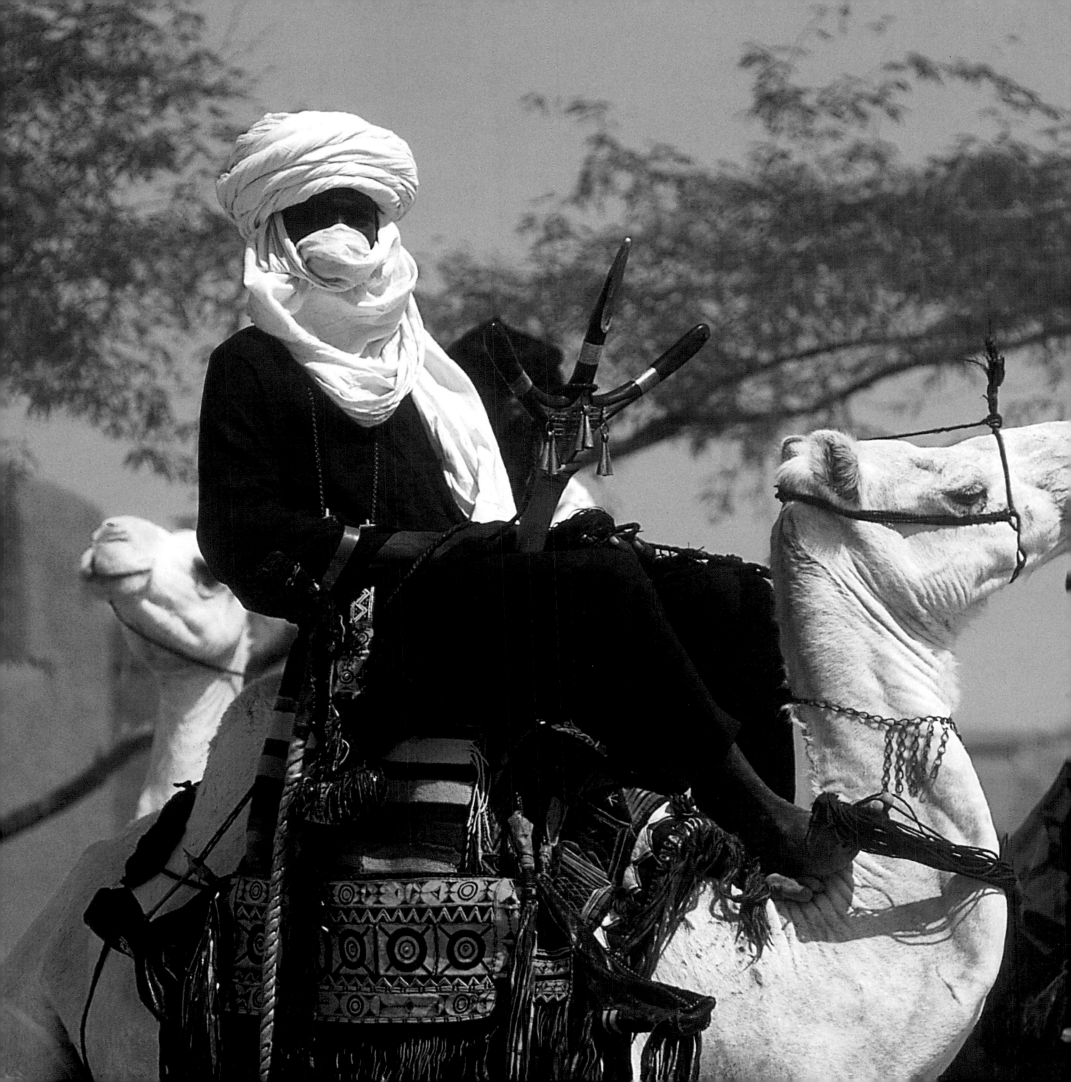

Right: Africa is not just desert and savannah; view of the mountains in the Namuli range of northern Mozambique.

Ben Hunter

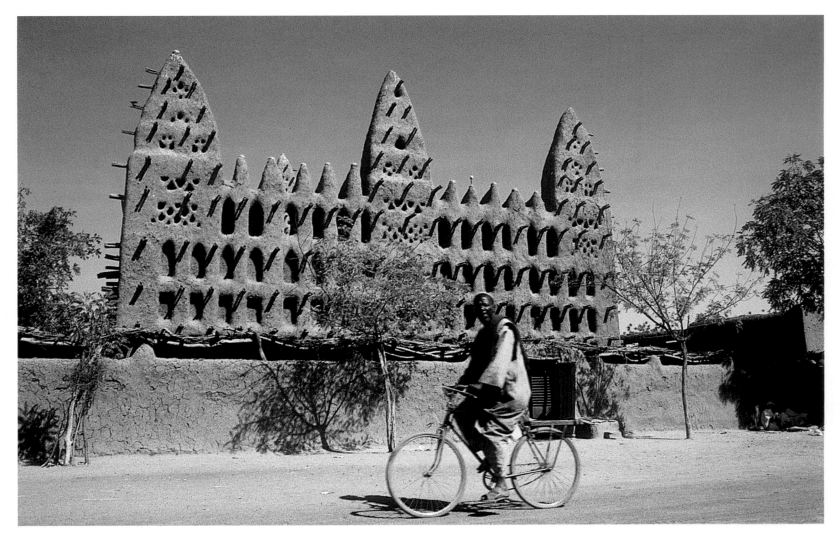

Egyptians, early Christian kingdoms in Ethiopia and Sudan, the medieval empires of Ghana, Mali, and Great Zimbabwe, to the Yoruba kingdoms of Ife and Oyo, alongside village-based chieftaincies and nomadic bands. Contacts with the outside world were extensive, with trade goods from sub-Saharan Africa, including gold and ivory, key commodities in both the Mediterranean and Indian Ocean trading networks since ancient times.

The twentieth century, in particular, has brought rapid change to much of Africa, as it has elsewhere in the world, bringing with it processes of modernization in which many Africans have actively embraced the new opportunities available to them in colonial and post-colonial states. As with all changes, this has involved both gains and losses. Many, but by no means all, of the traditions we will introduce in this book are less widespread today than they were a hundred years before. Some have been abandoned altogether. Yet the familiar story of traditions unchanged for centuries just captured before they finally disappear, is generally a misleading cliché. All traditions have always involved a process of handing on from the past in which some elements are preserved, but other aspects change with each performance of even the most sacred

ritual, or each new carving of a particular mask type, bringing with it greater or lesser degrees of change. It has been a common mistake to view the first incident or example that happened to be photographed or collected as the definitive old version from which any subsequent changes are some kind of decline. More thorough research, and a better understanding of the nature of local traditions, has made it apparent that such changes are a continuous process, albeit at faster rates in some periods, and for some groups, and some cultural practices, and at slower rates for others. Moreover, the wider changes and disruptions of the twentieth century have themselves stimulated new traditions and cultural practices that respond to the new needs of the day. The brightly colored Ndebele wall paintings, to take one example, seem to have developed only as a consequence of the need to affirm a common identity visually after the separation of Ndebele people as indentured laborers on white-owned farms following their military defeat at the close of the nineteenth century.

Wherever possible, the time period at which a particular example was documented will be indicated, and it will be important to recall that things may have been substantially different before as well as since. Even the cultural entities, the

Left: Mosques such as this in established Middle Eastern styles are gradually replacing more distinctive local forms across much of Africa.

Ben Hunter

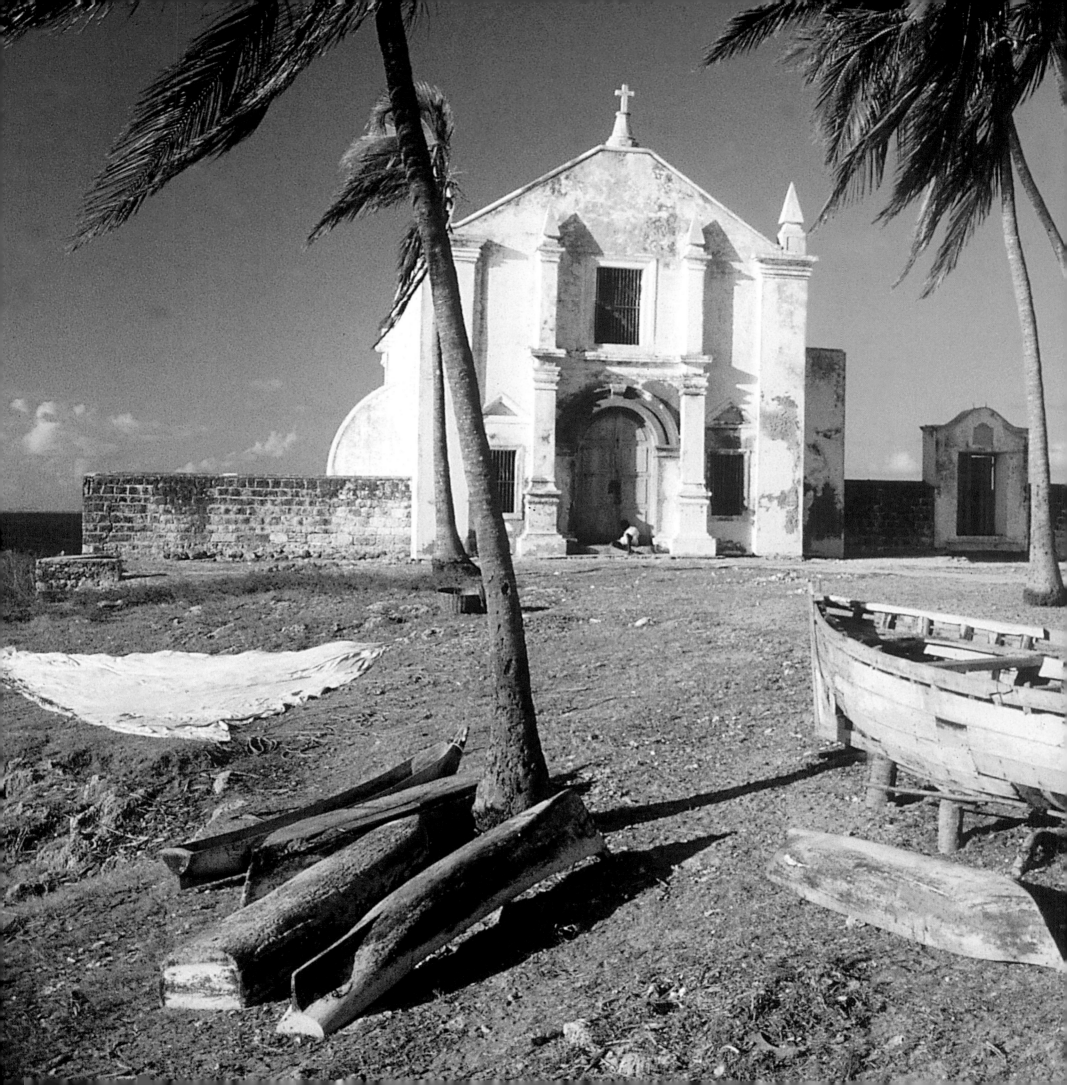

Previous page: Canoes on the beach in front of an old Portuguese church in Mozambique.

Ben Hunter

people to which ethnic names such as Ndebele, Yoruba, Igbo, Maasai, etc. refer, cannot be taken for granted as having some kind of independent, timeless existence. Instead, each name, like each group of people, has its own history, in many cases having been adopted only in the nineteenth or early twentieth century as people found the need to transform earlier, looser senses of cultural or linguistic similarity and difference into more distinct "tribal" identities, usually as a means of political mobilization in the newly formed nation states.

In celebrating something of the diversity and creative inventiveness of African peoples over the centuries through the traditions introduced in this volume, we need to remember that all of these arose from numerous acts of individual inventiveness and artistry, even where all trace of the individuals involved has been lost.

As art historians study the cultures of Africa in greater depth, it is becoming increasingly apparent that "Yoruba art," for example, is as much the product of individual artists, reacting to the constraints of materials, genres, and institutions of patronage, as is that of the Florentine Renaissance. Recovering the traces of these artists is simply more difficult in a culture where history was largely oral, works were not signed, and individual achievement was marked in different ways.

Whether or not there is some essential African cultural unity underlying the diversity of individual behavior, and of group customs, traditions, and practices is a controversial issue beyond the scope of this book. It is certainly a political issue, the answer to which seems, like so many, to depend on where and why you are asking the question. Nevertheless, when we look at color, both in general and through specific examples, similarities between diverse peoples will be as apparent as their differences.

Color is, in part, a way of making sense of the world, of dividing up the myriad impressions in ways that can be thought about, classified, compared, and contrasted. Color becomes a system that is good to think with, a fruitful source of the images and metaphors from which cultural life in general, and religious life in particular, is constructed and comprehended. As demonstrated in the remainder of this chapter, color names are not just words for talking about colors, they can become a structure of classification useful for talking about and acting on a huge range of other areas of social life. The spectrum as analyzed in western optical physics is merely one way of dividing up the continuous range of colors in light.

The anthropologists Berlin and Kay studied the ways in which colors are classified in languages around the world, identifying a maximum of eleven of what they called "basic color terms," one-word terms which identify a color without using similarities such as "leaf color," or imported loan words

Right: Dogon *togu-na* men's meeting house, Mali.

Ben Hunter

farming to festivals, from medicine to dress. Other colors were identified when necessary by means of similes, the green on an imported cloth, for example, would be "the color of leaves." A few of the many examples of these languages include Tiv, from central Nigeria (where *ii* means dark, i.e. black, *pupu* means light, and *nyian* means red), Yoruba from southwestern Nigeria, Ndembu from Zambia and Angola, Baganda from Uganda, Bamana from Mali, Shona from Zimbabwe, and Swahili from the East African coast.

Before looking in more detail at the cultural significance and use of these three-part classifications, it is worth noting that a number of other African languages, in some cases of neighboring peoples, fall into different groups, with four, five, or more color terms. It seems apparent that the link between color vocabulary and the complexity of material culture is not a simple one. Among the languages having four color terms are Ibibio (*afia* means white, *ebubit*, black, *ndaidat*, red, and *awawa*, green) and Igbo (*oji* means black, *nzu*, white, *uhie*, red, and *odo*, yellow) both from southeast Nigeria. Why should the Igbo have a basic term for yellow but none for green, while their close neighbors the Ibibio have a name for green but not yellow? Linguists can, as yet, only speculate. Perhaps surprisingly, the !Kung, nomadic hunter-gatherer "bushmen" of the Namib desert, have five basic color terms, *gow* meaning white/gray, *zho* meaning black, *!ga* for red, *!oun* for green and blue, and *gow* for yellow.

Languages with six terms include Hausa and the neighboring Nupe (who also adjoin the three-term using Yoruba), while there are at least two languages, Bari and Siwi, that have seven terms. This research does not imply that people speaking a language with only three basic color terms, such as Yoruba, are only able to observe three colors—the whole spectrum of light is as visible to Yoruba speakers as it is to Germans or Italians. On one level, it is simply a matter of vocabulary: to describe blue in Yoruba one says, "the color of sky," while green is "the color of a leaf," etc. Yet, at the same time, distinctions in color that would be remarked in English, between, say, red and brown, or dark blue and black, are frequently lumped together, as the terms for red, *pupa*, black, *dudu*, and white, *fun-fun*, are extended across a wider range of shades. As in many other African languages, a wider exposure in the twentieth century to the language brought by the colonial power (English in this case, but French or Portuguese elsewhere), has led to the development of vocabulary that the Yoruba art historian Moyo Okediji has called a "pidgin chromacy" in which loan words are adapted for local use, giving a Yoruba term "*yelo*" for yellow and "*buluu*" for blue.

The existence of only three basic color terms did not prevent other colors taking on a significance. For example, each

from other languages. In English these eleven basic color terms are white, black, red, green, yellow, blue, brown, purple, pink, orange, and gray. They found that languages with only two basic color terms named only white and black, those with three added a word for red, those with four named either green or yellow, while those with five named both green and yellow, those with six added blue, etc. Colors which in English would be distinguished, such as pink or brown, would instead be regarded as part of the range covered by red.

Languages with only two color terms were extremely rare worldwide, but along with several instances in New Guinea, the authors noted one African example, namely Ngombe, a Chadic language, in which the only color terms were *bopu*, meaning white, and *bohindu*, meaning black. However, it would appear that, in the past, although specialists such as bead workers and cloth dyers made use of a huge range of minor color variations, many African languages distinguished only three of the basic color terms: red, black, and white, forming a three-part classification, available for use in contexts ranging from

Left: An unusual Ewe women's wrapper cloth from south-eastern Ghana. Imported cotton in bright colors has replaced local hand-spun fiber in most areas.

Duncan Clarke

Left: A Dida ceremonial shawl woven from palm fibers and tie-dyed using natural pigments.

Duncan Clarke

Right: View of a village on
the edge of the Sahara.

Ben Hunter

deity in the pantheon of Yoruba gods called *orisa* had a locally recognized color of bead which was worn by his or her followers as a sign of cult membership. Many of these were shades of white, red, or black, but in the case of deities such as Orunmila, the god of divination, at least some of his priests wore alternating green and yellow beads. Moreover, the Yoruba were famous for their astonishing multicolored beaded crowns, decorated with birds, that allude to the mystic powers of their divine kings. Nevertheless, even where a far wider set of colors was available, the three basic color terms took on a special significance. It was not so much that there was a single fixed meaning identified with each color, but that the triad of colors became a means of dividing all sorts of things into threes. Some Yoruba farmers, for example, classified soil types into black, red, and white, in descending order of fertility, while an *Ifa*; verse from the complex Yoruba system of divination or fortune telling, classified mystically powerful women into *eleiye funfun*, who bring prosperity, *pupa* who bring suffering, and *dudu*; who cause death. A study of Yoruba medicine found that ideas about the appropriate relationship of colors, where black represented a healthy skin tone, red was blood, and white, bodily fluids, played an important role in healing procedures.

Although color symbolism has only been the direct focus of research in a small number of African societies, it is evident from references in more general ethnographic accounts of widely separated groups that the three basic colors, red, white, and black, played a role of considerable cultural significance across much of sub-Saharan Africa. There have also been a few archeological discoveries that suggest that similar concepts may be of considerable antiquity, including a (white) ostrich eggshell coated internally with black, externally with red pigment, excavated in a Late Stone Age "bushman" burial in South Africa.

It is important to stress that while it was apparently the case that the three colors had important meanings across a large number of African societies, the specific reference of a color varied both between and within each society depending on the context in which it occurred. Black, for example, was associated with pollution among the Dogon of Mali, but with the rain-bearing clouds that bring fertility and new growth among the Shona of Zimbabwe, where, at least in the early decades of the twentieth century, shrine priests of spirit-guardians wore black cloth and sacrificed black cattle or chickens to bring rain.

Something of the complexity of ideas about color in an African society can be understood by a brief extract from the

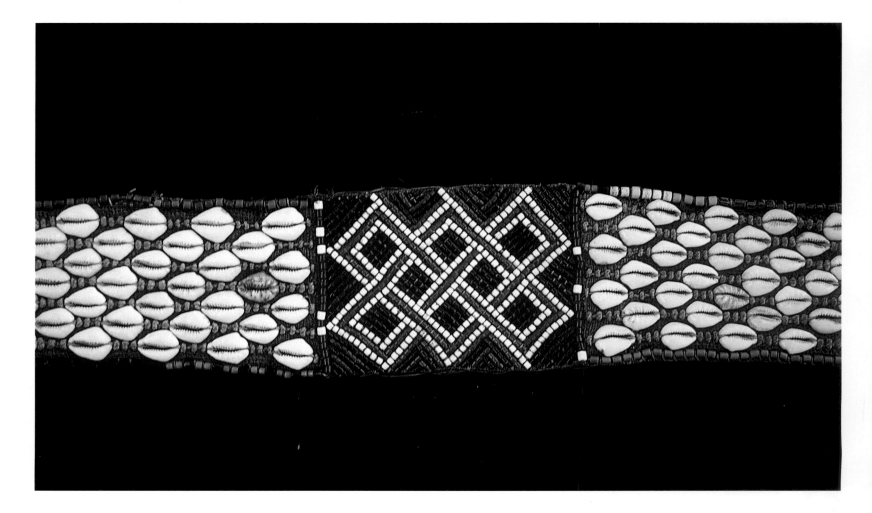

Right: A Kuba ceremonial belt from central Congo, with cowrie shell and beadwork decoration.

Duncan Clarke

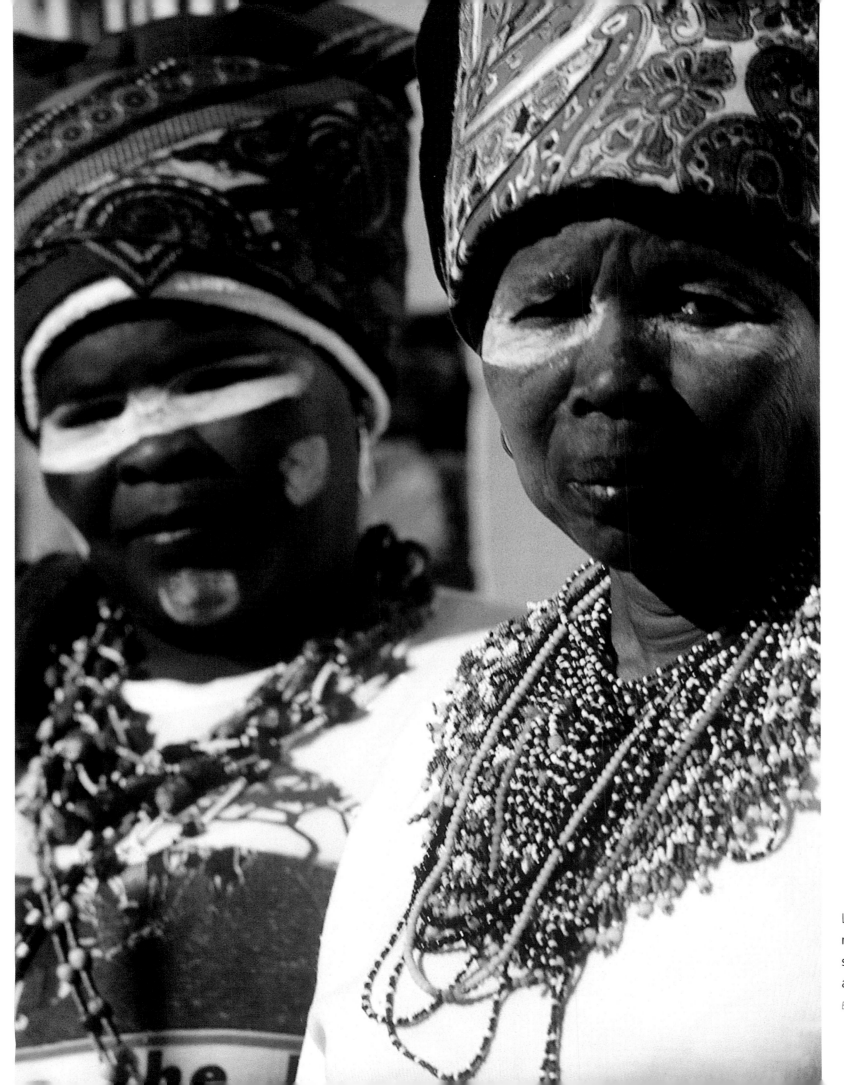

Left: Zulu *sangomas* (spirit mediums and medicinal specialists) with white chalk around the eyes.

Ben Hunter

23

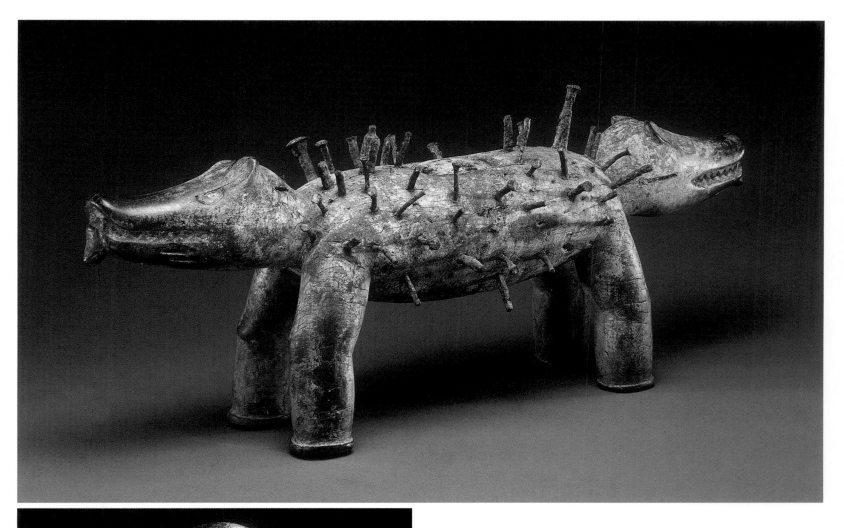

Right: A Kongo medicinal nkisi in the form of a two-headed dog. Dogs were seen as familiars of the ancestral spirits because of their ability to move easily from the village to the forest.

Christie's Images

Right: A Kongo nkisi in the form of a squatting figure with medicinal substances attached to the stomach and back.

Christie's Images

writings of Victor Turner, one of the first anthropologists to consider the issue of color symbolism in Africa. Among the Ndembu people of Zambia and northern Angola, he argued, "the colors are conceived as rivers of power flowing from a common source in God and permeating the whole world of sensory phenomena with their specific qualities." Red, black, and white form three principles of being: "Evidences of these principles or powers are held by Ndembu to be scattered throughout nature in objects of those colors, such as trees with red or white gum, bark, or roots, others with white or black fruit, white kaolin clay, or red oxidized earth, black alluvial mud, charcoal, the white sun and moon, the black night, the redness of blood, the whiteness of milk, the dark color of feces. Animals and birds acquire ritual significance because their feathers or hides are of these hues."

It is this sense that colors have powers that can become efficacious in themselves, that they can transmit or promote some change or state of being associated with the color, that underlies their important role in medicinal practice and ritual procedures in African societies. Although African medical traditions of the recent past seem to have been extremely diverse in their specific details, enough research data is available to observe some general principles. One key aspect was

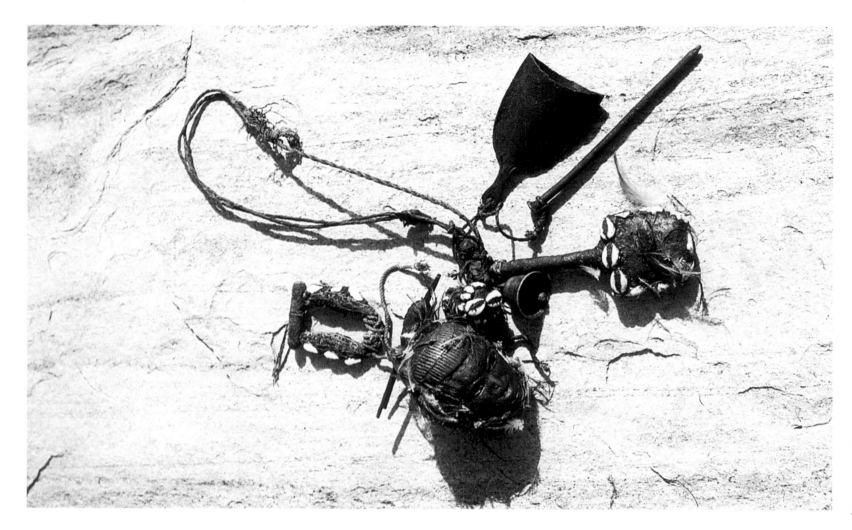

the assembling of packages of medicine through processes which go well beyond the inclusion of leaves and herbs which a western doctor might consider to have a direct physical impact. In particular, ingredients that are thought to have, or to promote, the desired quality in the patient through relationships such as metaphors and metonyms, such as plants having the same name as the desired effect, or an animal body part which transmits a quality associated with that animal, are common. Binding the package of ingredients with twine, or including a locked padlock, might be considered to bind or lock up some aspect of the condition or person towards which it was directed.

Aside from any other properties they may possess, red, white, or black ingredients were frequently selected in order to promote a specific result associated in that context with the color chosen. It is objects of medicinal use such as these that were condemned as "fetishes" by ill-informed European observers during the colonial period. In many areas, this kind of medical treatment lives on alongside European medicine, which is often expensive and inaccessible. Moreover it offers apparently effective remedies to a far wider range of problems. In particular these traditions offer the ability to combat the malevolent attacks of enemies using witchcraft and sorcery,

which many people in both rural and urban African societies consider to be a pervasive danger.

The best known of this type of medicinal objects are the *nkisi* of the Kongo peoples who live around the lower reaches of the Congo river. *Nkisi* are packages of medicinal ingredients, sometimes taking the form of a sculpture of a person or animal, to which medicines are attached, but more commonly a bag, shell, pot, or other container filled with medicine.

Portuguese navigators found a powerful Kongo kingdom when they first reached the coast of Central Africa at the end of the fifteenth century. They established diplomatic and trade relations with the Kongo king, whose court was rapidly converted to Christianity. Among the ordinary people, however, several centuries of Catholic missionary activity made little direct impact, and, as in most other parts of Africa, it was not until the early decades of the twentieth century that large-scale conversion took place. Fortunately, the mostly Swedish missionaries in the region made an exceptional effort to document aspects of Kongo religion just as it was undergoing rapid change.

Drawing on this documentary material, the Swedish anthropologist Anita Jacobson-Widding has made the most detailed investigation to date of the role of colors in an

African culture, published in her book *Red-white-black as a Mode of Thought*.

In the Kongo language Kikongo, the word for red and yellow is *ambwaki*, white is *ampembe*, black is *andombe*. There is also a term for green, *ankunzu*, but this translates as "like fresh grass." Kikongo then has three basic color terms. However Jacobson-Widding found that, in use, the colors were generally named after the material used to make them, so that red-colored powder from the *tukula*, or coral tree, was called *tukula*. Black powder usually came from the pounded bark of the *mwindu* tree with added charcoal, which was mixed with water to produce a black pigment. White was obtained from kaolin or chalk. Both in the manufacture of *nkisi*, and in ritual procedures, there were certain circumstances in which each color was used alone and others where two or all three were found in combination. By exploring these circumstances in considerable detail, it was possible to reach sensitive and subtle conclusions about the connotations of each color in Kongo thought.

Red was used alone in a variety of contexts. Red pigment made by mixing *tukula* powder with red palm oil was widely used in the past as a cosmetic. Young women, and occasionally young men, would smear themselves all over with this red pigment to make their bodies gleam when dancing at feasts. Girls of the Yombe subgroup of the Kongo went through a period of seclusion before marriage, lasting in the past for up to a year, but more recently restricted to about a month. During this period, known as *kumbi*, the bride was confined to a house painted red, her body and clothes were kept rubbed all over with *tukula*, and red powder was sprinkled on her bed. More red powder was sprinkled over the containers of food brought for the feast that ended the *kumbi*.

Other periods of seclusion, whether to recover from an illness, or to mourn the death of a close relative, were also concluded by a feast at which the person rejoining society painted his or her body red. Red pigment was worn by people who had certain illnesses, and by those considered vulnerable to disease such as crawling babies and pregnant women. Red was also used in association with death, most spectacularly in the celebrated Niombo funerals accorded to powerful chiefs and magicians among the Bwende. Prior to burial, the corpse was mummified and shrouded in thick layers of cloth and mats, until a huge doll, twice or three times the size of the body, was created. The outer layer of this cloth coffin was made from imported red blanket material, while the head and body of the *niombo* was marked with designs corresponding to the tattoos of the deceased. The body was then carried to a huge grave by the children and grandchildren in a procession accompanied by drums, gongs, and trumpets.

Right: The face and body of an initiate at a Fon *vodu* ceremony are painted with white chalk, indicating his transitional status.

Ben Hunter

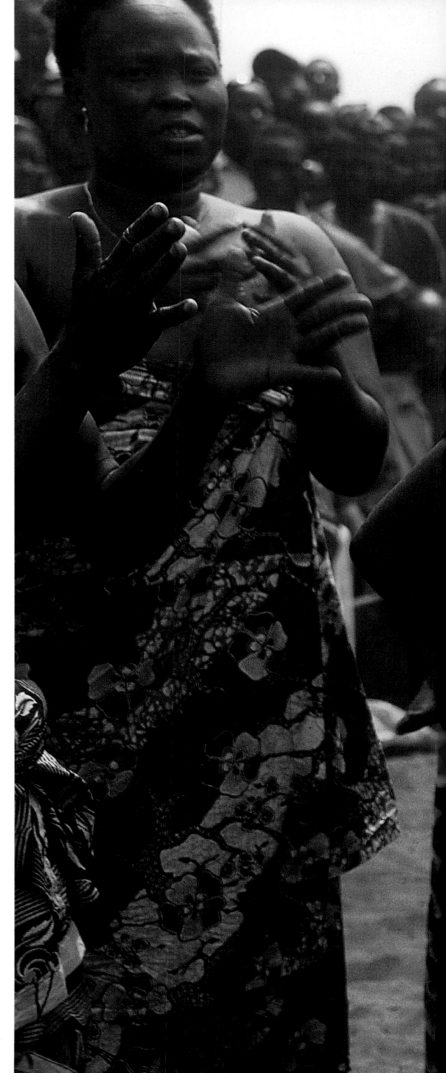

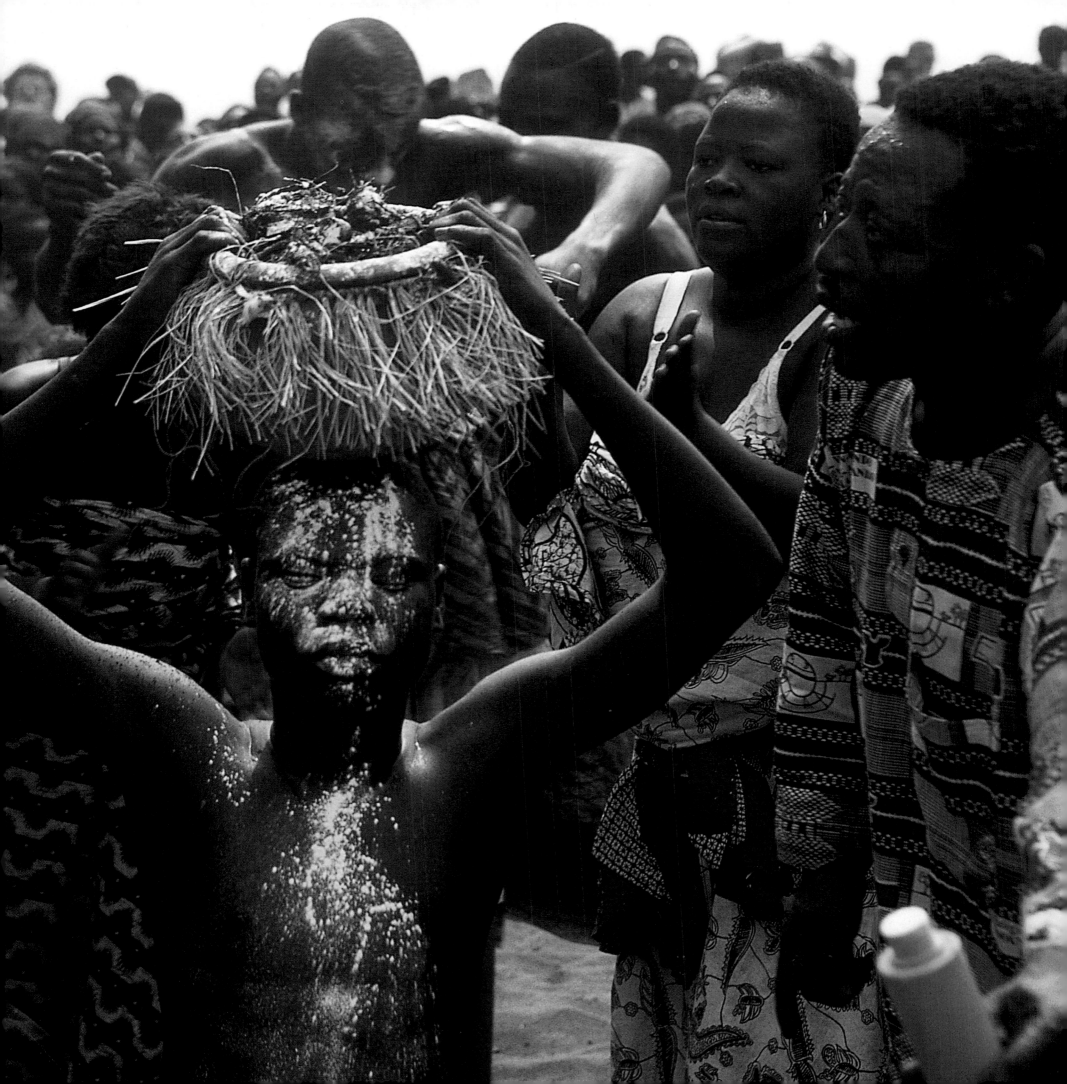

Red alone was not common in the ingredients of *nkisi* (plural *minkisi*), although it was for a *nkisi* called *Lemba*, which drew on the power of close paternal ancestors to combat stitch or chest pains, while another red *nkisi* called *Longo* was used in circumcision rituals. By exploring in detail all the circumstances in which the color red was used alone, Jacobson-Widding concluded that the common factor in all the qualities linked with red was a lack of moral associations, for example sexual desire among young women, of whom it was neither prohibited (as between close relations) or required (as in marriage).

Warriors used to daub themselves with black lines before going into battle. Black alone was also a feature of the assembling of a type of *nkisi* called *Nkondi*. Since these are usually in the form of human figures in an aggressive pose bristling with nails and knife blades, they have become well known to western collectors of African art. *Nkisi Nkondi* were generally painted black, and their role was to exact revenge on thieves and others who did evil, often by killing the suspect. They could also be used to seal a contract, or swear an oath, when a blade would be driven into the statue. If the deal was broken, the *nkisi* would be expected to punish or kill the defaulter. They were thought to draw their power in part from the medicinal ingredients attached to the sculpture, but more importantly from the presence of the evil spirit of a recently deceased ancestor, which the *nganga*, or doctor, who created the *nkisi* had induced into the figure.

Black was the color associated with antisocial behavior, whether expressed in killing, in sorcery, or in extreme grief. White, on the other hand, had largely positive connotations of social order and, as might be expected, was far more widely used. Kongo people had elaborate courts in which judicial disputes were debated and cases settled by recognized judges. It was a feature of these judicial procedures that both the judges

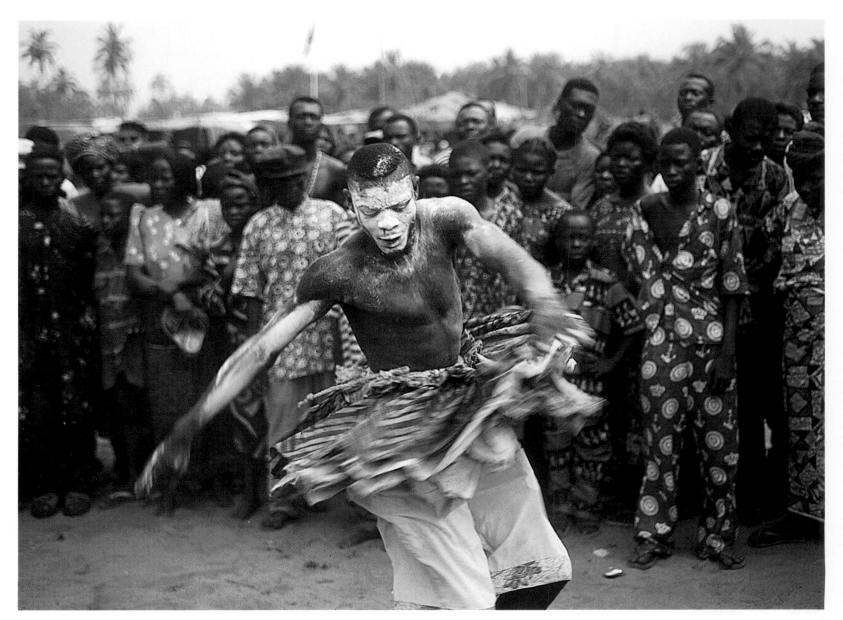

Right: The spirit of the *vodu* deity may possess the chalk-painted dancers as the ceremony proceeds.

Ben Hunter

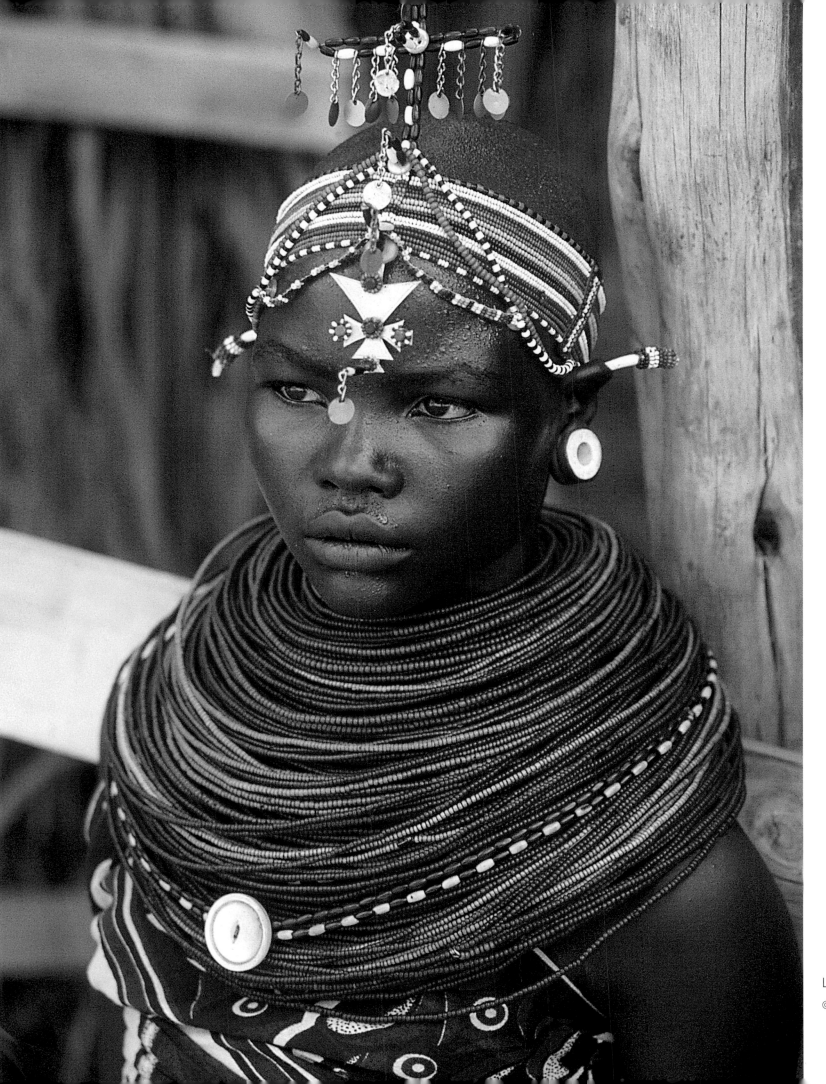

Left: A Samburu girl.

© Mark Kucharski/Swift Imagery

29

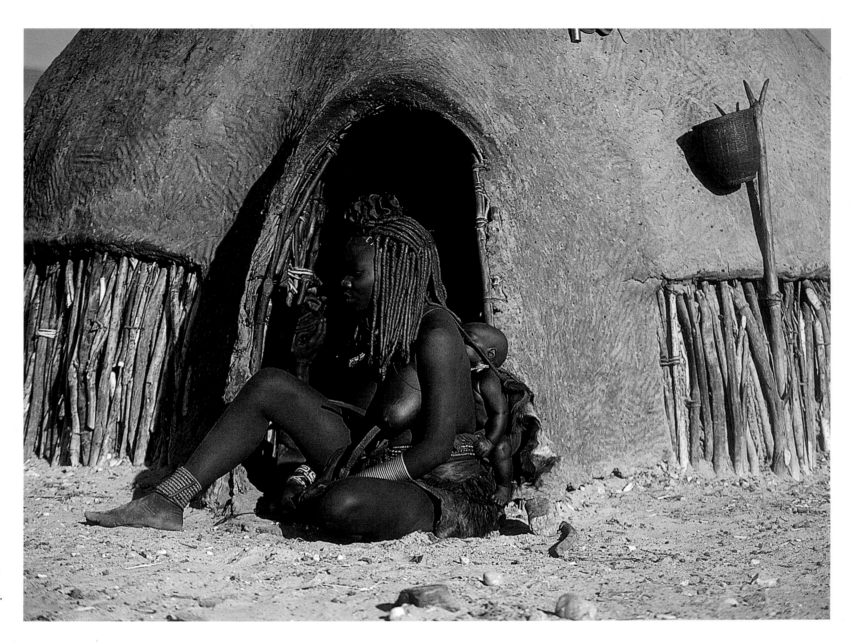

Right: Himba mothers smear themselves and their babies with red ochre paste.

Struik Image Library

and the winning party were marked with white chalk pigment, with the marking of one litigant by the judges often serving as a sign that they had decided in his favor.

Among the nearby Chokwe people is has been reported that a basket of white powder was emptied over the head of the winner in a legal dispute. In some areas, the party that was blamed in a divorce dispute was marked with charcoal, while the party deemed innocent was marked with chalk. Judges among the Luba wore white shells and white feathers. *Nkisi* containing a *simbi* spirit from the water were made using white ingredients to cure diseases ranging from headaches, to leprosy, mental illnesses, and epilepsy, which were themselves thought to be caused by the *simbi*. Among them was *nsonde*, made by combining white chalk powder with various plants and seeds thought to "make the heart eager." This was sprinkled on the sick person at night, then kept in a lidded basket to cure

depression. White *minkisi* were also used to secure good luck, and to ensure success in hunting and war. At times of death, the deceased's relatives might wear a white band to show that they had done him or her no ill, while each could bring a white cloth to contribute to the burial shroud.

In general, white was associated with innocence and social order, as well as other virtues such as reason, health, generosity, and good fortune. Among the Kongo all these were linked with ideas about matrilineal descent, as opposed to the real threats posed by the clan and ancestors of the father. The combination of white and black was relatively unusual, but white and red were frequently found together, both in the manufacture of nkisi and in ritual procedures such as the induction of cult members and the training of nganga. Put simply, the morally neutral but powerful red was seen as complemented by the socially approved aspects of whiteness in order to be

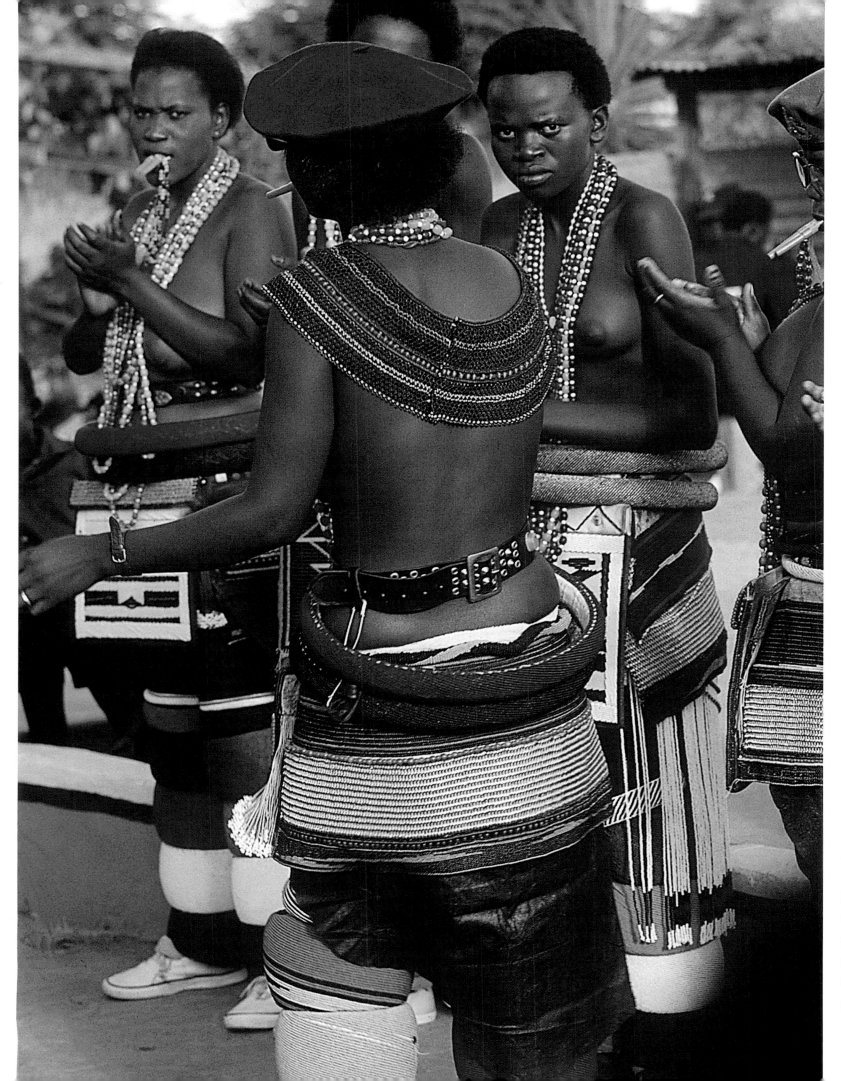

Left: Young Ndebele women wear beaded hoops that represent rolls of fat, regarded as a sign of wealth and beauty.

Struik Image Library

31

used for communal benefit. By the same token, red and black would rarely be combined in public, as they would tend to direct the result towards negative, antisocial purposes such as sorcery.

All three colors, however, could be found together in contexts ranging from divination to witchcraft ordeals, to certain types of ancestral mask. They represented the three principles of life, and their combination often marked the early stages of a process of investigation or inquiry before the nature of the outcome as black, red, or white had been established. While the specifics of color meanings among the Kongo are dependent on the context in which they occur, more vague general implications could be traced underlying and informing each use. As with other examples later in this book, a similar interplay between context-based connotations and more abstract general references marks ideas about color among many other African peoples.

Right: **Himba cattle herders in Namibia build tiny mud plastered houses that blend in with the arid landscape.**

Struik Image Library

LIVING WITH COLORS

Houses, Murals and House Decoration

Across the continent of Africa, people live in an extraordinary variety of dwellings, from temporary leaf-thatched shelters abandoned after a few days, to huge concrete and marble mansions; in societies ranging from single family groups to some of the world's largest and most rapidly expanding cities. Life in the cities of Africa confronts most residents with all the problems of poverty and unemployment that face urban dwellers in developing countries worldwide, although their responses are frequently framed in distinctively African ways.

Away from the cities, many others continue to live in towns and small villages where the impact of twentieth century development is less obvious. It would, however, be a mistake to view rural African dwellings as unchanging traditional structures, as in almost all cases further inquiry would quickly reveal that both the physical processes of building a shelter and the social organizations expressed in patterns of residence have been transformed over recent generations to a greater or lesser extent in even the most remote regions. Nevertheless, it is in the rural areas that continuities with the past are most apparent.

Traditions, in architecture as in other fields, are not static. They involve a conscious selection from what is being handed on from past, with some aspects being continued, others rejected, while still others are modified to meet new needs. Some groups of people are highly conscious of the fact that they live in the same kind of houses as their ancestors, often taking a pride in this continuity that leads them to downplay any changes. Others take equal pride in new forms, whether these be replacing round mud-brick rooms with square ones, thatch with corrugated iron, or building a concrete block house complete with mains electricity, or even cable television.

African indigenous architectural practices reveal a wide range of responses to the diversity of environmental and climatic conditions found on the continent and to the ways of life that have developed to best exploit the available resources. Despite the pressure to settle often imposed by state governments, nomadic or semi-nomadic groups of cattle-herding pastoralists are found wherever conditions permit, including the Fulani in many parts of West Africa, the Nuer and Dinka in southern Sudan, and the Maasai and other peoples in Kenya and Tanzania. Even the apparently simple dwellings built wherever these groups halt and establish temporary camps are governed by complex and long-established ideas about the organization of social space, with relative position being

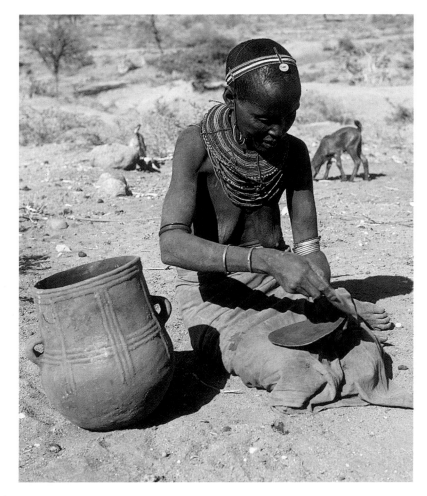

Right: A Samburu woman making a pot. Potting is a female craft in most parts of Africa.

© *David Keith Jones/Images of Africa Photobank*

Left: A Dogon woman clearing away the ash after firing her pots.

Polly Richards

established through ideas about clan genealogies, the seniority of family members and incoming wives, gender roles, marital status, etc. For the settled, predominantly agricultural people who live in more permanent structures, frequently arranged together in family compounds, which in turn make up villages, ideas about status, gender, and other concerns are also frequently mapped out in the layout of space. For many such people, relationships expressed in terms of ownership of the land were important. Often the descendants of the family or group accepted as having lived in the area longest were held to be the "owners of the land" and had responsibility for placating the spirits associated with it, either directly through sacrifices to an earth shrine, or indirectly through sacrifices to the ancestral settlers.

Shrines often took the form of pillars or mounds of earth, or of a special tree planted when the compound was first built. In the West African savannah, compounds often had male areas, usually near the entrance, and other, female, areas further inside, to which access to non-family males was denied. Ideas about gender in relation to living spaces were common elsewhere, too. Frequently, the whole village was considered to be a female space associated with order and social control, while the more dangerous and unpredictable bush or forest sur-

rounding it, home to spirits and dangerous animals, was conceived of as male. Among some groups, the houses themselves were considered to be like people, having a head, limbs, etc. Houses were frequently seen as female, producing a conceptual relationship between women and the houses in which they lived which could be both fruitful and problematic.

In Africa, as elsewhere, her control over the mysterious processes of reproduction, essential to the future viability of each family unit, is thought to place a woman in a unique condition where she is both especially vulnerable and especially powerful. Pregnant women, in particular, were hedged around by taboos and prohibitions which protected them and shielded other vulnerable people and procedures from the powers they embodied. By now it should be no surprise that the three primary colors frequently played a key part in these protective procedures.

Red camwood paste was formerly smeared on both pregnant women and newborn babies by the Yoruba of southwestern Nigeria, white chalk had a similar function for Asante women in Ghana, while among people such as the Lunda and Chokwe in Angola, pregnant women painted their bodies with both red and white earth. As will be seen in a later chapter, the colors of the earth were also used to dye textiles,

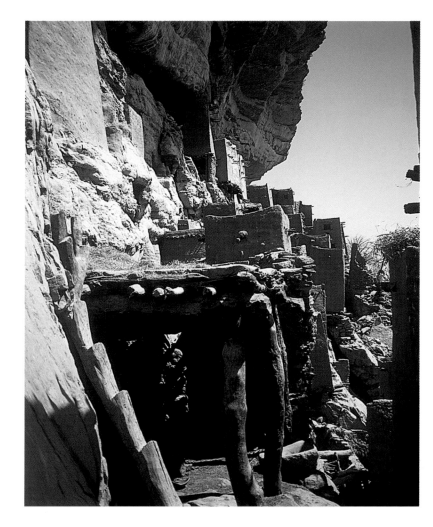

conceptually rich process which contributes directly to these concerns.

In areas where mud was used for building, ideas about the fertility and nurturing power of the land were widely applied to the houses that were so directly drawn out of it. Pottery, the making of vital containers for food and water from the earth, was generally the responsibility of women (although men were potters in a few cultures). Across the savannah and Sahel belts of West Africa, grain harvested from the fields is stored until needed in huge round clay containers, usually built by women, and often capped by a thatched roof against the rain. Circular mud-built houses that formed individual dwelling rooms are themselves grouped into compounds with complex circular patterns, often ringed by a circular mud wall for privacy and protection against wild animals. It doesn't take much observation to recognize the scaling similarity from pots, to granaries, to houses, to compounds, all of them circular clay-built structures. Although men contributed labor to the actual construction of houses, the finished dwellings, built on and from the earth, were invariably decorated by women. Compounds and the houses within them, like pots, were thought of as primarily female spaces, drawing on ideas of containment, wombs, and nurturing.

In a number of cultures, women potters were the wives of blacksmiths, the anomalous and frequently dangerous individuals who tapped special powers to produce the iron tools necessary for cultivating the earth. In turn, the earth was the major source of pigments used in house decoration, furnishing a range of colors to the women artists that extended the metaphorical association. Although wall painting was probably the exception rather than the norm across Africa as a whole, from areas as diverse as the Upper Guinea coast, the Nuba hills of southern Sudan, the rain forests of southeast Nigeria, to the northern savannah regions of Ghana in West Africa and the high veldt of South Africa and Lesotho, women used earth pigments, mostly in shades from white through red to black, to both beautify their homes and mark them out as both social and sacred spaces. For many, the annual renewal of these decorations—necessary in the aftermath of the rainy season—became a potent metaphor of rebirth.

In some cases these traditions have been largely abandoned in the course of the twentieth century, but, in others, they continue apparently much the same as in earlier periods, while in others again, the access to new paints and pigments has led to the development of new traditions. This is most notable among the Ndebele in South Africa, whose now famous wall paintings made use of industrially produced paints to create a vivid program of mural decoration alongside similar designs in imported beads. Like the older traditions, these forms were

notably the bogolanfini or mud cloth of the Bamana in Mali, which was worn primarily by those encountering unpredictable and dangerous forces, whether in childbirth or as hunters in the bush.

In many parts of Africa, houses were made from earth, using bricks of sun-dried mud, or mud plaster over a wooden frame. African builders displayed incredible creativity, using earth to produce structures from single-room dwellings to vast royal palaces, and the famous mud-brick mosques of Mali and Burkina Faso. Indeed, outside of urban areas, where it has been largely replaced by concrete, mud bricks are still the most widely used building material in much of sub-Saharan Africa. Aside from being cheap and readily available wherever there was sufficient water, earth buildings are ideally suited to the African climate since they have far greater insulating properties than modern substitutes. Houses and other buildings are about more than just immediate practical necessities of protection from the environment and defence against wild animals or hostile strangers. They are also spaces where cultural life is enacted and reproduced, expressing ideas about crucial issues such as status, cosmology, and particularly about gender, the socially constructed understanding of male and female roles. Building your house directly from the earth is clearly a

associated with aspects of female roles and gave expression for the creativity of women artists, yet they emerged in response to a political context in the colonial and apartheid eras.

The Asante, or Ashanti, were the dominant power in much of present-day Ghana for several centuries before the British colonial conquest at the close of the nineteenth century. At the height of their empire, the "wattle and daub" technique mud-built houses and shrines of Asante towns had rectangular courtyards which were decorated with a complex program of low-relief designs constructed on wooden frames. The beautiful patterns, also used in their well-known adinkra cloth decoration, were clearly influenced by Arabic calligraphy reflecting the important role Muslim scholars played as diviners and record keepers in the Asante court.

In the seventeenth century, a European trader also noted that the courtyards were "kept clean by the daily application of red and white earth" to the walls, a procedure we might suspect involved more than simple housekeeping. Although many aspects of court procedure and regalia were spread northward well beyond the Asante heartland at the edge of the rain forest belt as part of a program to co-opt conquered local rulers with the symbols of central power, the peoples of northern Ghana and southern Burkina Faso seem to have retained their indigenous, very different tradition of wall decoration despite a long period of Asante power over trade routes and the smaller political entities of the region. Moreover, their compound-based style of decoration has continued to flourish long after the Asante have abandoned theirs and developed new media for expressing court prestige in the changed circumstances of colonial and independent Ghana.

The role of women as artists in Africa has, until recently, been ignored by art historians who have been preoccupied with primarily male art forms such as sculpture and masquerading. Women's arts, such as pottery and mural decoration, were dismissed as domestic crafts despite their importance in the life of the people themselves. The Gurensi, also known as Frafra, who live around the city of Bolgatanga, are one of a number of groups in northern Ghana and the southern districts of Burkina Faso where women co-operate to decorate the mud-plastered walls of their family compounds with elaborate painted designs.

Although other pigments have been used occasionally in recent years, red, white and black are the main colors selected. The red is an earth color made from soil found in only a few places, while white and black are made from pulverized chalk and a local soft rock.

Like many other people in the dry savannah belt of West Africa, the Gurensi live in family compounds established and

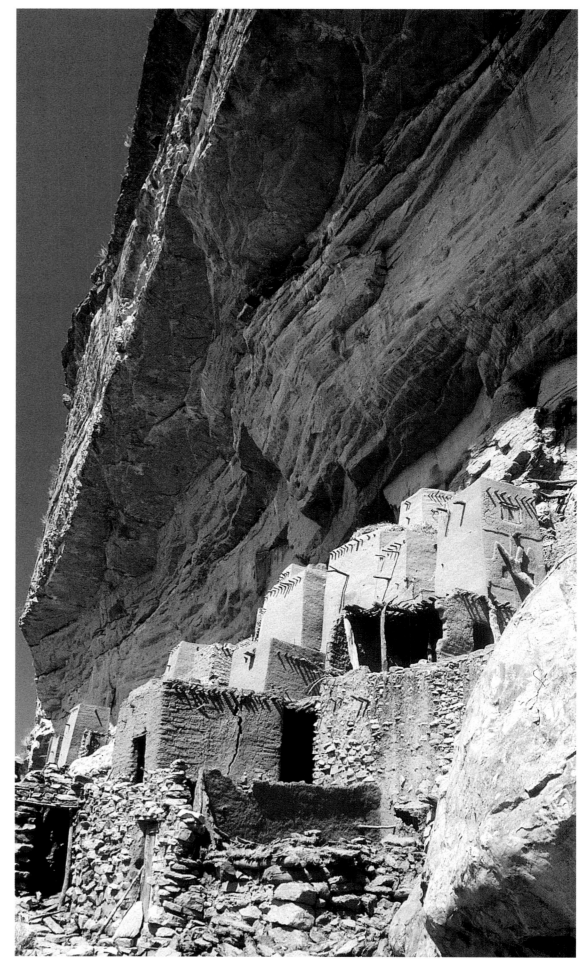

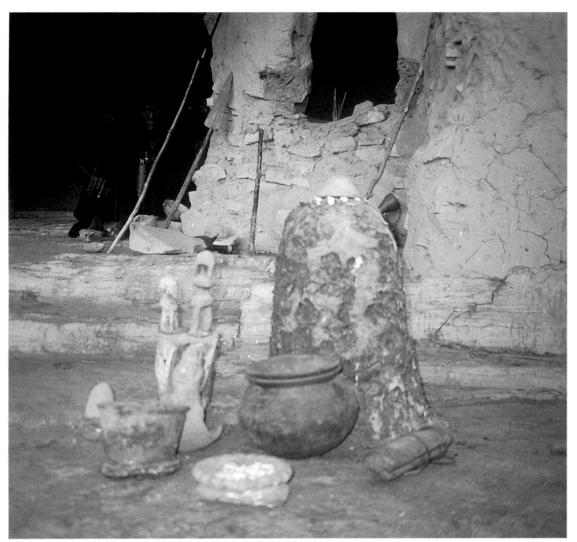

Above: The shrine of a Dogon ritual specialist or *hogon.*

Ben Hunter

Right: Mud-built circular grain stores echo the form of houses in miniature.

Ben Hunter

controlled by the senior man. Each compound consists of separate circular, single-room buildings, one for the compound head, one for each his younger brothers or his adult sons, one for each of his wives, and for the wives of other male residents, plus a kitchen building for each wife. In between are smaller circular structures to store grain, and for use as animal pens. Linking the outer dwelling rooms together and forming a protective barrier around the exterior of the compound is a high wall. In many ways the compound is like a living organism, expanding outwards as new rooms are built on to house new family members, while the houses of deceased residents are often left to decay in the center, collapsing back into the mud after many years of rains.

According to the art historian Fred Smith, a typical small compound would take about forty days to construct, usually with a specialist builder guiding the work of both male and female residents. Once the buildings were complete, however, it was entirely the responsibility of the women to plaster and decorate the walls. All compounds had to be plastered, as this served to protect them against the seasonal heavy rains, but not all were decorated. The decision on whether or not to add

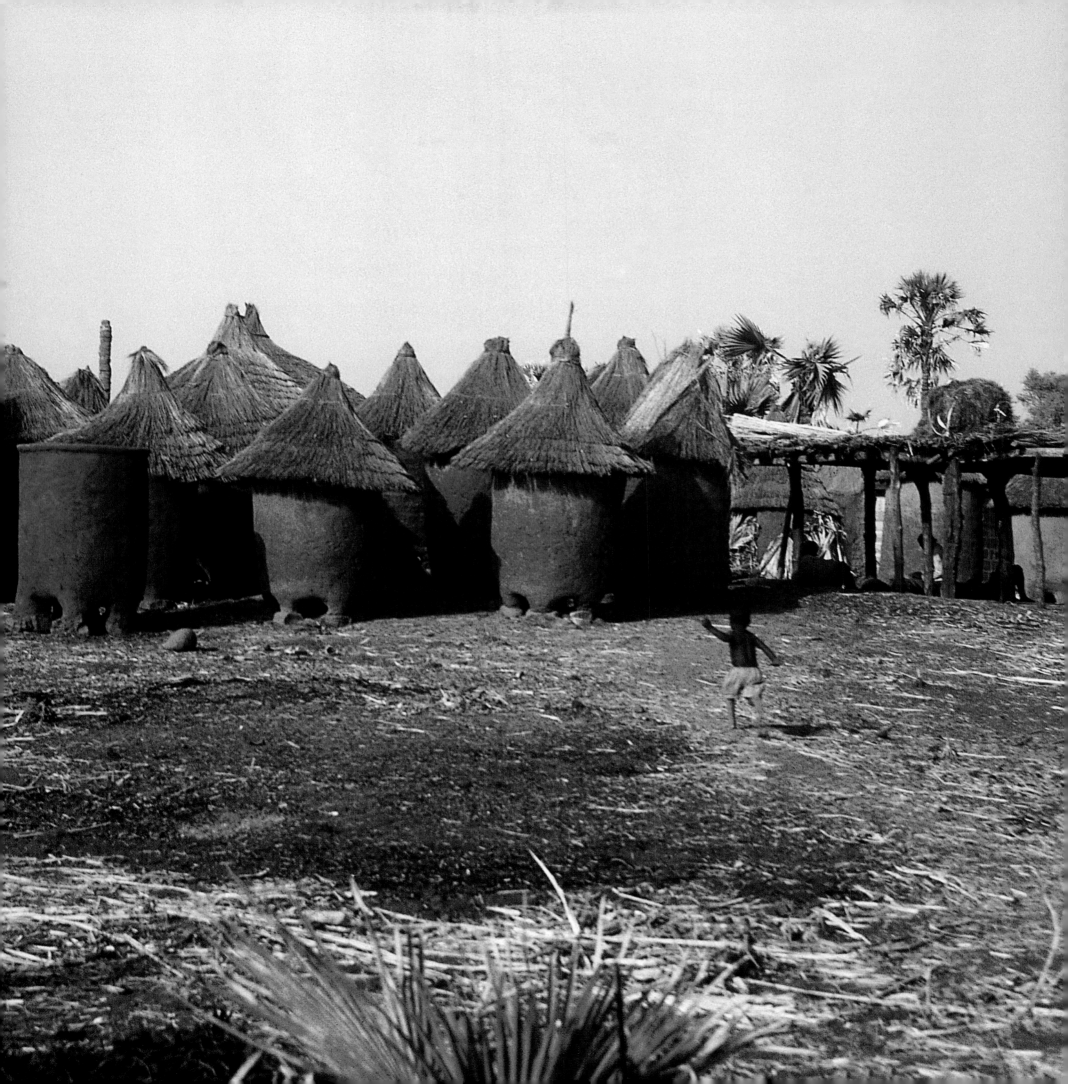

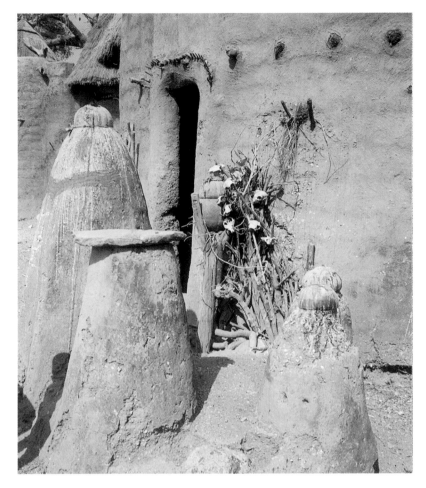

decorated plaster depended, in part, on there being an adequate water supply nearby, but the compound also had to be sufficiently wealthy to be able to spare the women from labor in the fields for the time necessary. Once completed, the decoration would last for between three and five years before it had to renewed.

Although sometimes a woman would decide to paint the wall of her sleeping room by herself, it was more usual for all the women in a compound to co-operate under the guidance of the senior woman. Often women from other compounds, such as their friends, and the wives of the husband's brothers would come to assist. After some discussion of the motifs that would be used, each wall was divided into small sections, each of which one woman would paint. Relief decoration and incised patterns were often combined with the three colors to create primarily symmetrical non-figurative geometric designs. Often the wall would be divided around the center and a single motif repeated along each of the two areas formed. Separate bands of designs along the top or bottom and around the edge of the doorway were also frequent. Although there were many standard named patterns, there was still scope for individual creativity and innovation, either within the framework of established geometric motifs, or by the addition of paintings of animals, snakes, etc. A successful innovation can

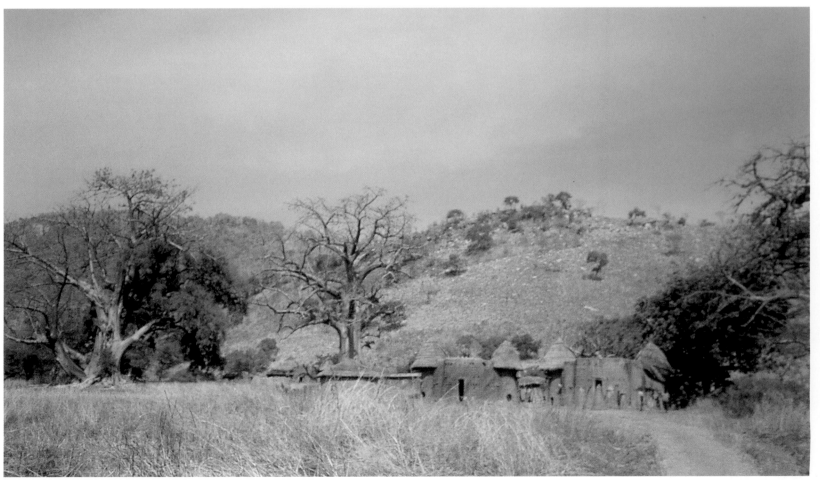

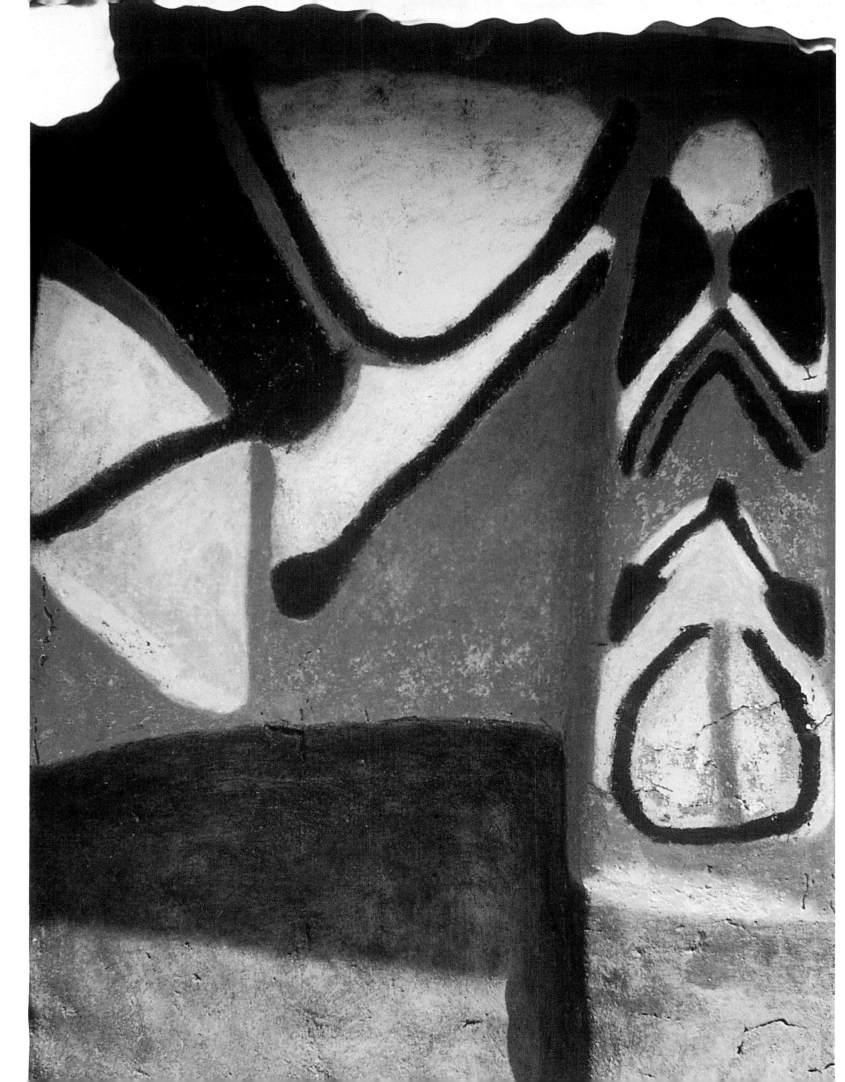

Left: Wall paintings on
Yoruba *orisa* shrines were
renewed annually by the
devotees of the deity.

John Picton

41

Above: A woman's store of calabashes, used as bowls in her daily task of food preparation. The diamond pattern of the net holding the calabashes provides one of the most widely used motifs in women's mural painting in the region.

Ben Hunter

Right: Painted houses in the south of Burkina Faso.

Ben Hunter

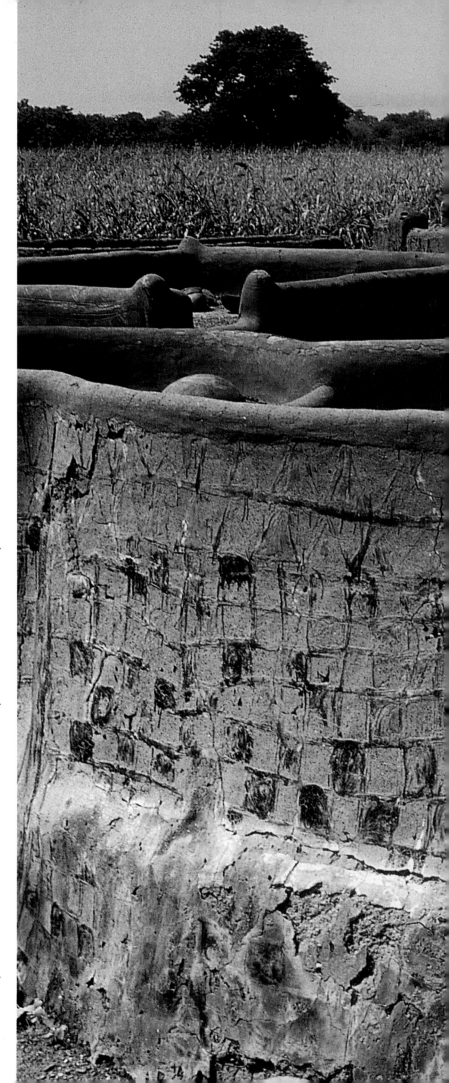

attract attention and admiration, enhancing the benefit that decoration brings to the compound. As Smith comments, "Gurensi wall decoration directly reflects on a woman's ability, her interest in the appearance of the compound, and on the prestige of her husband." The Gurensi have a term bambolse, which means decorated, or made more attractive, which is apparently used almost exclusively to describe their women's murals. Nevertheless, it is worth noting that many of the motifs that appear in wall decorations are used to decorate pots, calabashes, and for women's body decoration, visually expressing an extended, if perhaps unvoiced, analogy between women and the pots and houses they create.

While the creativity expressed by women of the Gurensi and other neighboring peoples in the decoration of their compounds is exceptional, less fully realized programs of mural decoration are widespread. In many cases these are restricted to shrines or other special buildings. The Yoruba, for example, did not usually paint the walls of their rectangular compounds, but once a year the women followers of each deity, or *orisa*, would repaint the walls of its shrine, often with dots and swirls of red, white, and black. Among the complex array of figures and images in red, black, and white painted on the facade of Dogon shrines are sometimes a representation of a rainbow as three horizontal lines curving down at each end, one red, one white, the third blue-green (i.e. black). For the Somba, who live in the Atacora mountains on the border between Togo and the Republic of Benin, the red in the rainbow recalls the earth, the white is the sky, and the black is the underworld, linking the three realms which it spans. Red, black, and white dots encircle the facade of some mud-built houses, primarily as part of a medicinal procedure. The Somba also call themselves *Batammaliba*, which means "the real architects of earth," recognizing their pride in their astonishing two-story houses like oval mini-castles of mud brick.

Recent detailed investigation by Suzanne Preston Blier allows us to see these paintings as part of a Somba understanding of color as a classification system and a set of metaphors within a

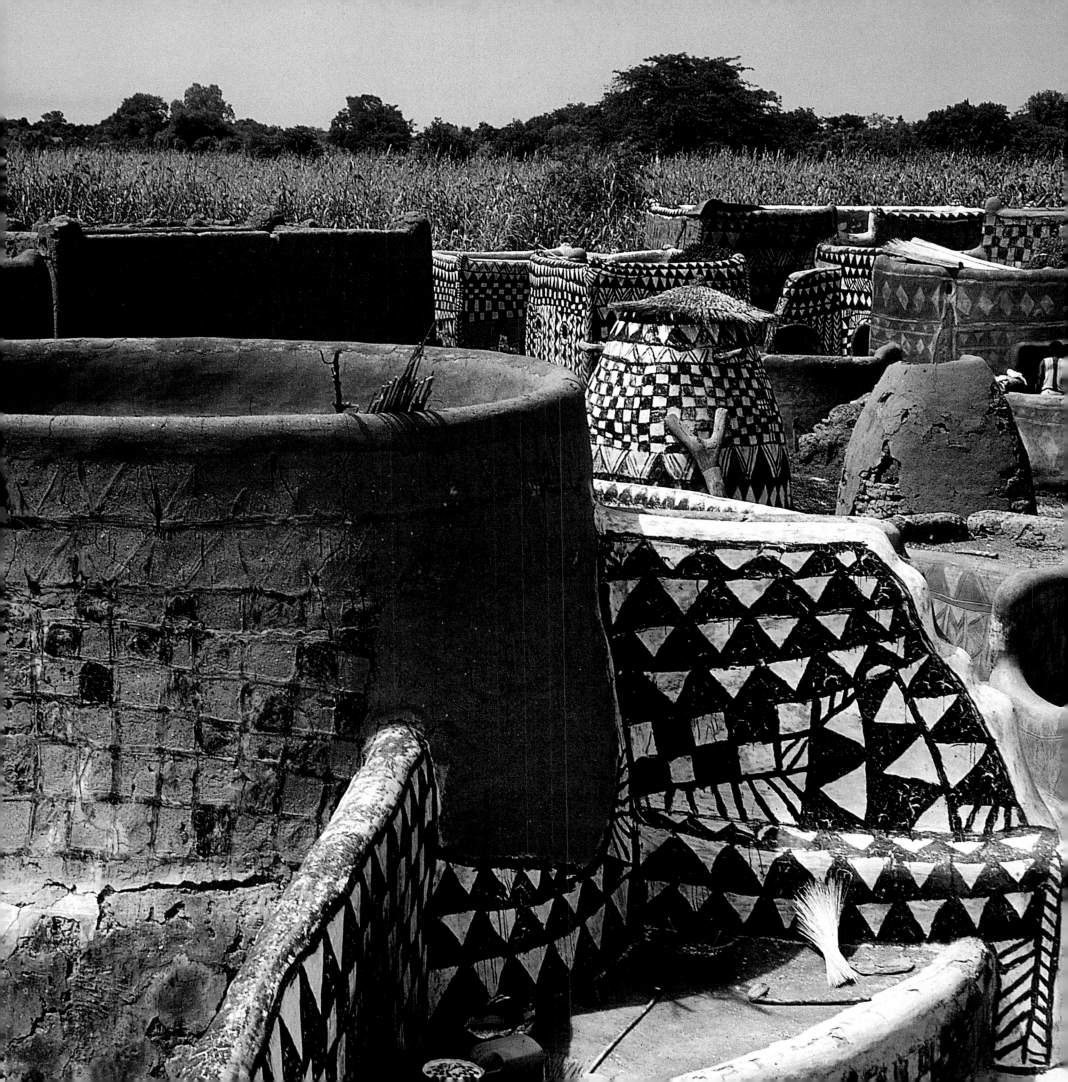

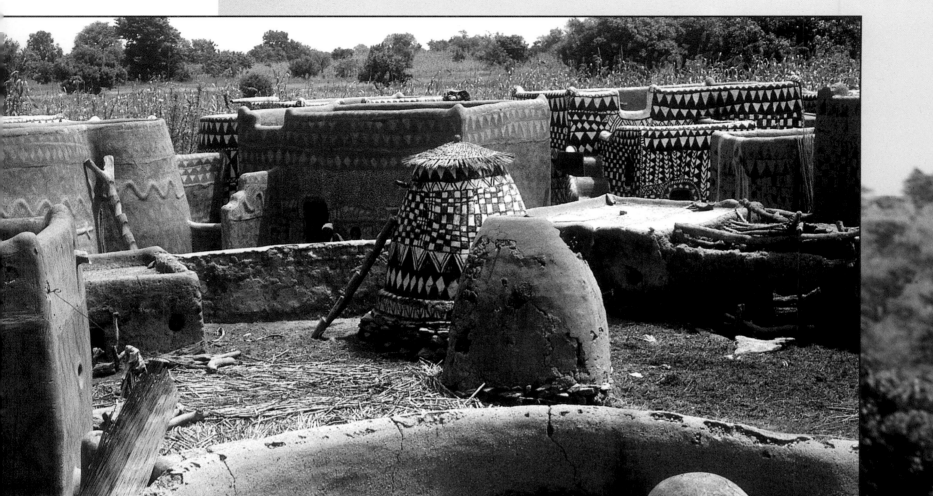

Above: Women's work contributes a series of vital containers, from pots, to grain stores, to decorated houses.

Ben Hunter

Right: The roof of the house provides a space for female tasks such as drying and preparing food crops.

Ben Hunter

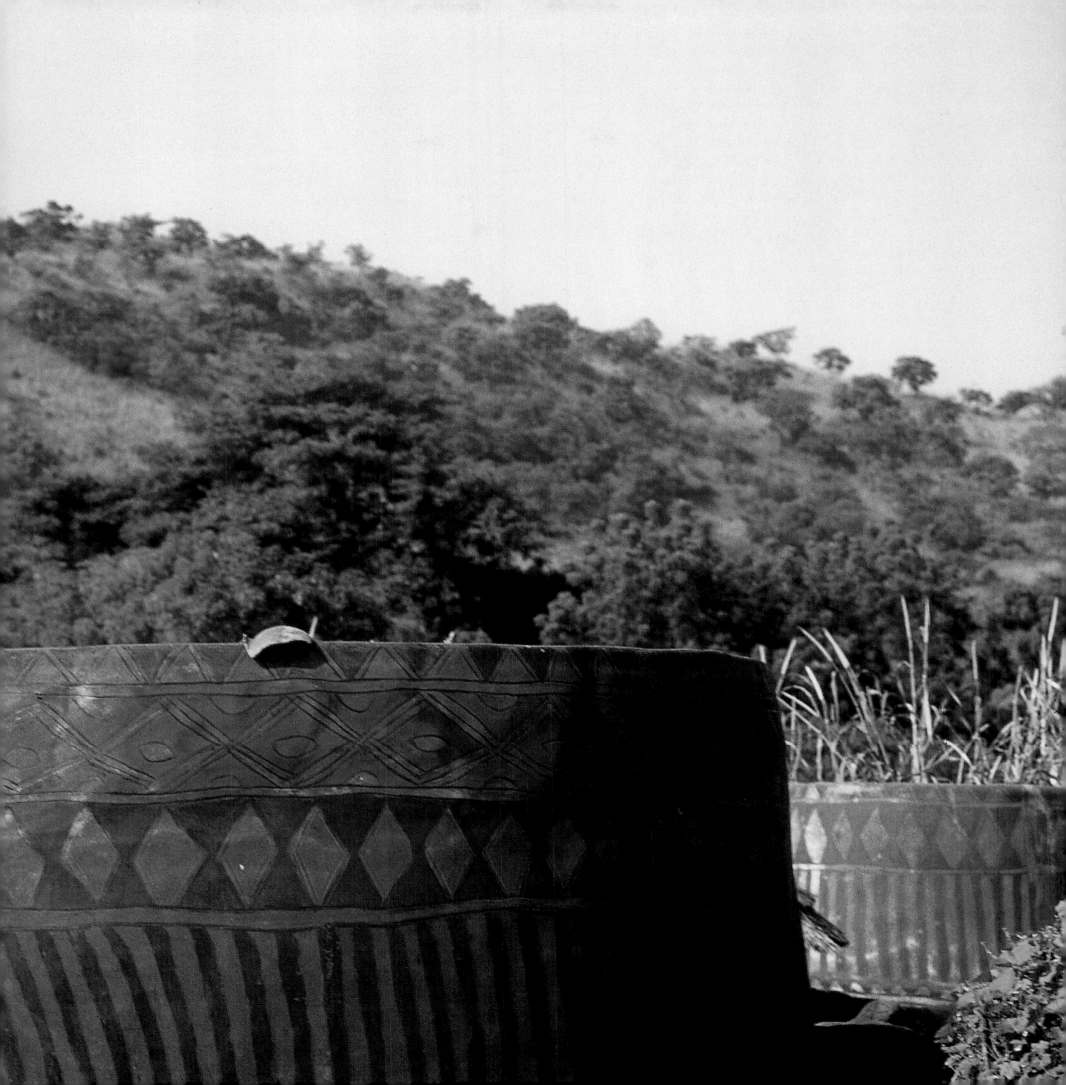

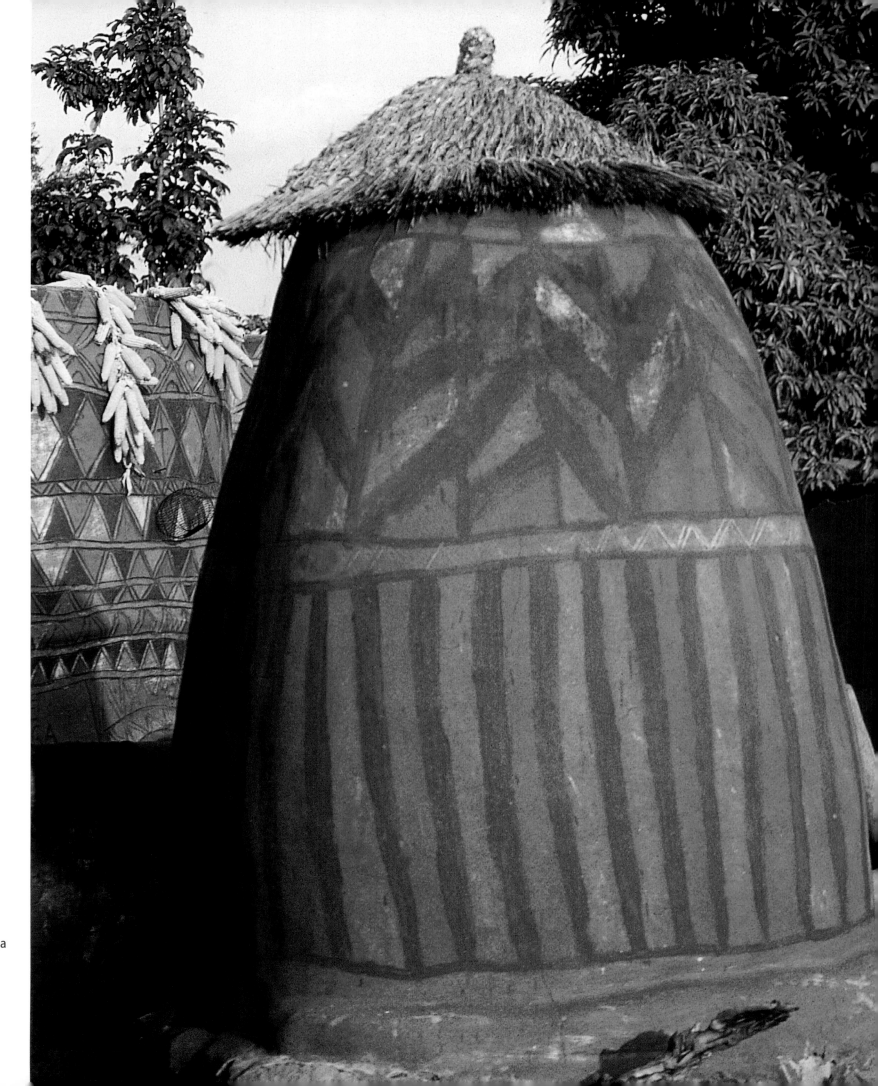

Right: A painted granary. Earth colors provide the dominant palette of red, white, and black still used throughout northern Ghana and neighboring areas of Burkina Faso.

Ben Hunter

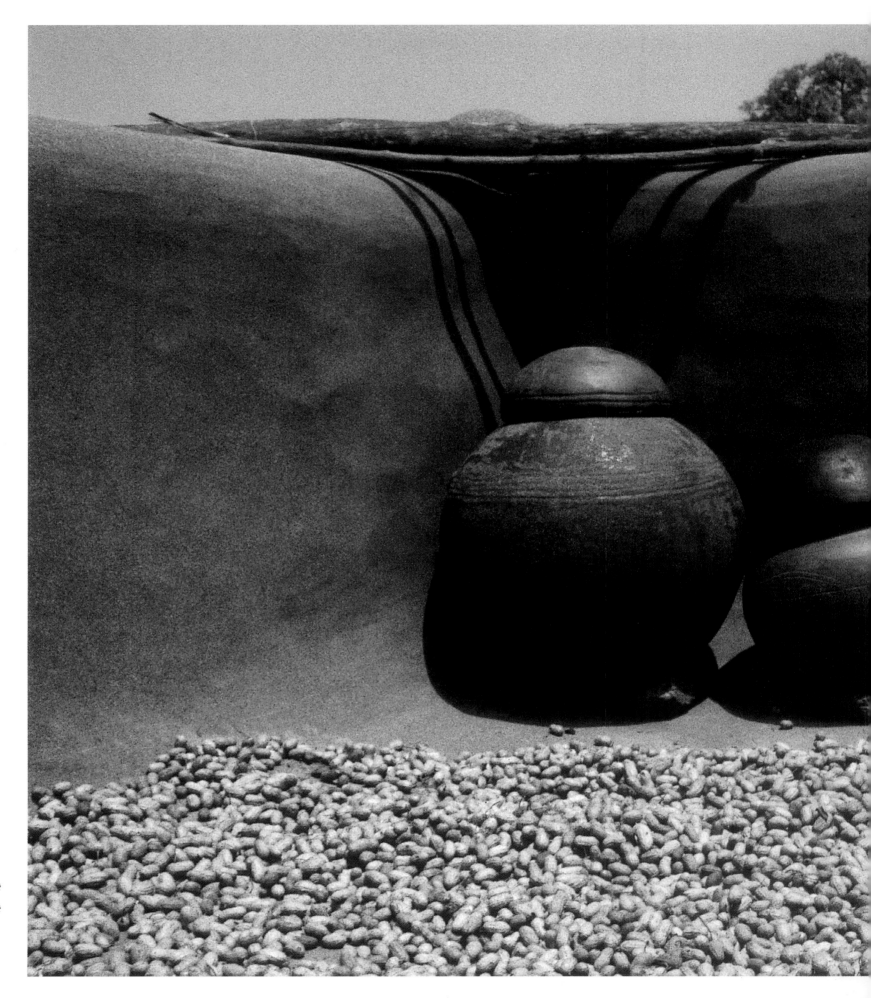

Right: The roof of the house provides a space for female tasks such as drying and preparing food crops.

Ben Hunter

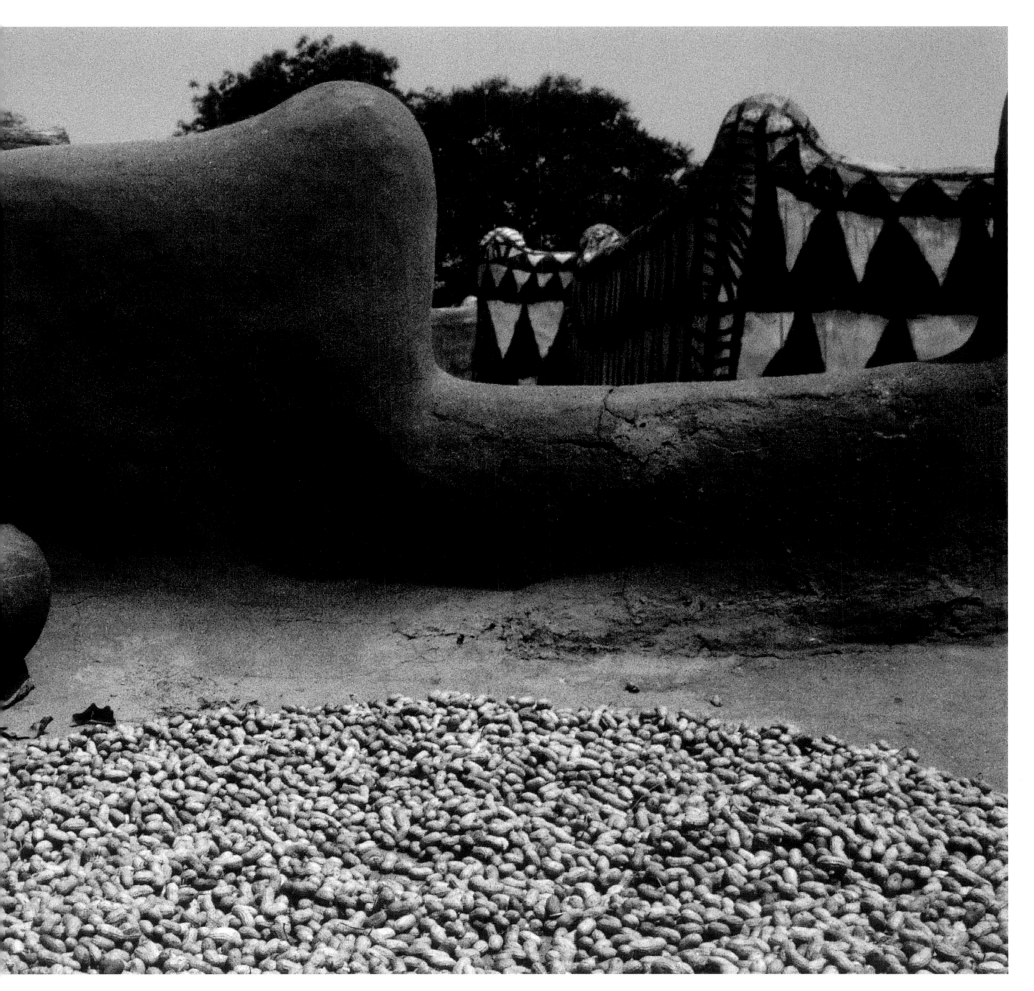

wider metaphorical system that frames every aspect of build-
ing and living in their extraordinary houses. Somba identify
three primary colors, red, which is called *kuwoku*, black, *kuso-
ka*, and white, *kupeku*, grouping other hues around these,
although, as Blier notes, they have a very precise set of sec-
ondary terms allowing them to distinguish dozens of distinct
greens by descriptive names. As we saw in the introduction, the
three basic colors serve as a means of classification. In jewelry
for example, black designates iron, red, copper, and white,
shells, including the cowrie shell. In reference to age, the
young are red, adults are black, while elders are white, with the
same schema extending to newly built and still strong houses,
which are red and black, contrasted with old, crumbling struc-
tures, which are white. At the same time, there are a number
of qualities generally associated with each color, many of them
similar to those identified among the Kongo and elsewhere. In
this case also, the precise meaning depends on the context in
which the color or colors appear. Thus, Blier lists the associa-
tions of black as "night, shade, the underworld, adults, strength,
masculinity, iron, power and fertility," while white is linked
with "day, sky, moonlight, elder, ancestor, life (life-force), phys-

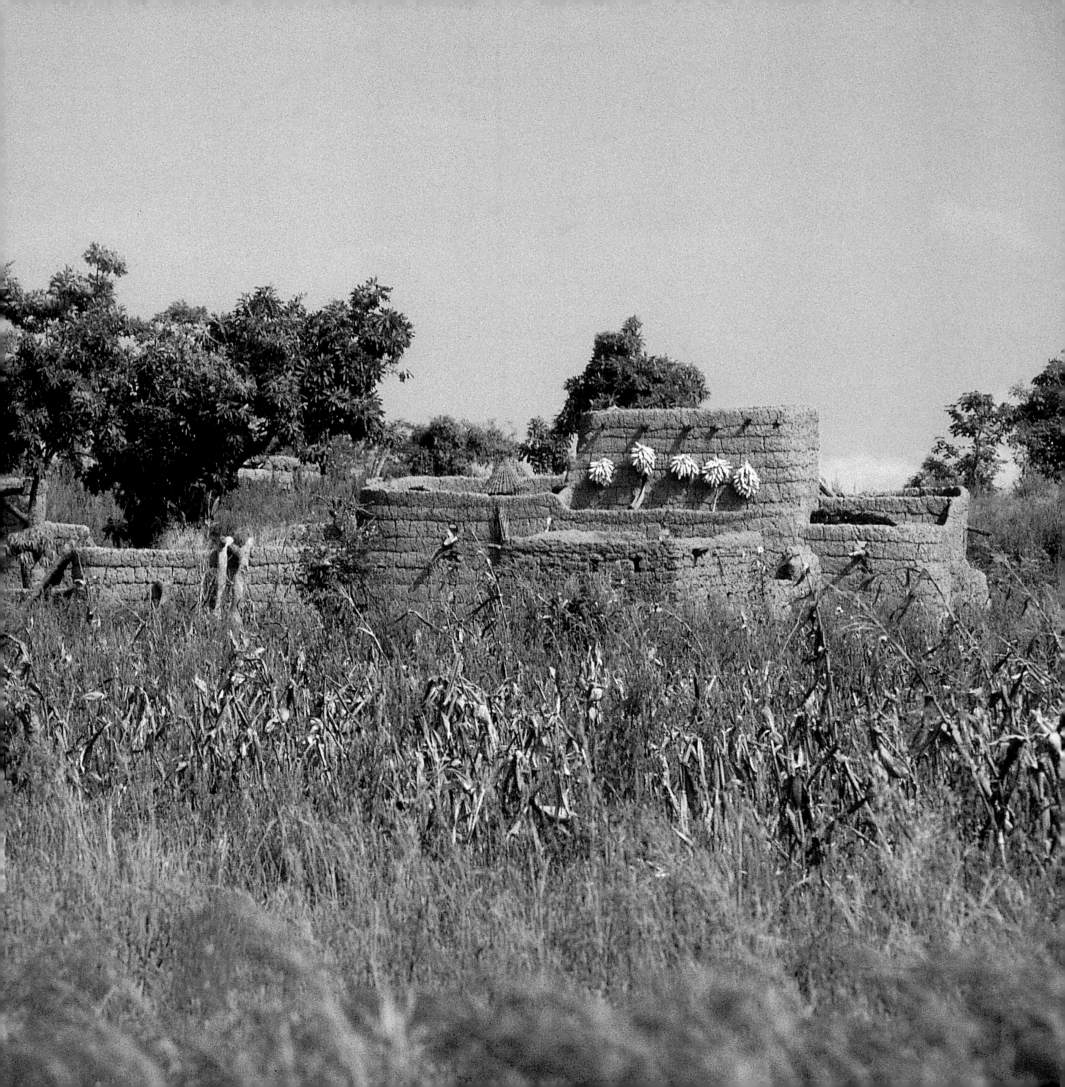

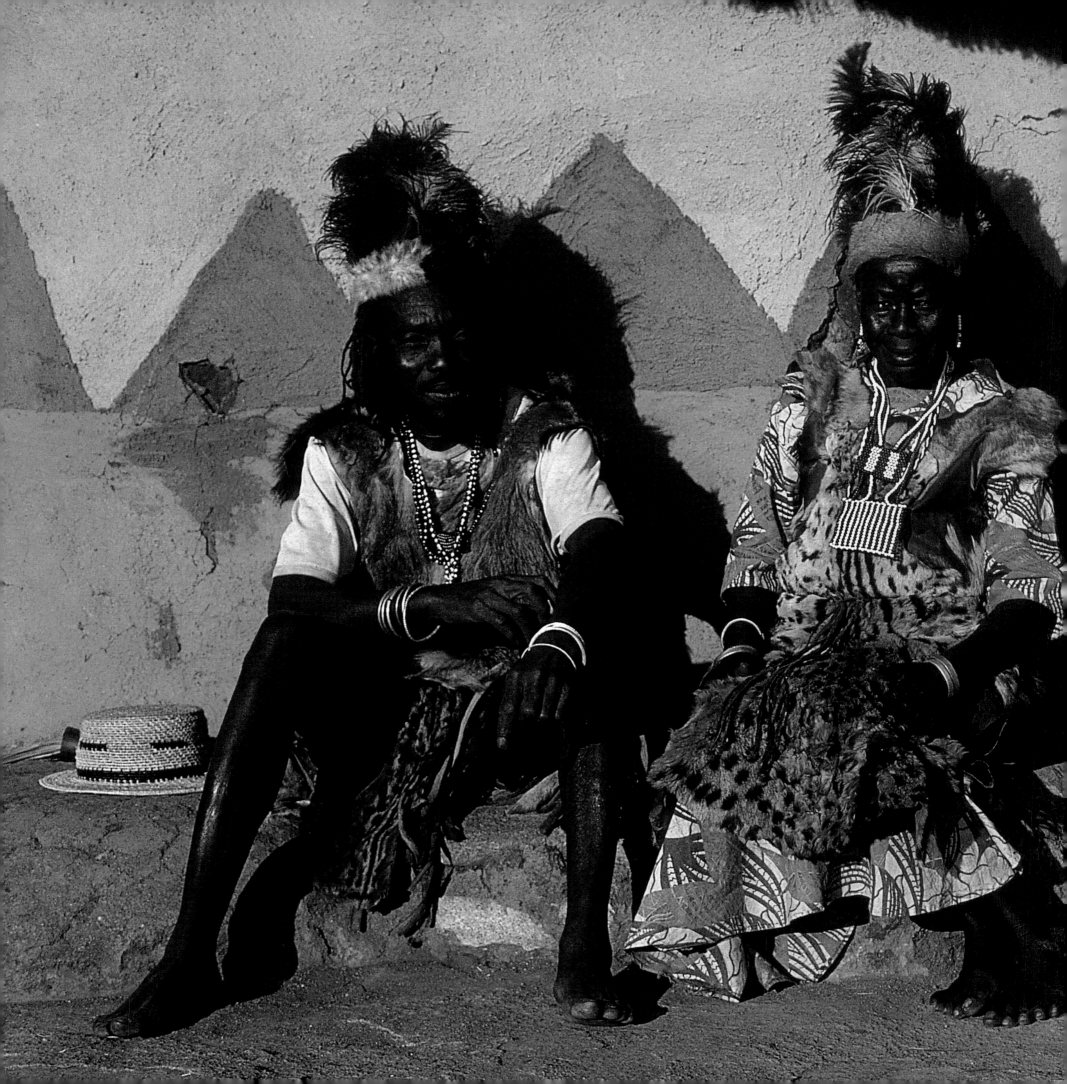

Previous pages: A relief-molded design of a lizard on a painted house.

Ben Hunter

Left: A Shona healer and his spirit medium wife outside a house painted red, black, and white; Zimbabwe.

© *Mick Murphy/Swift Imagery*

55

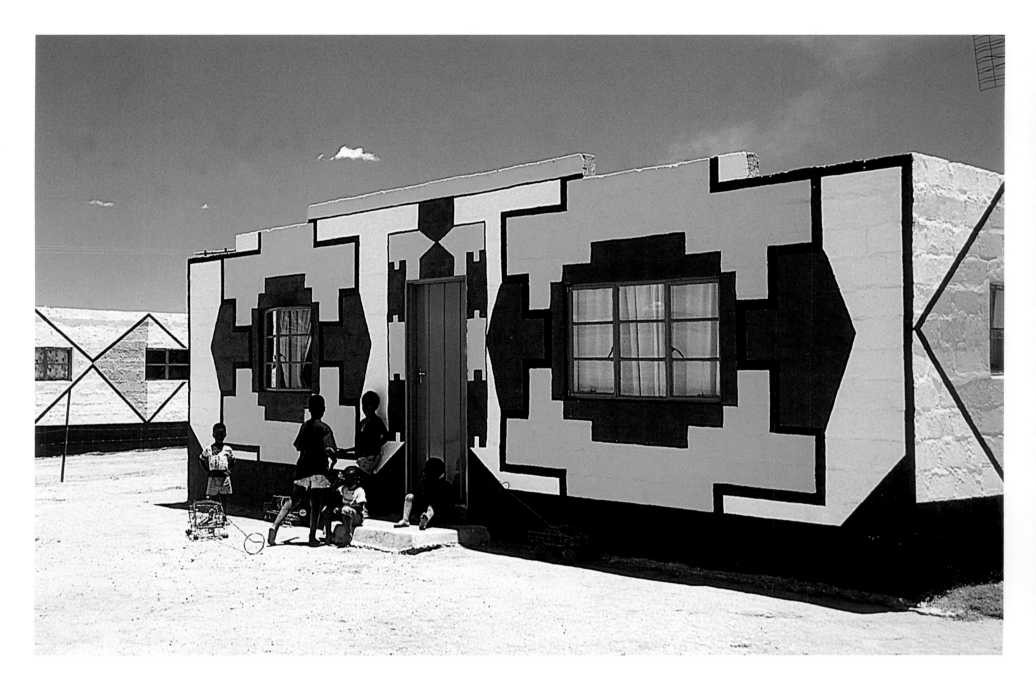

ical frailty, transition, and infertility." Red "suggests dawn, infancy, soft metal, adolescence, femininity, blood, danger, and characteristics that, in some respects, mediate between those associated with black and white." These associations are enacted and reproduced in contexts ranging from medicinal practice to initiations to funerals, expressed in dress, jewelry, ritual procedure, and wall decoration among other media.

Moving from the savannah belt of West Africa to the high veldt of South Africa and Lesotho, very different styles of house mural decoration have emerged that, nevertheless, display overlapping concerns with female creativity and the social marking of space through the use of color and form. Just as they have taken advantage of the widespread availability of colored-glass beads in the twentieth century to develop a flourishing art form out of earlier, more limited means of adornment, women among some Southern African peoples

have adopted modern paints and pigments in the place of earth colors, using them to express both old concerns around female status, and new political issues of ethnicity and relationship to the land.

The Ndebele are the best known of the southern African mural painters, with their brightly colored geometric designs appearing in recent decades everywhere from tourist brochures, to advertisements, to fine arts galleries in Europe and America. Before considering the Ndebele artists, however, it is worth mentioning another less well publicized, but equally interesting painting tradition, namely that of the Basotho (sometimes spelt Basutu) of Lesotho.

Archeological investigation among the Basotho suggests that their tradition of wall painting dates back at least 500 years (van Wyk, 1998). The decorations are called *litema*, from a verb meaning to cultivate, with the women's artistry in reproducing

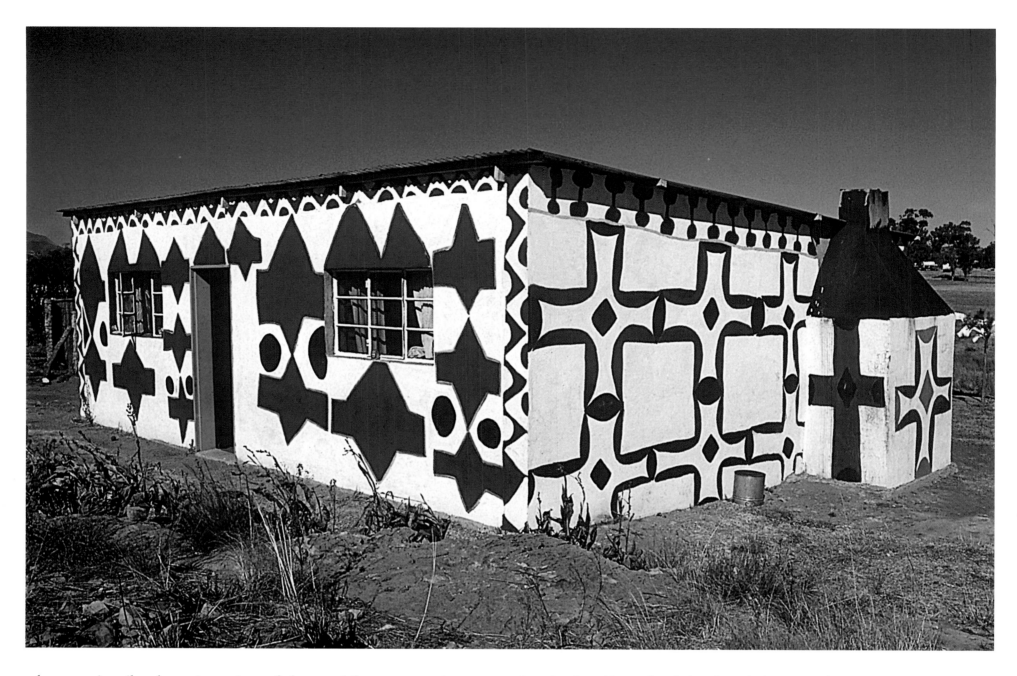

what are primarily schematic versions of plants and flowers on the walls of their homes echoing their work as field laborers in a society where agriculture was primarily a female responsibility. Designs are a combination of painting, engraving in the damp mud plaster, moulded reliefs, and, less commonly, mosaics.

Here the houses are rectangular, providing regularly shaped walls, each of which is divided into small sections as the first stage of decoration. The chosen motif is then incised or painted in a single square, then generally inverted or rotated in each neighboring square, completing a design that balances symmetry with contrasts of color and texture. Additional designs are introduced around doors and windows. Among the motifs identified by van Wyk were: numerous plants, including sorghum; woven reed objects, including a mat used in grinding grain and a mask worn by young women as part of initia-

tion ceremonies; clouds, spider web, a hairstyle, a design incised on the face, a game, etc. As van Wyk put it, "It may well be that at a profound level all *litema* designs are signs of civilization not only of cultivating the fields but of being cultured, cultivated humans."

Despite the vivid color range of contemporary *litema*, van Wyk argues that for the Basotho, too, red, white, and black are the most important and significant colors both in house decoration and in initiation into adulthood. The designs are intended to please the ancestors, and therefore to bring the rain which is essential for life in the region. Red, black, and white were particularly used in marking doors, windows, roof lines and wall bases, areas which may be seen as transitional. Red ocher pigment, dug from the ground in certain valued sites, is called *letsoku*, blood of the earth, and was also used in rainmaking ceremonies. White, derived from chalk, indicates

Above: Red, white, and black retain symbolic significance for the Basotho, and are often used in house decoration.

© Ivor Migdoll/Images of Africa Photobank

57

innocence and good intentions and serves as a sign of peace in murals. Black, which is some contexts alludes to the underworld, also refers to the dark life-giving rain clouds that the ancestral dead bring. At one stage of the initiation of young Basotho women into adulthood, their bodies are smeared with white chalk, and designs resembling *litema* are drawn on their legs. The same designs are made on house door posts, and the women wear thick reed belts and reed masks which can be seen as recalling the reed fence screen that used to be built around all Basotho houses, suggesting that, at some level, a parallel between fertile young women and the houses which they will decorate is being expressed. This may echo ideas of the earth as a womb expressed in Basotho creation myths and now abandoned styles of wattle and daub house forms.

The mural art of Ndebele women has often been presented, especially by the apartheid government in South Africa, as a classic example of an unchanging rural African tradition. Such was its importance to the distorted view of Africans as unchanging "primitives" the apartheid regime promoted to justify its rule, that when areas to which they had previously directed tourists became inaccessible, the government went so far as to create a wholly artificial "Ndebele village" conveniently close to the capital Pretoria. However, a closer look at the history of the Ndebele reveals that far from being a long-standing tradition, the practice of wall painting by the Ndebele appears to have developed on any significant scale only since the 1940s. Moreover, it is a history that reflects Ndebele resistance to foreign rule rather than complicity with it. Only the Southern Ndebele, who call themselves Ndzundza Ndebele after their royal clan, paint murals. They had been forcibly scattered around white farms throughout the Transvaal as indentured laborers, under almost slave conditions, following their defeat and the confiscation of their land by the white Boer settlers in 1883. Although some were able to regroup after their defeated chief was released from prison in 1899, the majority of Ndzundza Ndebele and their descendants continued to live as laborers on white-owned farms through most of the twentieth century.

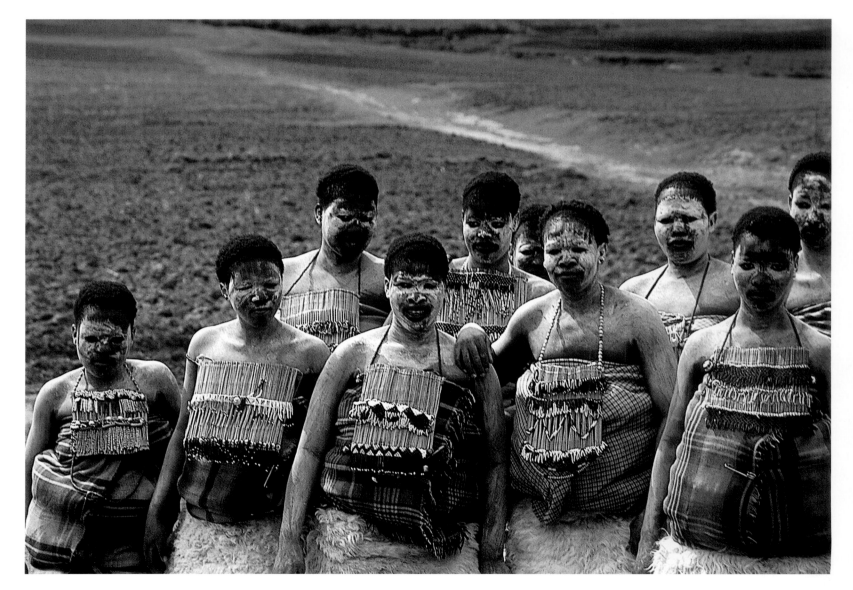

Right: Young Basotho women during initiation, their bodies painted with white chalk, wearing costumes that allude to the reed fences of houses.

© Friedrich von Hörsten/Images of Africa Photobank

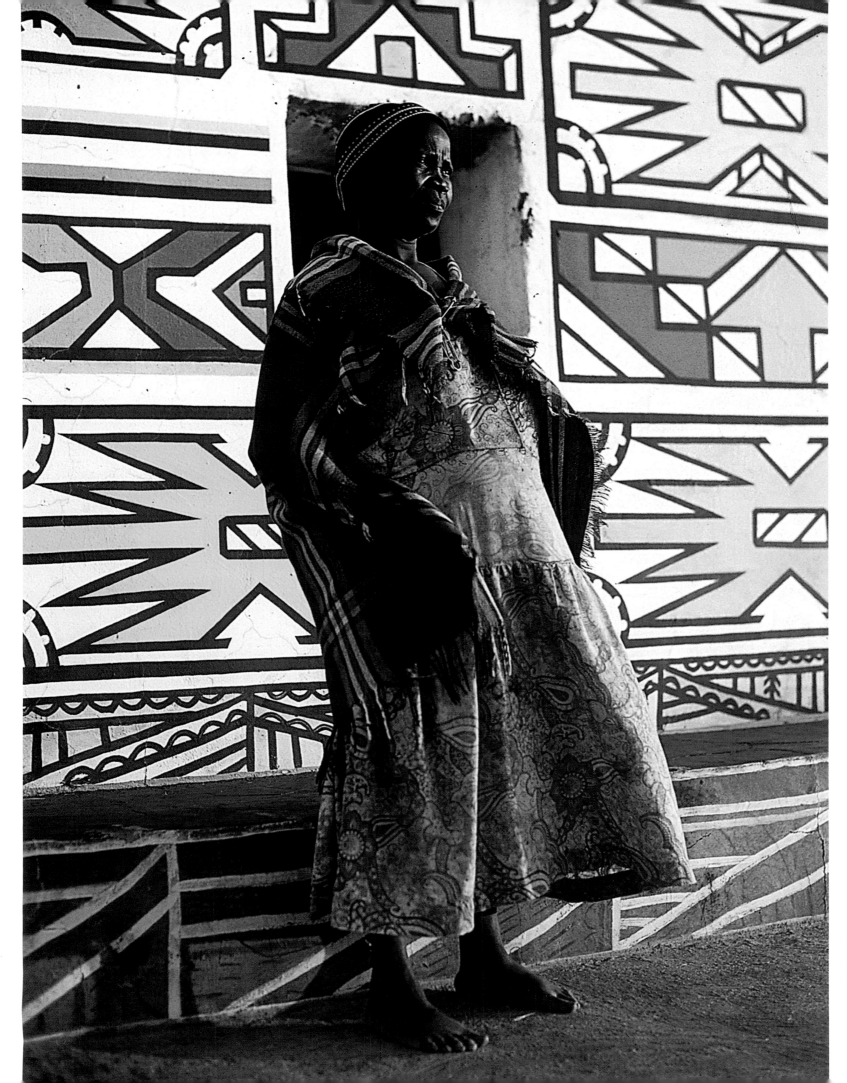

Left: A Ndebele woman in
every-day dress stands
before her painted house.

© Massimo Falloni/Swift Imagery

59

It was on one of these white farms near the town of Hartebeestfontein in the 1940s that the first reports emerged of mural decorations in the form of whitewash outlining doors and windows, together with some geometric designs executed in earth colors and laundry blueing. The increasing attention they received encouraged the women farm workers to elaborate on their decorations and renew them each year. After the farm owner died in 1953, the government moved the settlement nearer to the capital Pretoria to a site that became known to the tourist board as "Ndebele Village," although to its residents it was Kwa Msiza after its informal head. Buses of tourists arrived each week, and the residents were given building poles, thatch, and commercial paints. The women received payments for being photographed with their art and from sales of beadwork, while the government, in turn, profited by showing to the visitors "its idea of a typical Ndebele village, a picture of an idealized ethnic life in the rural areas and a showplace for apartheid" (Schneider 1989).

At the same time, however, the developments were taking on a momentum of their own. Other groups of Ndebele still living on white farms, or on smallholdings of their own began decorating their homes in response to the benefits the Kiwa Msiza residents had obtained. Beadwork, a long established art form among the Ndebele, where women used imported glass seed beads to create ceremonial garments marking their progress through life, provided a repertoire of colors and motifs. The new style rapidly became an instantly recognizable mark of Ndebele identity among the widely scattered farm homesteads. Anyone, whether Ndebele or stranger, crossing the bleak, flat landscape, could see instantly from the brightly decorated houses that they were Ndebele homes. Entire walls were painted, with a number of local sub-styles emerging, reinforcing the role of the art as a marker of ethnic identity.

This phase of the development of Ndebele mural art was severely disrupted when the policy of the government changed in the early 1970s. New areas were designated as "independent tribal homelands" in a bid to deny Africans their nationality, and whole communities were resettled by force in these isolated and inhospitable regions. Kwa Msiza fell within the borders of the supposed Tswana homeland, Bophuthatswana, so the flow of tourists was cut off and the remaining non-Tswana residents harassed into moving. Settlements in the KwaNdebele "homeland" were mostly bleak tin shanty towns. Faded paintings on abandoned houses could be seen across Transvaal. Yet mural painting began again in at least some parts of KwaNdebele and women played a prominent role in a successful 1986 campaign to reject the artificial "independence" on offer. A few mural artists began to gain international recognition, and one of these, Angelina Ndimande, spoke of incorporating the colors of the anti-Independence party in her work, demonstrating a continuity between older concepts and contemporary needs expressed through color: "yellow for mineral wealth; brown for the earth that links us to our ancestors; green for nature and agriculture; and red for emotions of hope and unity among the amaNdebele" (Pohlmann & Mchunu 1991).

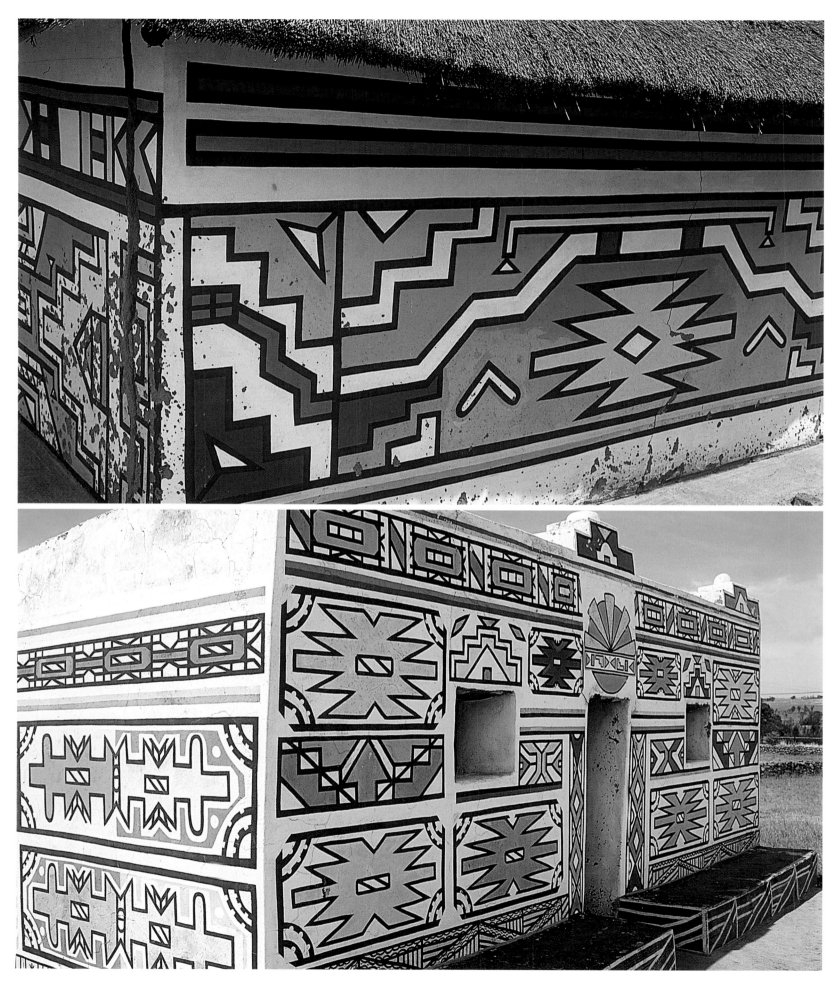

Left: The painting requires regular renewal, involving the labor and resources of women, friends, and relatives.

© Rob Morris/Swift Imagery

Left: Ndebele house painting uses industrial paints to create an instantly recognizable sign of the residents ethnic identity.

© Rob Morris/Swift Imagery

61

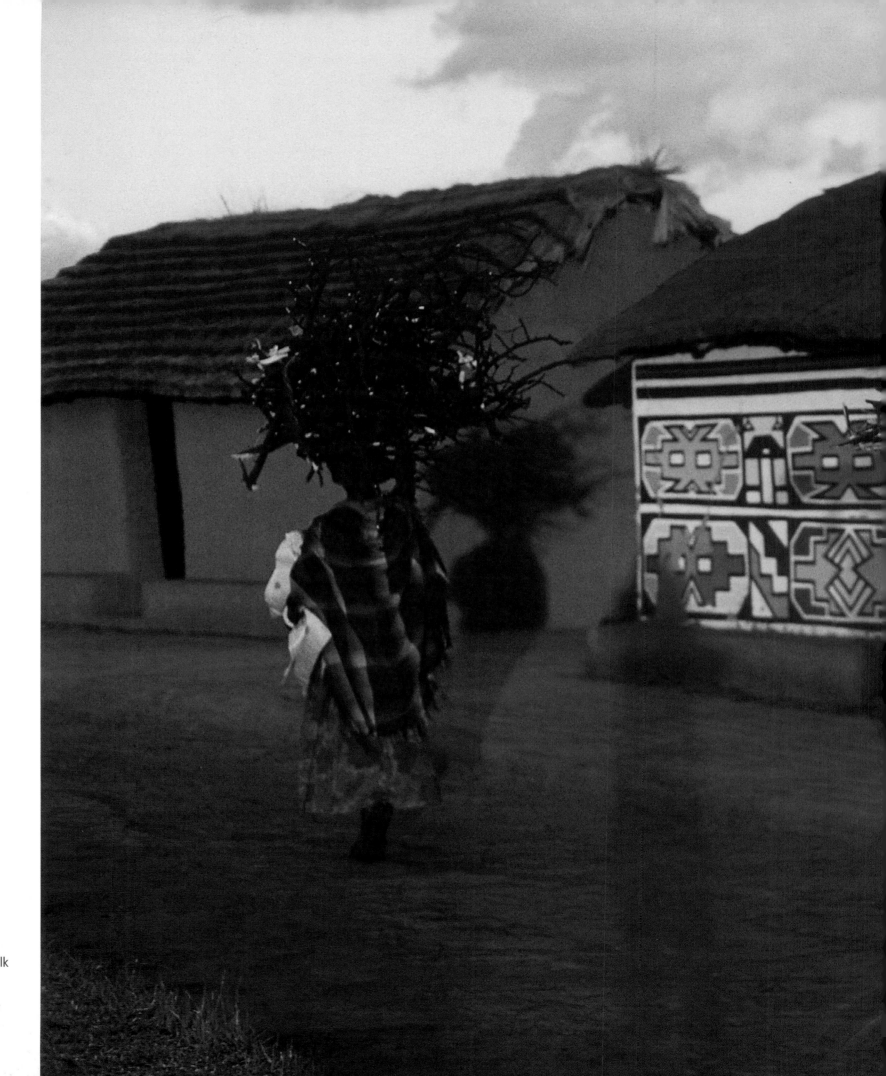

Right: Women collecting
firewood for cooking walk
past a painted house.

© Massimo Falloni/Swift Imagery

62

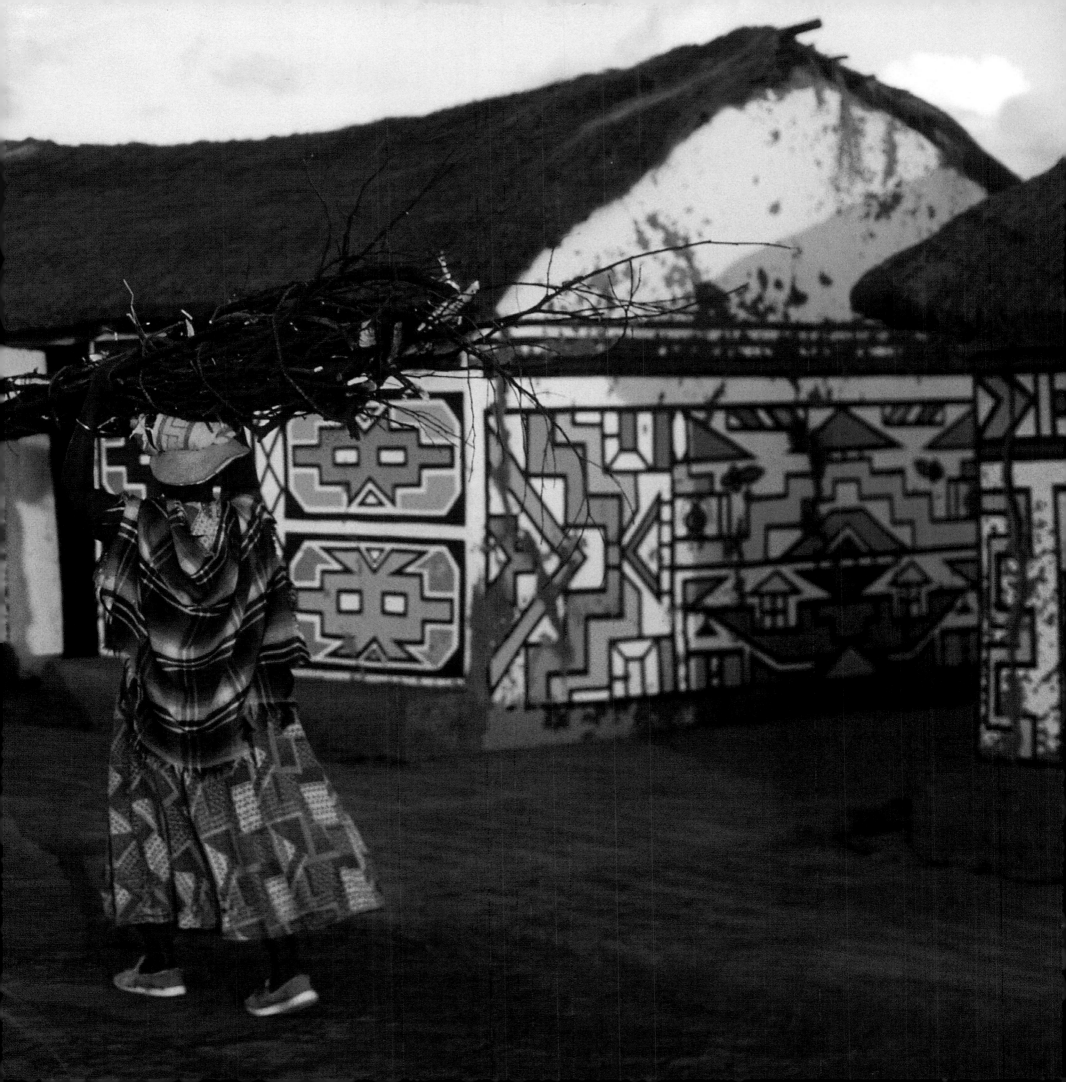

COLORING THE BODY

African Body Decoration

Having explored the way in which some African peoples use color in the decoration of their houses, we will move on in the remainder of this volume to look at issues of personal adornment, beginning in this chapter with the role of color in body decoration. Body decoration involves the marking or altering of the body surface through such methods as henna, painting, tattooing, and scarification, as well as hairdressing, and the permanent or temporary reshaping of the body. The latter can take the form of dieting, or as was more common in some parts of Africa, "fattening": when young women were secluded and fed special foods for months prior to marriage. The body may be reshaped to highlight certain areas, either literally by such means as cranial modification, lip plugs, and earlobe distentions, or by material additions such as the wrapped layers of cloth once worn by Yoruba women to add bulk to their physique, or the thick, beaded leg rings that young Ndebele women wear to simulate rolls of fat. As the last examples suggest, there is a considerable overlap between direct body decoration and related arts of jewelry and dress in the preparation and presentation of the person both for daily life and for a variety of ritual and ceremonial occasions.

Often body painting, hairstyles, beadwork, and dress all together mark out the participant in a particular festival, such as a Maasai warrior in the process of becoming an elder, or a Wodaabe youth dancing at a wet-season camp. Not all forms of body decoration in Africa involve the use of color, but we will see that now familiar ideas about color once again play a major role.

Perhaps because they are so intimately involved with the human body, decorations and modifications practiced in other cultures can often seem not just exotic, but bizarre, and sometimes distasteful. Yet the desire to take control over our body, and to modify its form is a human universal which is strongly manifested in contemporary American society through such everyday behavior as dieting, exercise, cosmetics, and, more radically, in cosmetic surgery, leaving aside recent vogues for such practices as henna and body piercing. In Africa, as elsewhere, many types of body decoration appear to be of considerable antiquity. Paintings on rocks in the Sahara, dating from a period several thousand years ago when there was still sufficient water to pasture cattle, show men and women with what appear to be elaborate tattoos. Designs that may be tattoos have been found on ceramic figures of women from predynastic Egypt, and the discovery of tattooed mummies makes it certain that the practice was established by the Middle Kingdom (circa 2000 B.C.E.). Tattoos, made up of groups of dots and dashes in geometric patterns, have been found on mummies to the south of Egypt in the Upper Nile cultures of Nubia, suggesting to some scholars that Nubia may be the source for its introduction. Tattooing in Ancient Egypt was virtually confined to women and seems to have had erotic associations. In addition to dot/dash type patterns on the thighs and abdomen, by the New Kingdom this association was being expressed by tattoos depicting the god Bes on the thighs of women such as dancers and musicians. Bes was a lion-headed deity of lascivious character linked with both revelry and childbirth. His image, in the form of a blue-black tattoo, is depicted on the thighs of scantily clad women dancing or playing musical instruments in wall paintings, bronze mirror handles, and a number of painted bowls and plates from the New Kingdom. In some cases, the erotic intention is emphasized by the presence of a small monkey, another symbol of playful lust in Egyptian iconography.

In contrast to Ancient Egypt, more recent body decoration in Africa has a whole range of connotations. It includes ideas about beauty and sexual desire, both for women and for men, but also such issues as social status, identity, whether as an individual, family or ethnic group, movement through the lifecycle, and the physical or mental condition of the wearer. Considerable complexity is involved in the tracing out of some or all of these concerns, and it is worth noting that not all marks on the body would be considered as decorative.

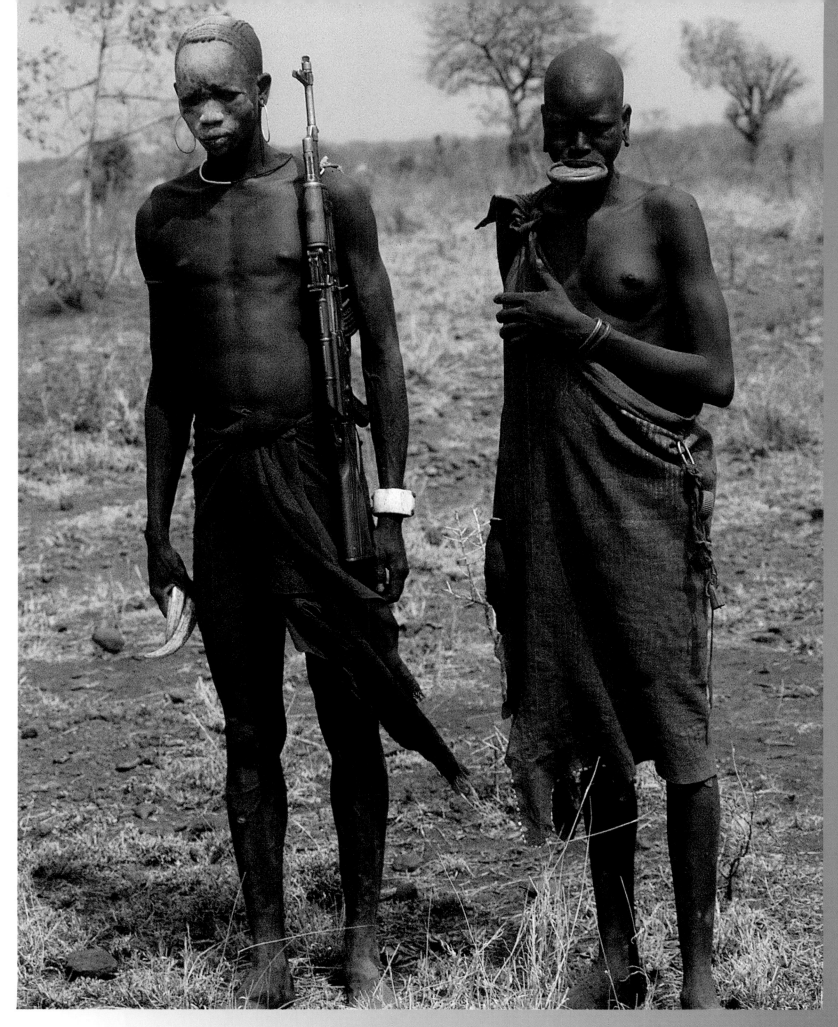

Left: A Mursi couple. The clay lip plate indicates that the woman is married.

Ben Hunter

65

To take the case of the Yoruba people of southwestern Nigeria as an example, an individual might receive a whole series of different incisions on the body. At the naming ceremony held a few days after the birth of each child, a series of shallow cuts could be incised on the baby's cheeks. Often called "tribal marks," in fact these sometimes indicated the area the family regarded as their home, but others were specific to individual lineages or extended families. However, other small incisions, in the form of small parallel cuts at the wrists, ankles, shoulders, small of the back, etc., might be made either at the same time, or at a later date when the child was ill, to be rubbed with medicine that would strengthen the baby.

From their teenage years, some women would accumulate decorative designs in the form of abstract or representational patterns on their arms, necks, chest, abdomen, etc. Called *kola*, they are numerous tiny parallel cuts rubbed with charcoal to make raised blue-black designs which have a textural as well as visual effect. While these are much less common today, one sees the same technique used on children in rural areas to mark their name and family compound on the stomach. Finally, before the widespread adoption of Christianity and Islam, initiates to the cult of deities called orisa often had incisions made in the scalp for the insertion of medicine as part of the initiation process. Sometimes these initiations also involved body painting. Men and women joining the cult of Sango, the god of thunder, had their shaved head painted white with red spots for part of the initiation period.

Other forms of treatment of the hair also constitute an important aspect of body decoration in many African cultures. Hair is a uniquely malleable and replaceable part of the body, alive but seemingly not really living, lending itself readily to manipulations that convey a whole range of information. As demonstrated later in this chapter, for the semi-nomadic pastoral peoples of Kenya, the Maasai and their neighbors, hair is one of the primary means by which changes in the person, and his or her social identity are expressed. The male priests who presided over the initiation of candidates in the Yoruba Sango cult usually wore their hair in an elaborate braided hairstyle otherwise associated with young newly wedded women. The significance of this was that the relationship of the priest to his deity, which would take control over his head in spirit possession rites, paralleled the submissive posture expected of new wives toward their husband. Women who had borne twins were the only ones to wear their hair long among the Bangwa in Cameroon. Women among the Himba and neighboring peoples in Namibia plastered their hair and added hairpieces with mud and red ocher creating long, thick, dry braids.

Body decoration can be either permanent or temporary. Permanent forms of body decoration found in Africa include numerous ways of altering the shape of body parts. Perhaps the most dramatic of these was the custom among the Mangbetu of northeastern Zaire of reshaping babies' heads while they were still soft in order to produce the extended oval shape that conformed with local ideals of beauty. Lip plugs, or labrets, made from ivory are still worn in distended loops in the lower lip by women of the remote Surma people in Ethiopia but were more widespread a century ago. More common was tattooing, found among people such as the Berber in North Africa and the pastoral Fulani in the west, and especially scarification which is, or was, customary in almost all regions of Africa. Scarification involves the creation of patterns by inserting charcoal powder or other material into small cuts in the skin so that it heals in raised bumps. Scholars of African body arts often suggest that, in general, permanent forms of body decoration of this type are used to mark or signify permanent changes in status, such as that from children to mature adults, which in many cultures was accompanied by a specific design as well as a gradual accumulation of decorative patterns.

Temporary decoration, on the other hand, more usually accompanies ephemeral or passing states. In particular, it frequently serves to indicate those who are in transition from one social status to another. In the course of this process, which generally takes the form of some kind of extended ritualized initiation, the initiates are in a kind of in-between or liminal, position, neither children nor adults, for example. They can be seen as "dying" to one phase or their life and being reborn in another, often after a long period of seclusion deep in the forest or the bush. This extra-social transitional phase, as an individual, or more often a group, goes through what has been called a "rite of passage," may be indicated by the use of body painting. Young Xhosa men who had just been circumcised, for example, lived in bush camps for up to four months, painting themselves all over with white chalk and speaking a special ritual language.

Similar ideas about distinguishing those who are temporarily outside of social norms sometimes come into play in the case of spirit-mediums or those understood to be in the possession of spirits. People who are in mourning are also often seen as being in a sense outside of societal norms, of being in transition from one set of family relationships to another one reconfigured by their bereavement, and they too may be marked out in some way. Kongo widows smeared their clothes and bodies with black ashes, and marked themselves with white chalk during an extended period of seclusion in the home that followed the death of their husband, then wore new clothes and colored their bodies with red pigment at the feast that marked their return to society.

It is in circumstances such as these that color comes into play in many other places also, with the primary triad of black, red, and white usually being favoured to provide a palette which marks out those in such transitional states. As we explore some instances of this type of temporary body decoration over the remainder of this chapter we will see that the distinction is not always clear cut, that temporary and permanent decoration of the body, together with other types of adornment, often accompany each other in practice as occasions such as initiations, weddings, and other life cycle events are acted out. Often a temporary form of decoration may be applied to those in liminal states during the rite of passage, but a change in permanent decorations mark the new status taken on after the rite is completed.

One form of African body decoration that is currently enjoying unprecedented popularity around the world is henna painting. It is worth noting in passing that henna patterns are normally a shade of red. Although generally associated with Arabia and India, henna is used in coastal parts of East Africa, in North Africa, by the Moors of Mauritania, and in countries such as Mali by the Tuareg and other peoples with a long history of involvement in trans-Saharan trade. A good early description of henna comes from the French explorer René Caillié, whose account of his pioneering journey to Timbuktu was published in 1830: "the Moorish women bruise the leaves and obtain from them a pale red tincture which they use to brighten their charms. The leaves being bruised and reduced to a pulp, this pulp is applied to various parts of the body which they are desirous of staining; it is kept covered to preserve it from the action of the air, and moistened at intervals with water in which camel dung has been steeped. The color is five or six hours in fixing: after that time the pulp is removed and the flesh to which it has been applied is stained a beautiful red. Henna is applied to the nails, the feet, and the hands; upon which last they make all sorts of patterns; I have never seen it applied to the face. The color remains a month without changing, and does not disappear entirely in less than twelve months. It is not only an ornament with the Moors, but a religious ceremony for women who are about to be married."

Henna is obtained from the Egyptian privet plant (*Lawsonia inermis*) said to be the flower of the Prophet Mohammed, and for Muslims in particular, the decorations created with it have medicinal and religious qualities as well as esthetic impact. Henna was used by the ancient Egyptians, both to stain the fingers and toes of bodies prior to mummification, and as a decorative cosmetic to pattern the hands and feet of women such as musicians and dancers. However, the use of henna in Africa today is most widespread in areas with a

Left: Nigerian Yoruba sculpture from a shrine for the thunder god, Sango, painted with red, white, and blue pigments. Similar designs were sometimes painted on the shaven heads of aspiring cult members during initiation ceremonies.

Christie's Images

long history of contact with the Middle East, and in the case of the Swahili speaking coastal cities from Somalia to Kenya, centuries of trade with India.

As Caillié observed, its use is particularly associated with marriage, with intricate designs being painted on the hands and feet of the bride, and in some areas the groom, as part of the festivities accompanying marriage ceremonies. Drawing on pre-Islamic ideas about warding off harmful spirits and the "evil eye," many North African geometric patterns based on crosses, dots and triangles are considered to protect the bride during a vulnerable transitional period, and additionally to promote fertility. Among the Berber of the Atlas mountains in Morocco, henna patterns complimented similar motifs tattooed on other vulnerable areas, particularly the chin, although Berber facial tattooing is now virtually confined to elderly women. On the Swahili coast, designs tend to be more flowing and floral. If a Tuareg man has not previously married, his hands and feet are stained with henna by the wives of blacksmiths before his wedding to protect him from evil forces in the two or three months before the color fades.

In some cultures, the distinction we have seen between temporary and permanent forms of body marking is used to develop ideas about gender roles. For the Nuba of southern Sudan, who have only adopted clothing in the face of oppression by a militant Islamic government over the last decade or so, body painting was the main form of artistic expression, with male bodies providing a canvas on which both conventional and innovatory designs were displayed on an almost daily basis. Men from their mid teens and their early thirties would gather with their contemporaries to co-operate and compete in creating an extraordinary variety of patterns, aspects of which were open to individual innovation, while other features conveyed conventional information about the age, clan, or village of the wearer. Boys painted themselves with red and white, and later yellow, but were prohibited from using black until they had officially been initiated into the status of a young man.

In contrast to the ephemeral paintings of the men, which had to be renewed every day, Nuba women decorated themselves with a series of permanent patterns of raised scarifications cut into the skin. These were cut in stages, beginning on the torso at about ten years old, extending up towards the breasts following the onset of puberty, then to the back, arms and legs after her first child was weaned. However, these permanent markings could be supplemented by other temporary indicators of status and identity, for example the precise shade of the ocher mixed with oil that young women smeared over their bodies daily until their first pregnancy might indicate to a knowledgeable observer which clan they belonged to.

It would be a mistake to regard all forms of body decoration as being primarily concerned with communicating information to others about the wearer's personal status and group identity. After all, we are dealing largely with small-scale societies in which such information is generally well known to all anyway. As important, if not more, is the acting out of the expected role for the "wearer," and the affirmation of identity and belonging this provides. Painful scarification processes are something that has to be endured as part of becoming a woman in Nuba and other societies, and the results are displayed with pride as a sign of bravery as well as a vital aspect of personal beauty. Types of scarification can change in fashion just as dress styles do, as was documented over several generations of Tiv men in central Nigeria. There, a particular type of decoration might indicate a man's age simply because it had ceased to be used forty years earlier, but this was incidental to its main purpose which was to display his courage and enhance his beauty.

Issues of status and genealogical identity are expressed among the nomadic and semi-nomadic Fulani by such means as the position of a man's camp or a woman's bed shelter relative to that of the family leader, and most importantly, by a man's rights of ownership or a woman's milking rights over cattle in the family herd. Strict rules of formality and modesty govern formal relationships between Fulani men and women, with no adult males except the household head entering the women's portion of the camp, while women will never enter the kraal except to milk the cattle. Nevertheless, the Fulani are known for some of the most spectacular displays of body decoration still to be seen in West Africa, in particular the men's dance festival known as geerewol staged by the Wodaabe group.

Fulani are a continual presence in the savannah belt across a huge expanse of West Africa from Senegal in the west to northern parts of Cameroon in the east. In the dry season, one sees small herds of cattle, carefully guarded by two or three young men, crossing roads as they walk long, arduous routes from one recognized pasture to another. In the towns, young women sell milk, butter, and cheese from the decorated calabashes balanced on their heads. Pastoral Fulani are tall, light skinned, and narrow featured, and are highly conscious of what they perceive to be their distinct racial identity from the settled farming peoples whose land they cross. This sense of Fulani distinctiveness is maintained by an ideal code of behavior, called *pulaako*, which—theoretically, at least—prohibits intermarriage or other less formal liaisons with non-Fulani. Although some form of extended settlement became increasingly common through the twentieth century, Fulani who, whether by choice or because of loss of cattle, adopt sedentary

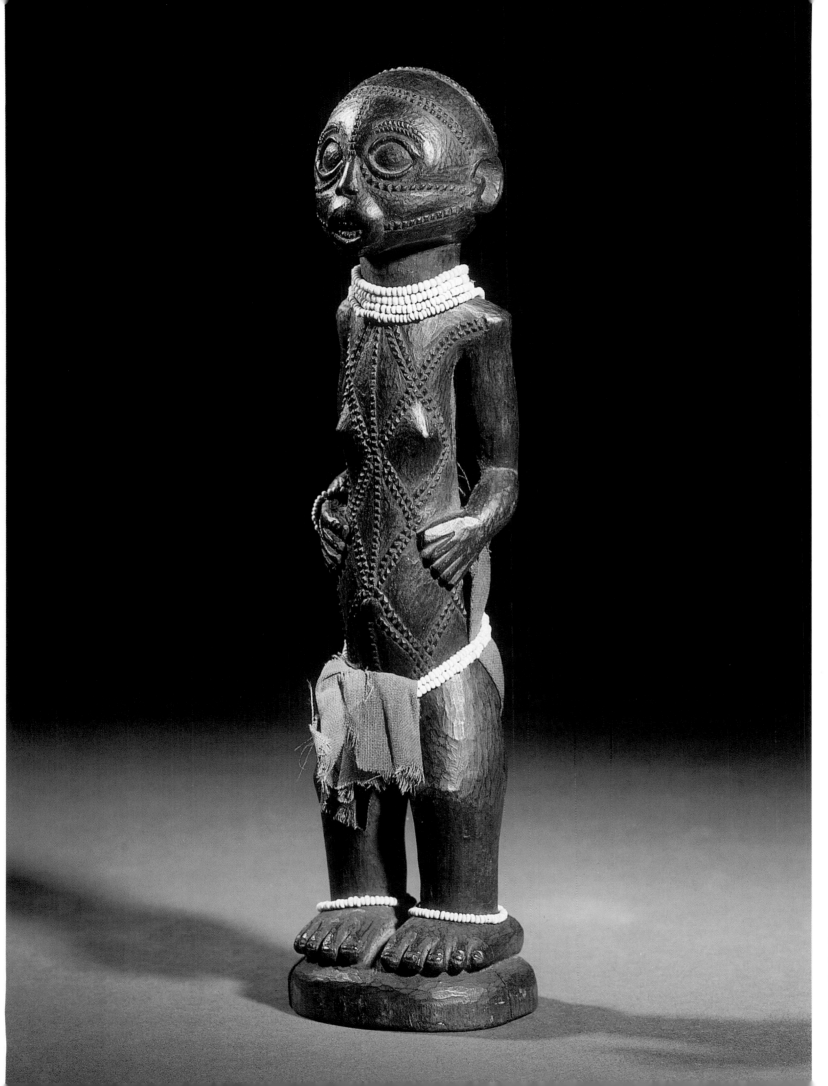

Left: Tabwa figure showing
scarification patterns and
wearing white beads.
Tanzania.

Christie's Images

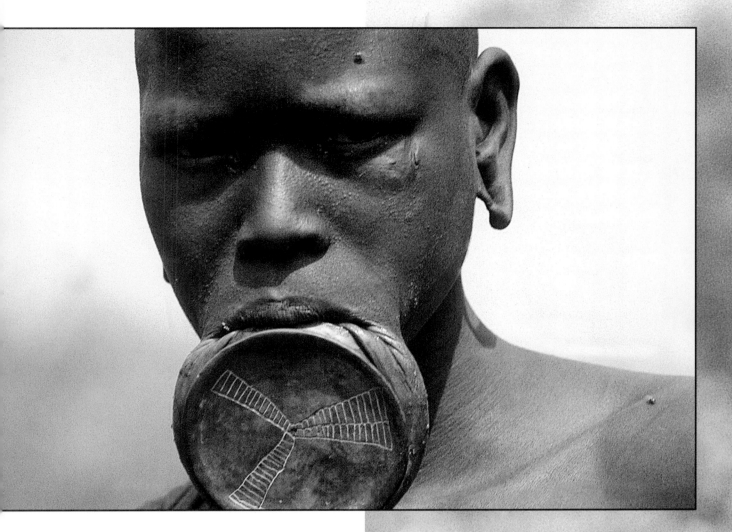

Above: **Mursi woman with lip plate.** The lower lip is pierced and gradually stretched in the months before marriage. The size of the plate indicates the number of cattle presented to her family at the time of her wedding.

Ben Hunter

Right: **Mursi children play at painting themselves with white chalk.** As adolescents chalk body painting becomes more serious as it is a key part of Mursi courtship for both young men and women.

Ben Hunter

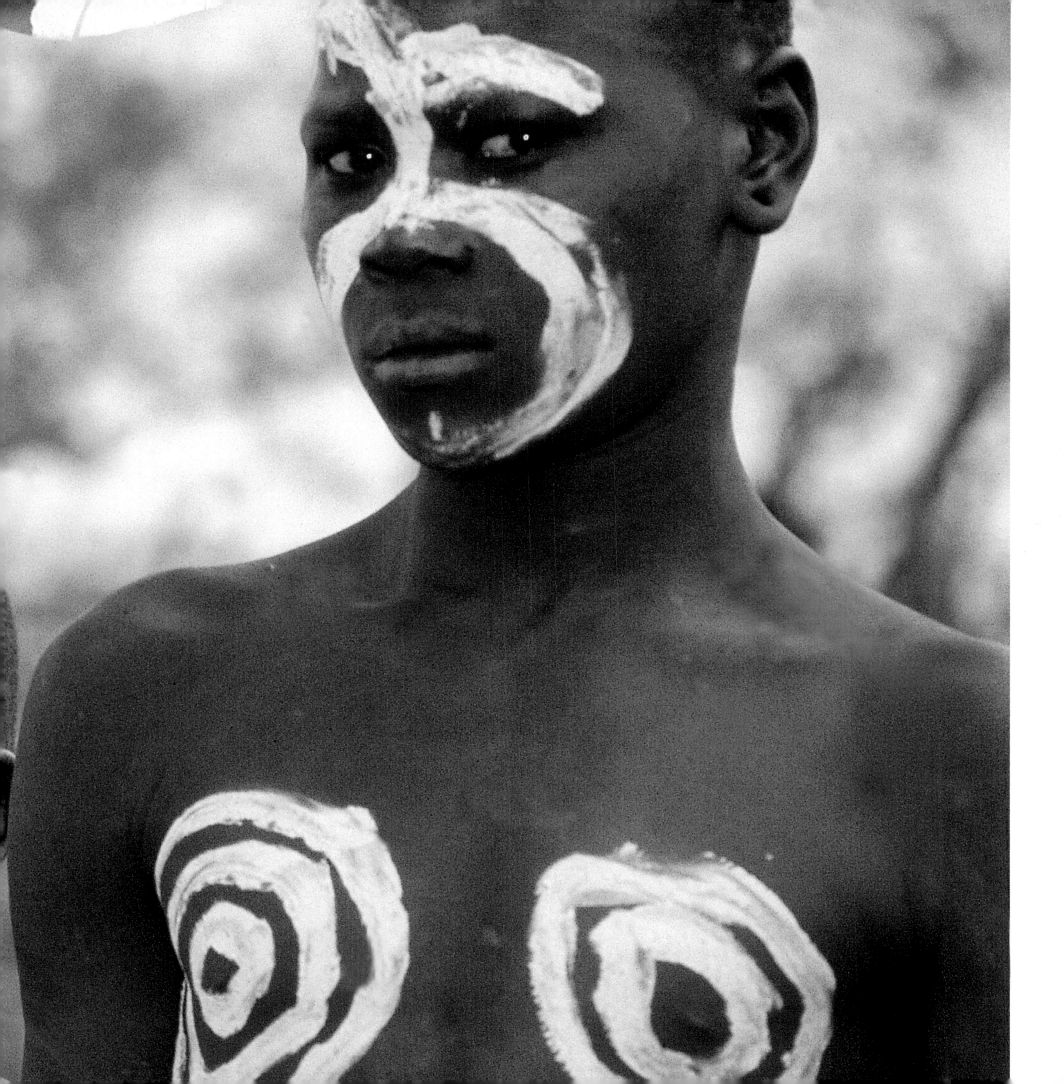

Right: Fulani "khasa" blanket
(detail); hand-spun wool,
Mali 1990's.

Peter Adler

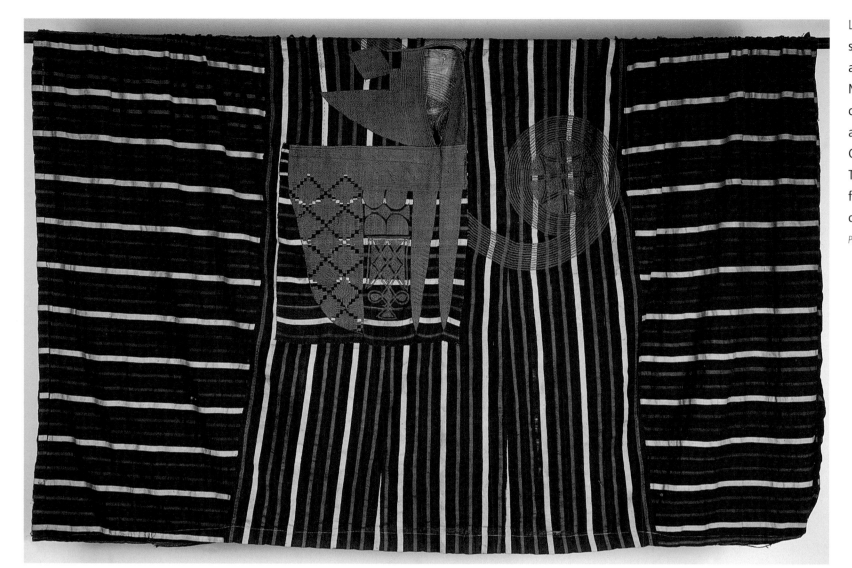

Left: Cotton and imported silk robe of the type woven and embroidered mostly by Nupe craftsmen for the courts of the Fulani aristocracy of the Sokoto Caliphate, northern Nigeria. This example probably dates from early in the twentieth century.

Peter Adler

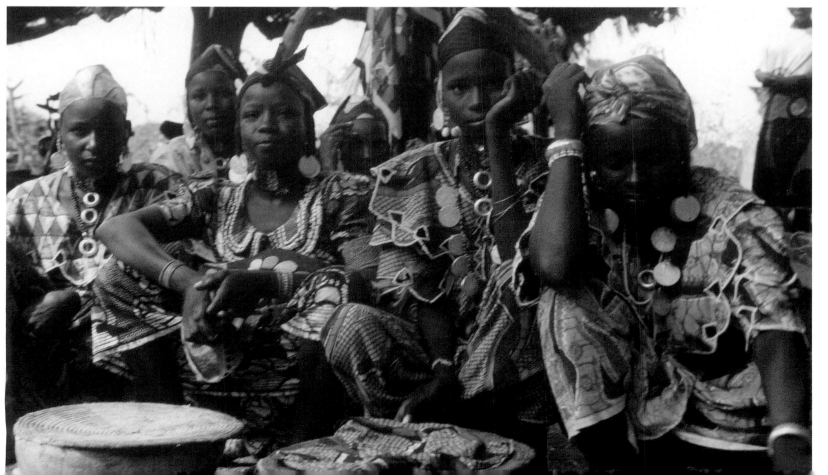

Left: Fulani women selling milk are an every-day sight in markets across the West African savannah.

Ben Hunter

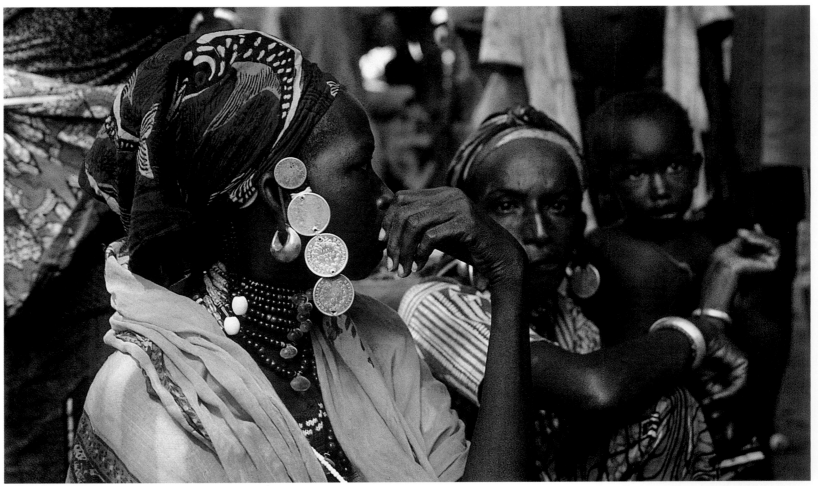

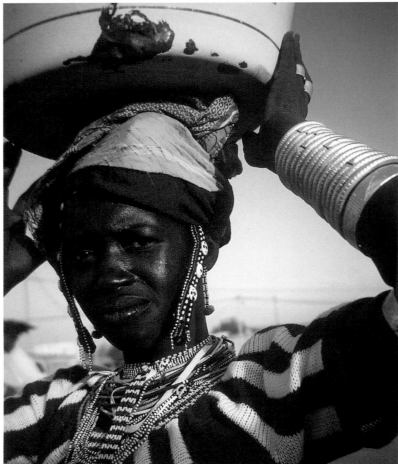

lifestyles, are seen as falling away from this code. A true Fulani man should have the network of family ties necessary to allow him to make good any unexpected fall in herd numbers by calling on loan animals from his kin.

The Wodaabe, who graze their cattle in the southern districts of Niger and neighboring regions of Mali, Burkina Faso, and northeast Nigeria are considered by themselves and others to remain closest to this Fulani ideal of *pulaako* in their continued reliance on a nomadic lifestyle. Like other semi-nomadic Fulani, the young men and women of the Wodaabe are intensely concerned with their dress and appearance, devoting considerable time and expense to enhancing their beauty. Young women, who are sent daily to market the herds' dairy produce in nearby towns and villages, are seldom seen without brightly colored clothes and extraordinarily elaborate hairstyles they create using hairpieces, braids, colored thread, beads, mirrors, and any other bright objects that can be bought in local markets. Leather talismans, beaded neck bands and bracelets, silver and aluminum armlets, are all accumulated and displayed even for daily wear. Young men, who take turns herding the cattle, visit towns less often, but they, too, wear similar jewelry, often topped by an embroidered cap. Both men and women may be tattooed, although women's tattooing is

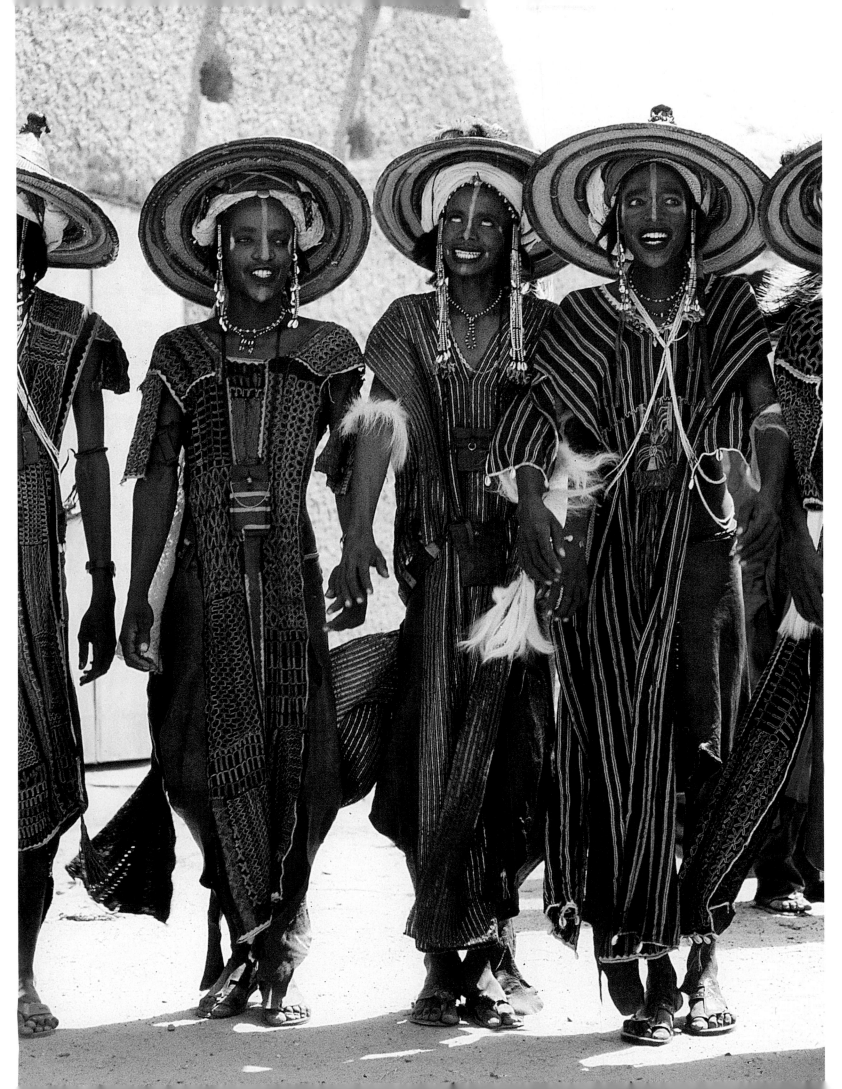

Left: A group of Fulani men in *Geerewol* makeup.

Ben Hunter

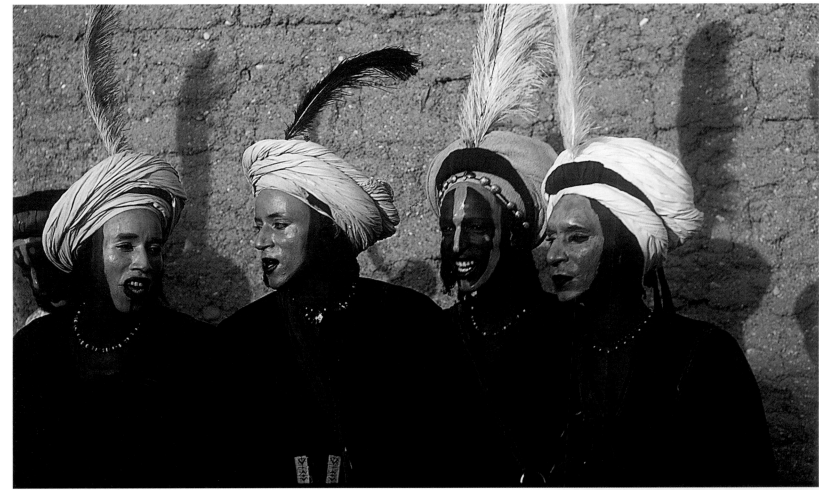

Right: Each dancer
completes his outfit with a
feather.

Ben Hunter

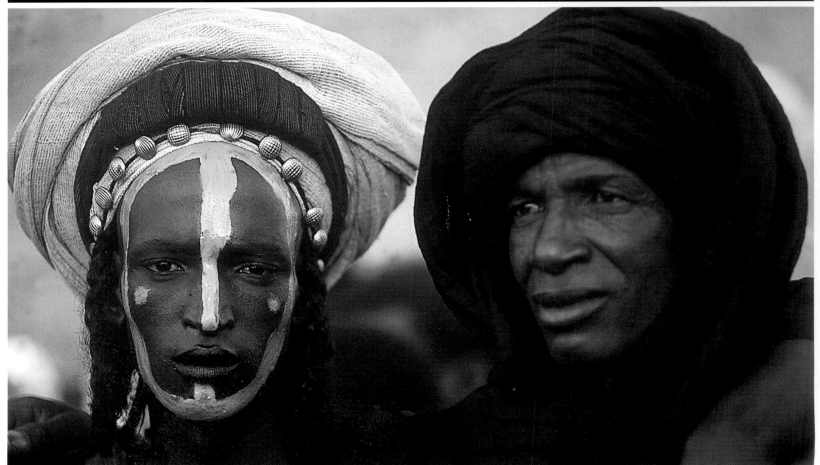

Right: An older man with
facial tattoos accompanies a
Geerewol competitor.

Ben Hunter

more extensive and elaborate. For the Fulani, facial tattoos, in particular, have a protective function, and are concentrated on areas believed to be vulnerable, with fine hatched designs at the corners of the mouth, underneath the eyes, and on the forehead.

In the rainy season, when grass and water are abundant, the cattle can be kept in one place and longer lasting camps are set up. This is a time of relative plenty during which betrothal ceremonies and other celebrations take place. For the Wodaabe, the closing weeks of the rainy season are marked by a seven-day festival in which the young men of two lineages will compete together in a choreographed beauty contest, the winners being selected by the most beautiful young women. Aside from the pride at stake in being judged and recognized as the most beautiful, and therefore most Fulani, there can be more fundamental issues of family survival at stake in the relationships formed or broken on these occasions.

Marriages among the Wodaabe are expected to take place within the lineage, ideally between paternal cousins or second cousins, partly because this is seen to preserve the purity of the lineage, and partly because it keeps the inheritance of rights over cattle within the family herd. These marriages are arranged in a series of recognized stages that begin with an agreement between the two fathers—often when the boy and girl are infants—and are only considered complete years later when the adult woman returns to her husband with her first weaned child after giving birth in her father's camp. It is only then that the man sets up a separate camp away from his father and is officially regarded as an independent adult. From that time on, he has to maintain a careful balance between his cattle and his immediate family, ensuring both that he has sufficient milking cows to feed his family and that he has a large enough family to herd and milk the cattle. He may marry one or more subsequent wives (by a less lengthy procedure), depending on the state of his share in the herd. Yet these marriages, in which so much time and prestige have been invested, and which are so crucial to a man's future role as a respected adult, can be highly unstable.

Young women in particular can, and do, leave at any time to marry someone else they prefer, especially if they feel that their interest in the cattle has been threatened. The *geerewol*, with its break from the daily work routine and heightening of focus on male beauty, provides a stimulus for many of these marital realignments, as dancers from the host lineage try to lure away young women from their visitors while attempting to prevent any of their own wives or unmarried girls from departing.

Men, including some married men, from the visiting lineage dance first. Each wears a woman's wrapper cloth pulled tight around the hips and knees, their waists, shoulders, necks,

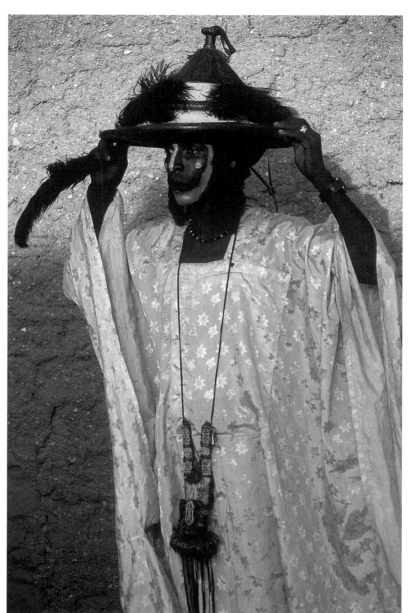

Left: Fulani man in his best robe and hat prepares to don his *Geerewol* costume.

Ben Hunter

wrists, and arms adorned with a carefully selected but profuse display of talismans, beads, brass rings, embroidered leather bands, etc. Ostrich plumes are attached to the dark blue headbands. At this stage, the men's make-up, based on red ocher mixed with fat, is identical, so that the dancers can be judged on their beauty alone. Later on in the series of dances, there will be scope for more individual designs in white and yellow that focus attention on the narrow nose, high cheekbones and other features considered distinctively Fulani. Carrying ceremonial axes and horsehair fly whisks, the men begin a highly stylized, slow stamping dance in front of the watching elders while nearby young women dance in a circle. The dancers sing the praises of the most beautiful maidens while the girls also indicate their choice of the men through their songs. In order to highlight their beautiful faces, the men roll their eyes to show the whites and bare their teeth, highlighted by blackened lips. After several hours of rhythmic dancing, the three girls

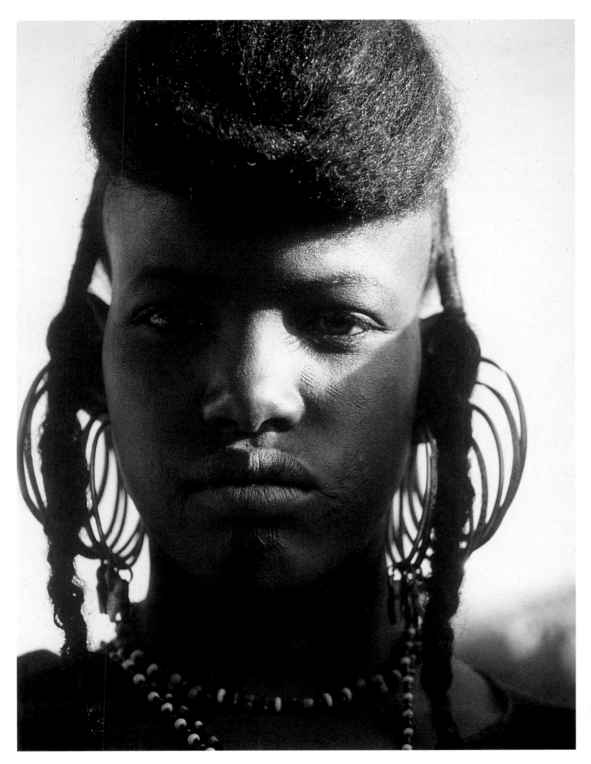

Above: Fulani facial tattoos are thought to protect the wearer from spiritual forces.

Ben Hunter

Right: The most beautiful young women are selected to judge the male winners of the *Geerewol* dances.

Ben Hunter

chosen as the most beautiful are brought forward and, with modestly lowered eyes, and amid mounting tension, each in turn touches fleetingly the man she considers the winner. The most successful couples pair off and may spend the remainder of the evening together. A similar dance is held by the host lineage the following evening, and others, attracting growing audiences, follow through the succeeding days.

Geerewol (which comes from the verb *yeera*, meaning "to look around") was seen by the anthropologist Derrick Stenning as an unusual form of initiation ceremony, marking the gradual transition to adulthood of both men and women.

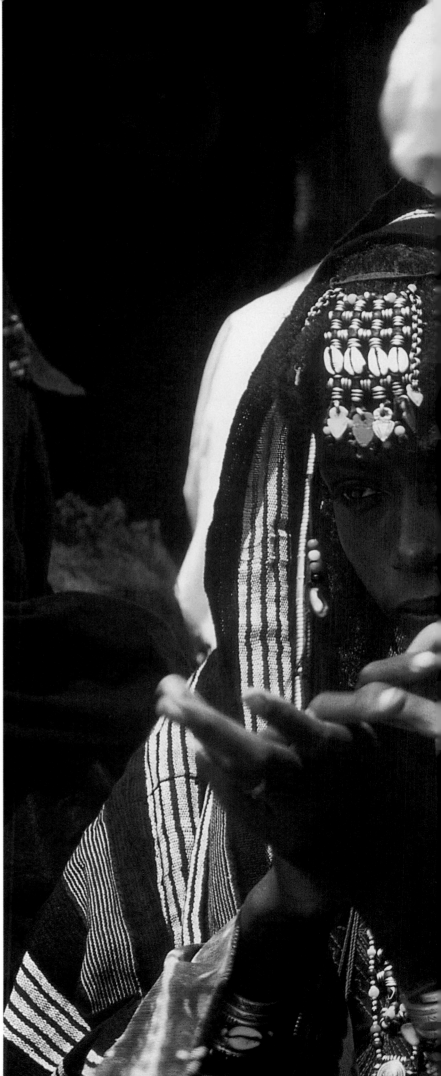

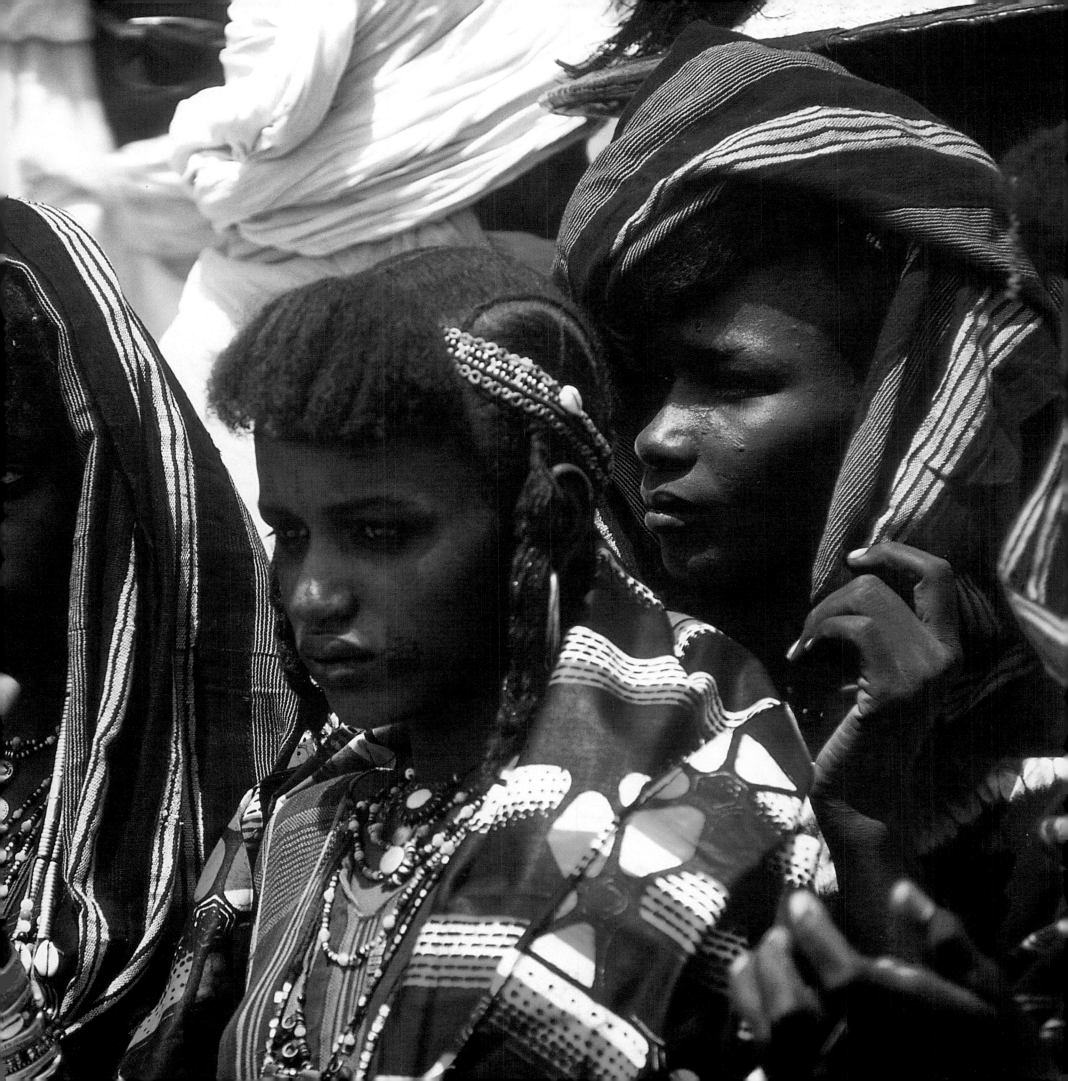

Above: **Fulani married woman.**

Ben Hunter

Right: **The *Geerewol* is the climax of the rainy season festivities and draws a large audience.**

Ben Hunter

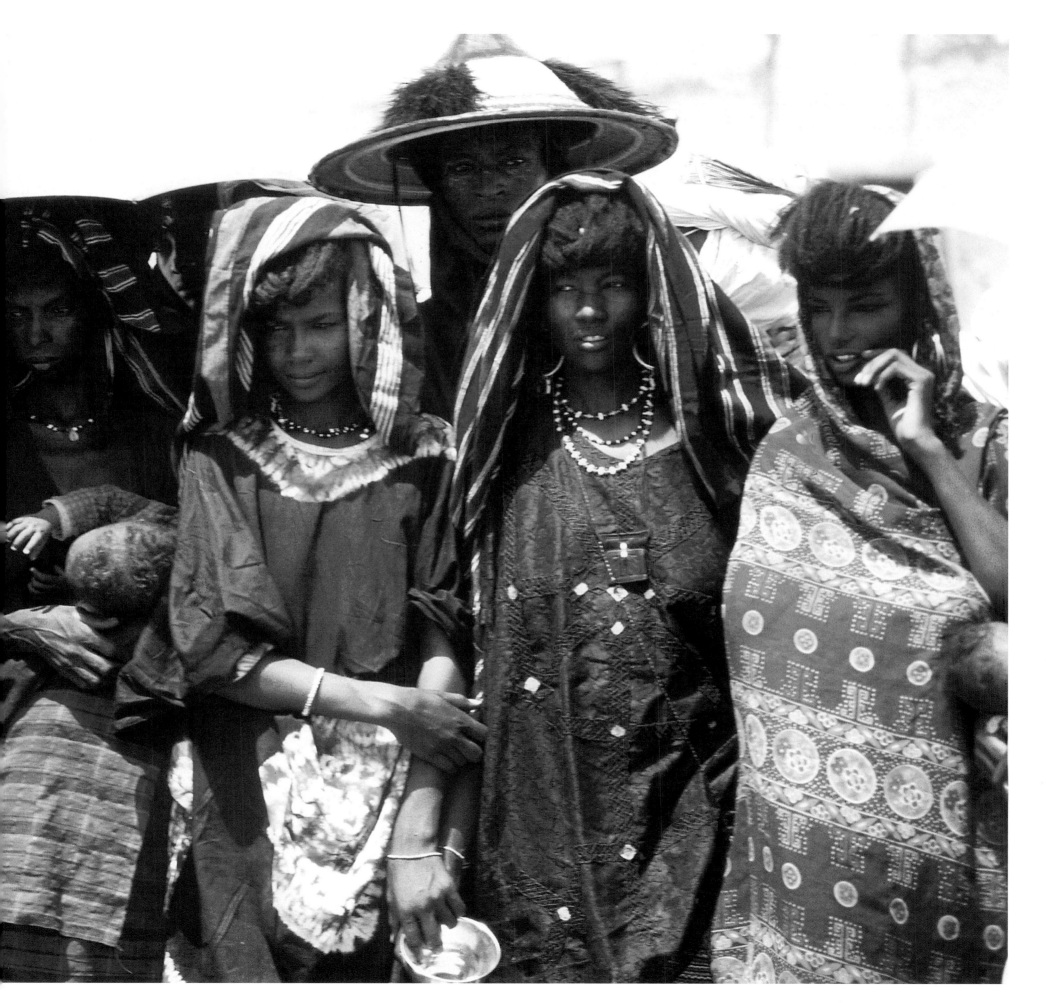

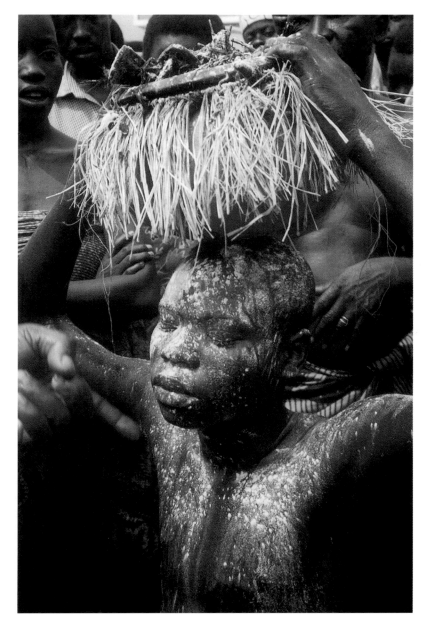

Right: A Fon *vodu* initiation ceremony in coastal Togo: the initiate, his face sprayed with powdered chalk, carries a pot of magic medicine on his head.

Ben Hunter

was not participation in the *Geerewol* itself that brought about a change in status (beyond the glory that was attached to the winners), but the successful completion of an appropriate marriage and the rights in cattle and establishment of a separate camp that followed. In many other societies in Africa, ritual ceremonies that themselves effected a change of status were the occasion for temporary body decoration. In addition to special forms of dress or of undress, those undergoing such a transition would often be singled out by having their bodies painted with white or, more rarely, with red or black pigment.

Many, but by no means all of, such transitions involved a movement from childhood to recognized adult status, or a more extended series of moves, such as the Maasai male progression first from youth to warrior, then, years later, to elder. Before we look at an example of these, however, we will consider other rites of passage, such as that between sickness and health, that of cult initiation, and that to the role of professional healer or spirit medium, all of which were frequently accompanied by body decoration. In fact, these three transitions could often be part of the same process. We saw in our discussion of Kongo medicine that African medical traditions take what might be called a holistic view of illness, looking to both physical and spiritual issues as the cause and the cure of most conditions.

Although there are, or were, an infinite number of individual and regional variations in specific details, similar ideas about the mixed causes of medical and psychological problems and about the appropriate places to look for treatment may be found across much of sub-Saharan Africa. In general, afflictions were believed to be caused by something external to the sufferer such as the hostile attentions of another person, or of some kind of spiritual entity. In some cases, the appropriate cure might be the construction of a kind of protective "medicine," that would guard the patient or even deflect the disease back on the person who caused it. As with the healing nkisi, the preparation of these frequently involved the interplay of the three primary colors, red, white, and black. In other situations, though, the process of curing a patient would involve initiation into the cult to which the healer belonged. The disease, which might be prolonged infertility, or failure at trading, or any of a vast range of physical or mental problems, could be seen as a call by a particular spirit for the patient to follow them. The cure would then take the form of the appropriate payments to the cult leadership, sacrifices to its deity or spirits, and the patient undergoing initiation into the cult.

Sometimes a general deity offered a whole range of benefits to its followers but in other cases there might be a specific cult for those who survived a particular disease. White, or less frequently, red body painting was a standard feature of such

He noted (Stenning, 1959) that it "has the effect of ranging the youths and maidens of a particular age group into a generally recognized order of physical desirability by which the status of a young man or woman in that age group is assessed. But after marriage this status is unimportant, for that of men—and in reciprocal terms that of women—is measured by the number of cattle and children they possess." The Wodaabe Fulani clearly have a highly developed aesthetic of personal adornment, but one that is primarily concerned with beauty, and only indirectly with communicating ideas about status or ethnicity.

Temporary body decoration, in this case taking the form of elaborate male face make-up, and a heightening of an already strong concern with self-presentation among both young men and young women, serves the Fulani as a focus for a festival that marks an extended period of transition from youth to the status of adult cattle owner or married woman. However, it

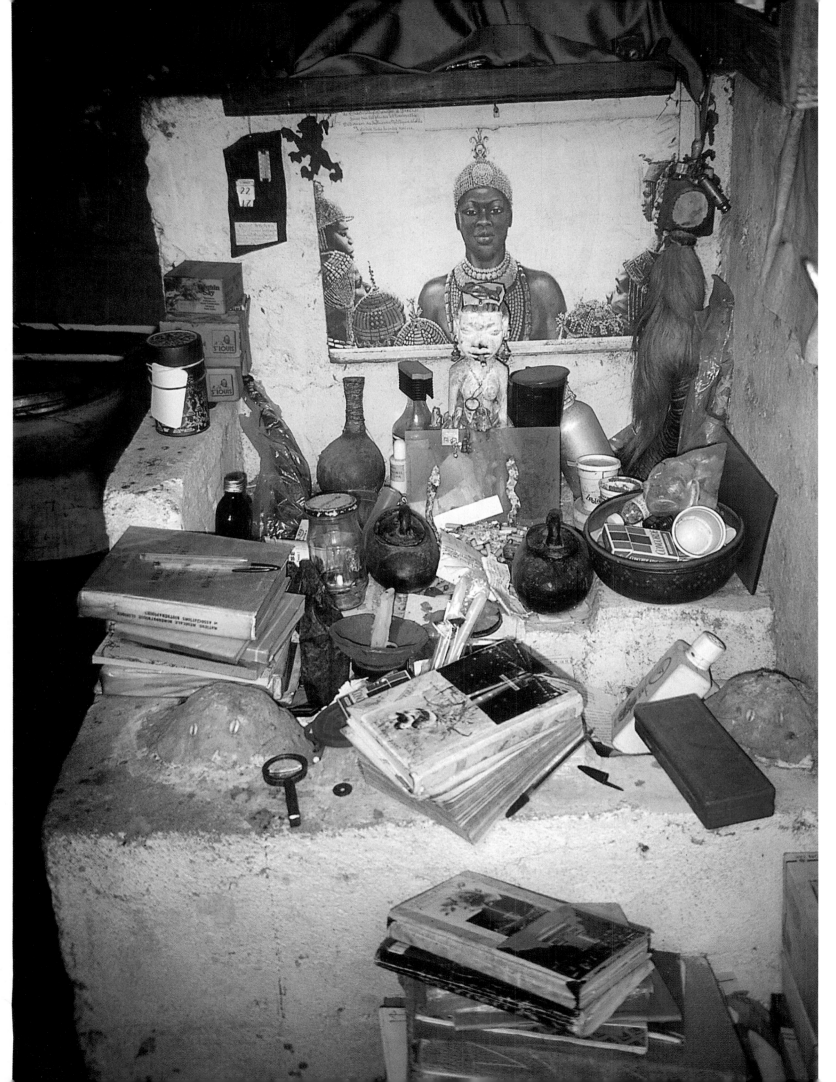

Left: The shrine altar of a vodu spirit. Books may indicate the wisdom of the spirit and the success offered to initiates.

Ben Hunter

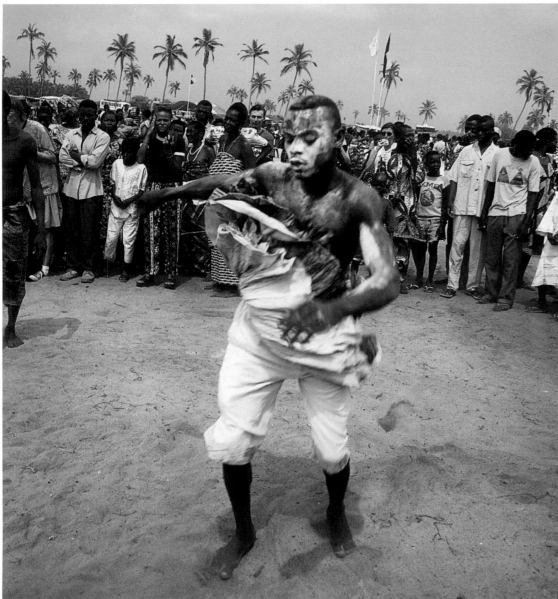

Above: **Chalk painted dancers at the initiation ceremony.**

Ben Hunter

Right: **Blood from an animal sacrifice is a crucial element in many *vodu* rituals.**

Ben Hunter

processes of initiation, serving to indicate that the patient was undergoing a period of change, and often conveying associations of purity and innocence as they were purged of their complaint. Once a member of the cult, the patient, assuming they were successfully cured, would be on a path which might lead them, as they acquired greater ritual knowledge, to become a healer themselves. Today, of course, healing cults such as these exist alongside hospitals, maternity clinics, etc., that offer an alternative mode of treatment to those who can afford the high price of imported drugs.

Religious and medicinal practices of this type are particularly widespread today in the coastal areas of the West African republics of Benin and Togo, where, despite a century of missionary activity and sporadic official persecution, the local religious traditions that gave rise to *vodoun* (voodoo) and other African-Caribbean religions still thrive. *Vodu* is the Fon term for a huge number of deities and spirits, each with their own

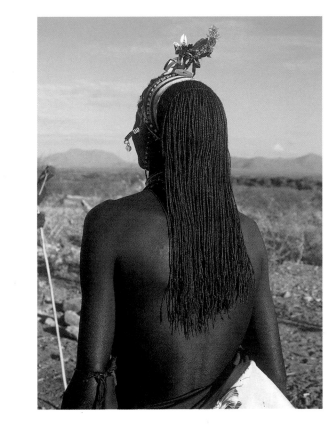

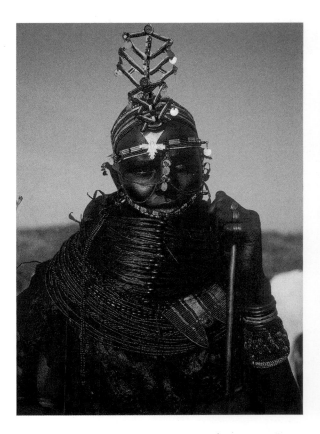

shrine houses, priests and priestesses, and larger or smaller groups of followers. Some of these spirits are of great antiquity, with figures such as Ogun, god or iron and war, overlapping with the *orisa* deities of the Yoruba to the east, and as a result of the movement of peoples during the slave trade, important entities in the African religions of the Caribbean and South America. Others such as Mami Watta, a mermaid-like figure who promises her followers wealth and beauty, emerged during the colonial era. Still others are the product of continuing processes of individual innovation and cultural mixing, where imagery and ideas are drawn from sources including Christianity, cheap lithographs of Hindu deities, and general popular culture to create numerous novel figures. Most of these are possession cults, where devotees and those that come to the shrines seeking assistance will be taken over mentally by the spirit entity during the course of ceremonial dances, temporarily displacing their own personality with that of the spirit, enabling cures to take place by direct contact with the deity. White cloth, sometimes with red adornment, is the standard attire for participants in these ceremonies, with the body, or parts of the body, of the priestesses, spirit mediums, and dancers, being decorated with white chalk paints.

On the other side of the African continent, in a vastly different cultural context in Kenya, both white lime and red ocher body paints are key features of Maasai male initiation into senior warrior and elder status. White and red paints are also used when young women are initiated into adulthood through circumcision. Like the Fulani in West Africa, the

Maasai and their neighbors are semi-nomadic, cattle-herding people whose main form of artistic expression is the decoration and adornment of the human form. For the Maasai, and the Maasai-speaking Samburu, status in life is related to a series of age-based groupings. For women, there are two major stages, childhood and adulthood, with the transition being marked by a ceremony at the age of about thirteen to fourteen that includes circumcision. Young men are also circumcised at about the age of fifteen, becoming junior *moran* (or *murran*) warriors whose responsibility is to protect the herds of cattle. For the next fifteen or so years the *moran* live apart in separate areas called *manyata*, and are prohibited from marrying, although they may have friends or lovers among the uncircumcised girls. At about thirty, they become senior warriors for a further fifteen or so years, living in the settlements and being permitted to marry. After fifteen years as senior warriors, the men become junior elders, then, following a further fifteen years, they are promoted to join the body of senior elders, who make decisions for the group. Each of these stages has its own traditions of dress, and in particular of beadwork, introduced in the following chapter. In moving from one stage to another, there are elaborate ceremonials in which the participants are marked out at certain stages by the use of color in the form of body paints.

For a short healing period after circumcision, both male and female initiates among the Maasai wear dark blue cloths and paint each others' faces with white chalk designs. The youths tie their cloths over their shoulder like women, and go out to hunt

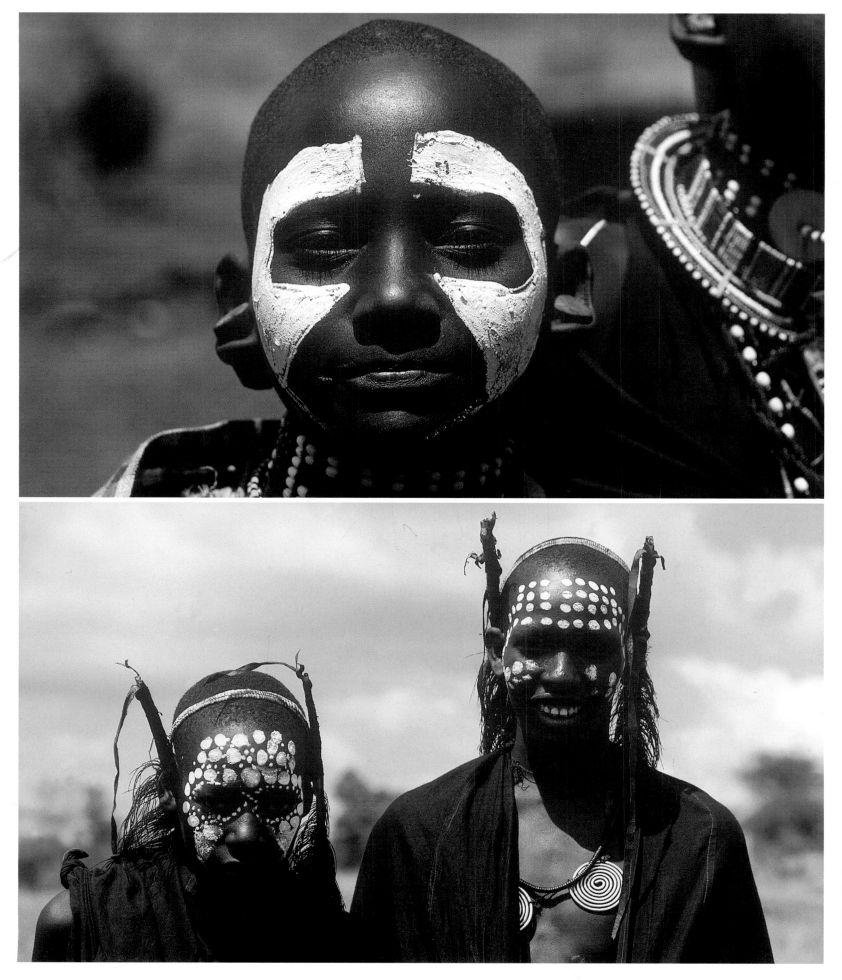

Left: Maasai girl during initiation period, her face painted with chalk and ash.

© David Keith Jones/Images of Africa Photobank

Left: Maasai youths in course of initiation to warrior status, wearing black cloth and chalk face paint.

© David Keith Jones/Images of Africa Photobank

in the bush with blunted arrows, making ceremonial crowns from a wooden frame holding the bodies of small birds they have shot. If a man has been brave and not flinched or cried out during the circumcision, he can wear colored birds, otherwise they must be brown. They also try to hit young girls with the blunt arrows, and each girl hit will give the initiate one of her beaded rings which he will wear as he becomes a warrior.

Young women initiates are looked after by their family during the recovery period, wearing special beaded circlets, often with metal links over the forehead, and painting their faces with white chalk and red ocher. They are forbidden from associating with, or even speaking to, men other than family members until their wounds are healed and they go to join the husband chosen for them. Similar periods, usually accompanied by a more formal seclusion during circumcision were, at least until recently, standard practice among other Kenyan peoples. Okiek women, for example, wore drab outfits, painted their bodies and faces with white clay, and blacked around their eyes with charcoal, dressing as a creature of the wild, during their seclusion, while Kikuyu covered themselves entirely with blackened hides.

The transition from warrior to elder status is apparently seen as a period of sadness by many Maasai men, as it involves abandoning the freedom and finery of their life as warriors for the responsibilities of raising a family. The most dramatic and poignant moment in the festival that marks this transition is often when the initiate's mother shaves off the long, ochered locks of hair on which the warrior will have lavished daily attention over the previous fifteen years. Unlike among some neighboring peoples such as the Pokot and the Turkana, the elaborate hairstyles of warriors cannot be retained as elders and the ornate beadwork of a warrior will have to be discarded, also. The newly shaved heads of the young men are rubbed with red ocher. The four-day ceremony, called *Eunoto*, is held once every seven years at a special site selected by the diviner or *laibon*. The mothers of the warriors to be initiated build a circle of huts around a central ceremonial house. On the first day, the warriors celebrate their greatest achievements over the

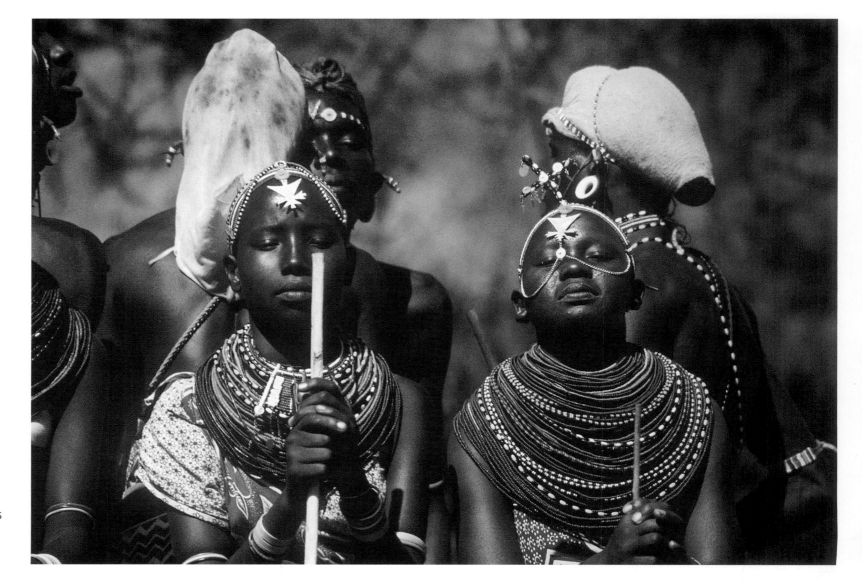

Right: **Young Samburu girls dance with the warriors.**

© *Mark Kuscharski/Swift Imagery*

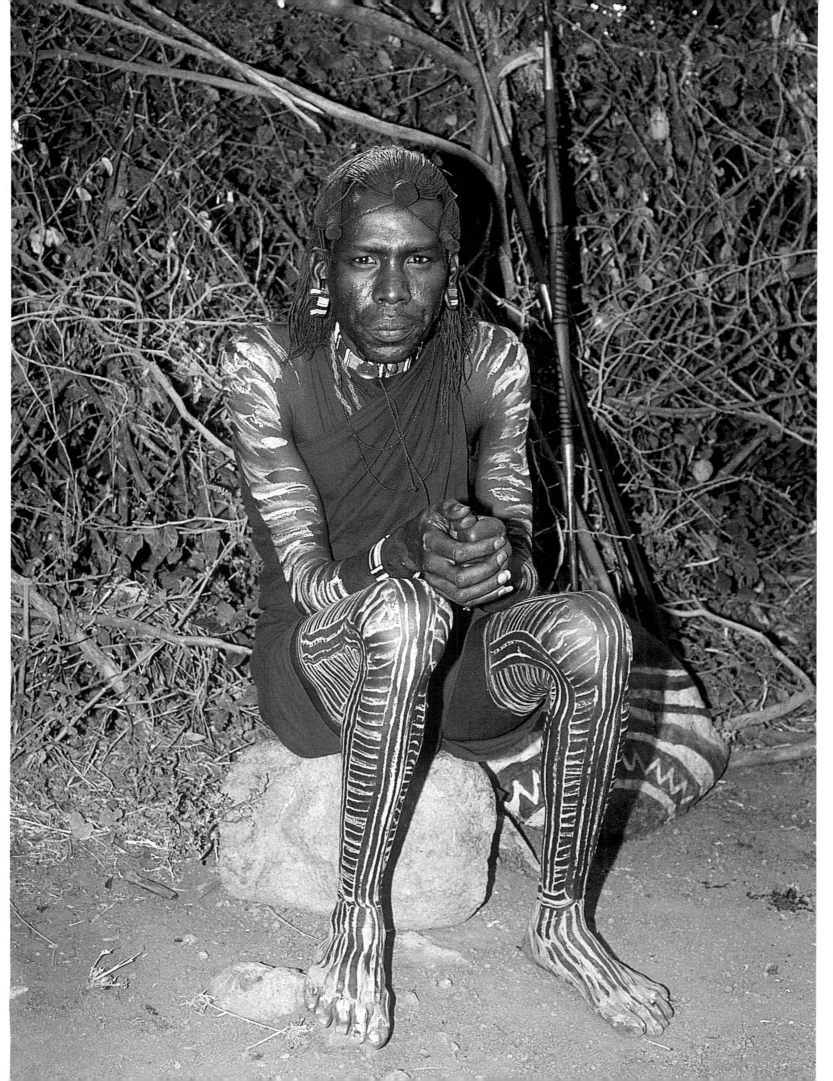

Left: Maasai warrior with
the chalk body painting
worn during part of the
transition to elder status.

© Mark Kuscharski/Swift Imagery

89

years in songs that praise those who have killed lions or captured large numbers of cattle from rival groups. Painted all over with ocher, the Red Dance marks the fierce hotness of the warrior. Lion fur head-dresses and buffalo hide shields are worn with pride by those who have successfully hunted such dangerous animals. Watched by their girlfriends for almost the last time, the men compete in a leaping dance.

On the following day, the ritual focus moves on to the White Dance. At a sacred chalk bank, the initiates smear their faces and naked bodies with white paint, tracing lines and swirls on their skin. After the blood-red pigment of the previous day, the white evokes the more peaceful, ordered existence as an elder that is to come. Those few men who have killed a lion or an enemy warrior are distinguished by wearing the white chalk paste only on one side of the body, while retaining the red ocher on the other. Partially transformed into elders, they parade back to the ceremonial camp. After two final days of dancing and rituals they receive the blessing of the elders they are to join, their heads are shaved by their mothers and their life as a warrior has ended.

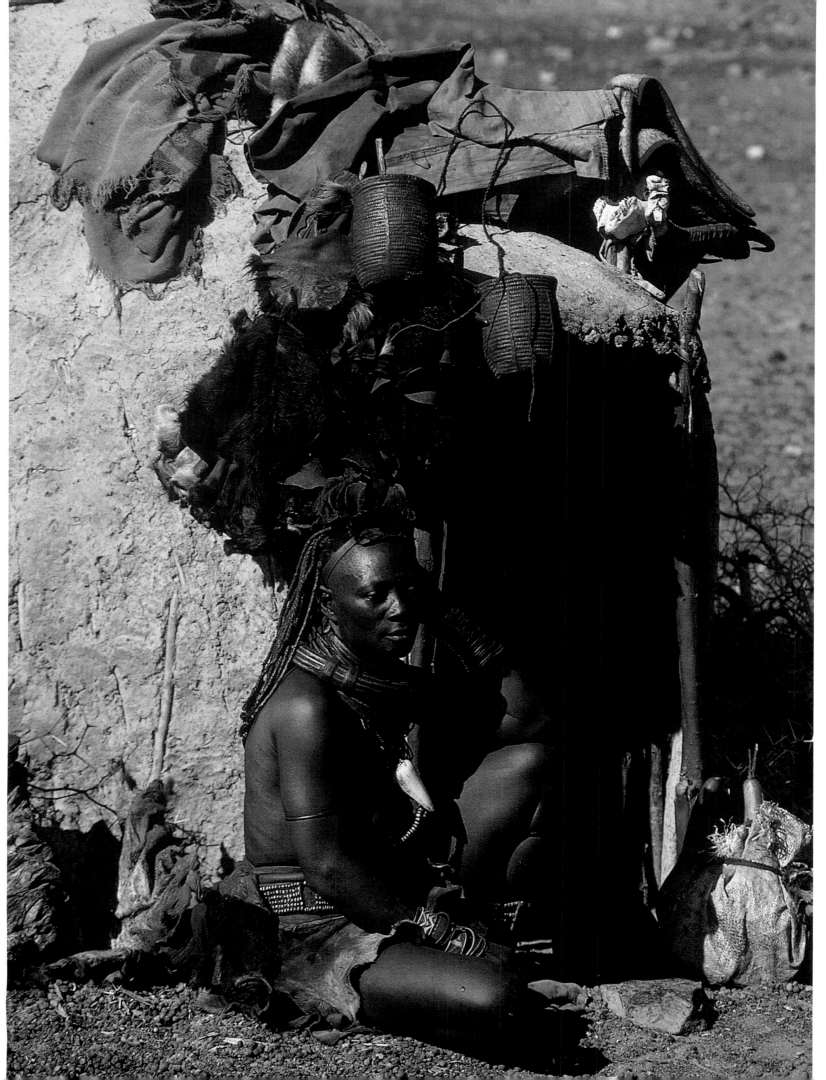

Following pages: A Himba child with ochre-smeared braids.

Struik Image Library

Left: The ochre and fat that Himba women smear over their bodies is believed to have medicinal value as well as protecting the skin from the sun.

Struik Image Library

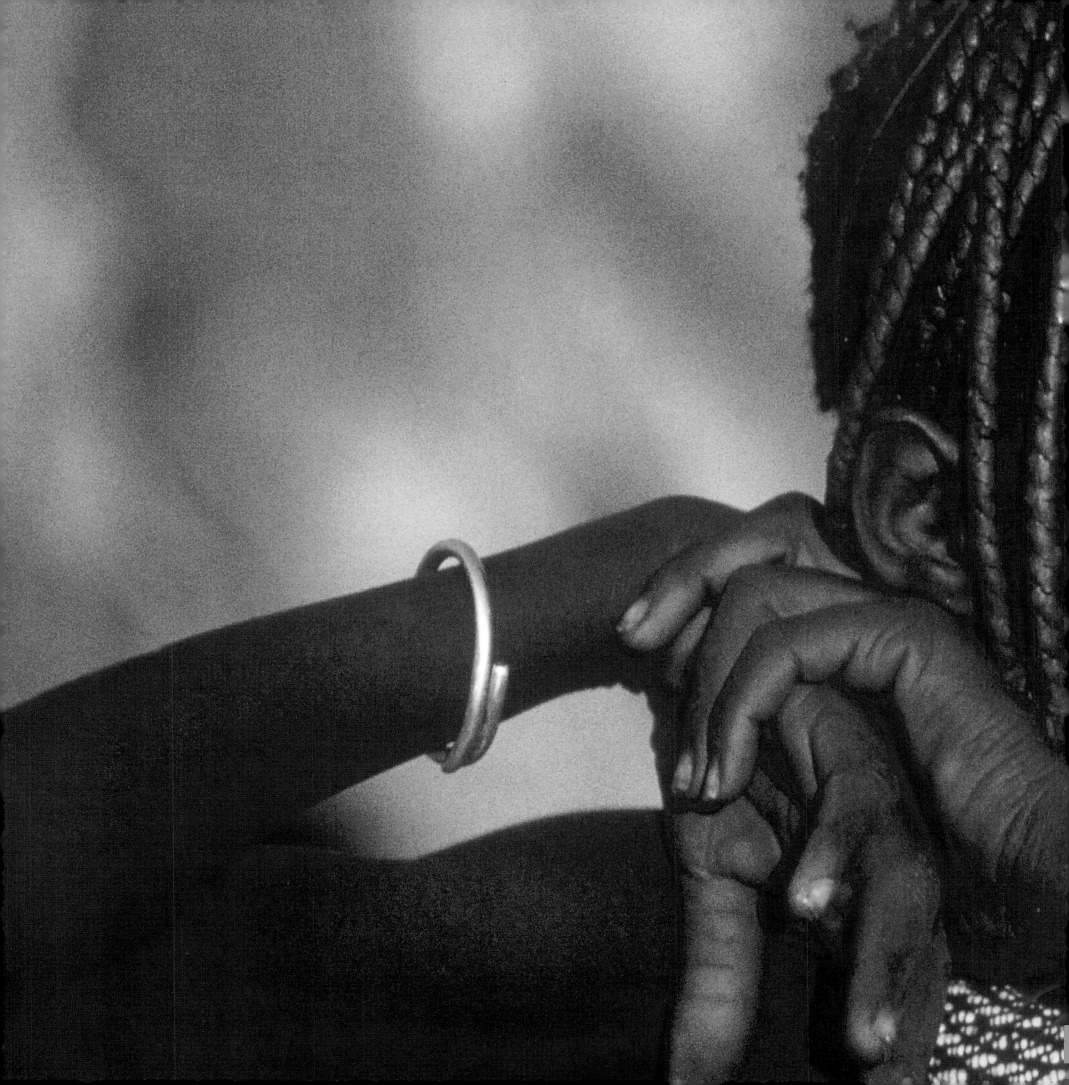

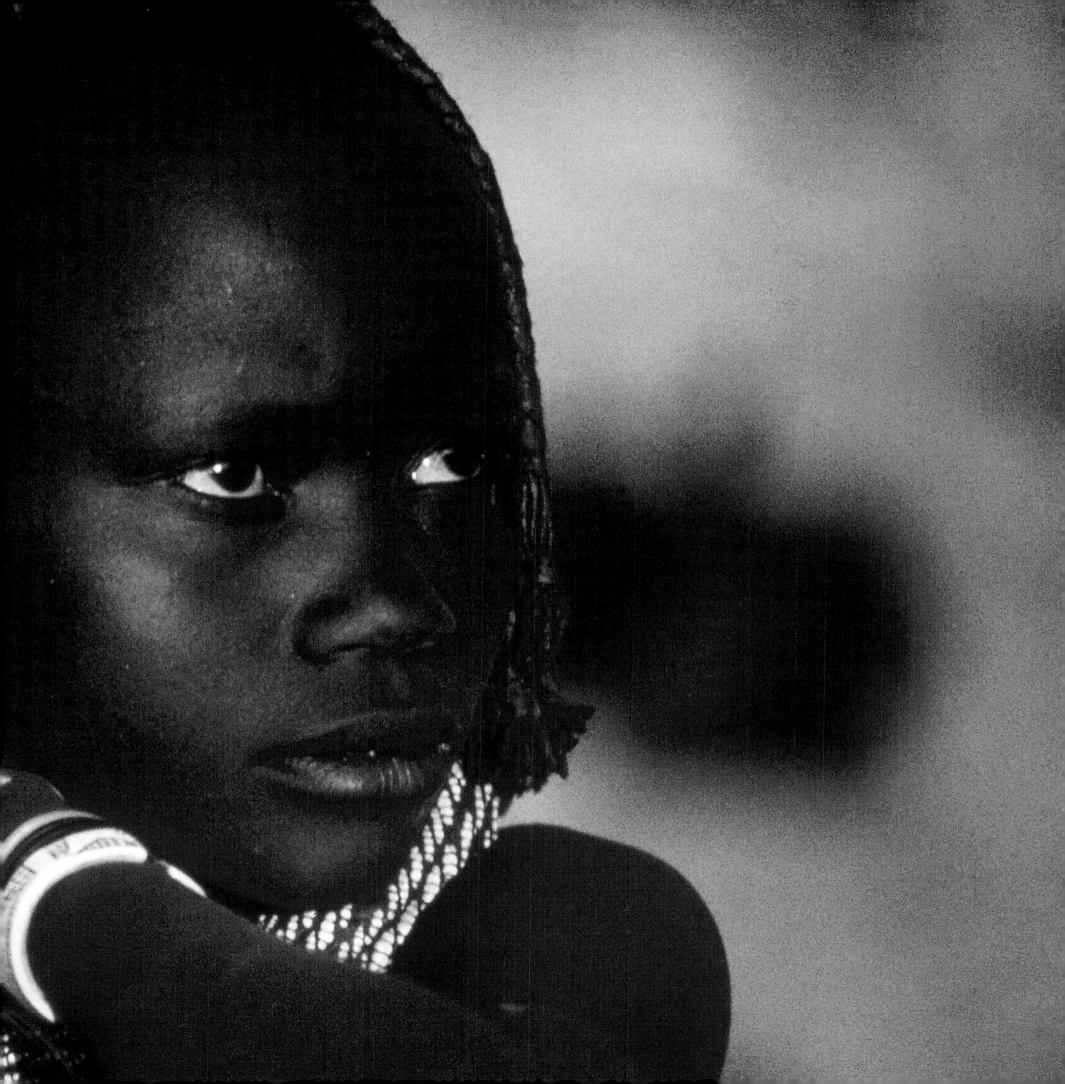

WEARING COLORS

Beads and Beadwork

In the ancient West African kingdom of Benin, in present day Nigeria, red beads and red metal—specifically coral beads and bronze regalia—were highly prized, and the rights to their use strictly regulated by the king. Red was a dangerous color, representing the deadly potency of the Oba, or king, who could kill with a look or a word. Royal control over these luxuries—notionally obtained from the god of the sea, although in fact bartered with Portuguese merchants—reinforced the king's status as ruler of the land. Unauthorized wearing of coral beads could be punished by death.

For the Zulu of South Africa on the other hand, beads could be used to send messages of love. As part of a complex of ideas about the appropriate use of beads and beadwork that developed with the influx of large quantities of cheap, brightly colored trade beads from Europe early in the twentieth century, young Zulu women sent color-coded messages to their boyfriends working as migrant laborers via beaded neck bands, bracelets and necklaces. At the same time, colors and patterns of beadwork adornment came to signify wider issues, from place of origin, to marital status, to fashion, even to political allegiances.

Today, certain patterns and styles even identify the wearer's membership of particular African churches. Ndebele beadwork, like their decorated houses, is associated with female status and female creativity, expressing a pride in Ndebele identity and displaying the life-cycle stage of the wearer.

To the Yoruba in Nigeria, beads have long evoked associations with the power of gods and kings. Only true kings descended directly from Oduduwa, the founder of the Yoruba people, could wear the conical beaded crowns with the fringe of beads which concealed the awesome power of their face from the view of their subjects. The followers of each deity could often be identified by the color of their beads, with the color associations seen as corresponding to aspects of the character of both the deity and his or her devotees.

In Kenya, the Maasai shared with neighboring cattle-herding people such as the Turkana, Pokot, and Rendille similar social institutions based on a progression through age sets, and similar esthetics of marking these progressions with changes in body decoration such as beadwork and hairstyles. Yet the specific types of beadwork, the colors used, and the arrangements of these colors differed from one people to another.

Although demonstrating or communicating ethnic or "tribal" identity to others was not the primary purpose of their beadwork, it did provide a focus for group solidarity, reinforcing a sense of similarity and difference as ethnicity became more important in modern states. Other non-pastoralist groups, such as the Okiek, have adopted what they regard as prestigious and attractive beadwork styles from the Maasai, although to the Maasai themselves, their imitations are rejected as "mistakes."

The oldest known beads in Africa are white discs ground from pieces of ostrich eggshell found in Libya and the Sudan and dated to some 12,000 years ago. Ostrich eggshell disc beads are still used by such widely separated groups as the Turkana in northern Kenya and the San in the Namib desert of Namibia, while similar beads made from the shells of snails were in common use as waist beads in West Africa until very recently.

At least by the first millennium of the present era, beads were being imported into Africa in significant quantities for use alongside those of local manufacture, setting a pattern of interaction between the two sources that has continued to this day.

Materials used to make beads locally, or traded from elsewhere within Africa, included metals such as brass, copper, gold, silver, and iron, stones including gneiss, agates, and jasper, clay, copal amber, wood and seeds, coconut shells, sea shells, egg shells, snail shells, and, in isolated instances, glass. Imported beads included stone beads from India, the Middle East and, more recently, Europe, amber from the Baltic, and vast quantities of glass beads from both India and Europe.

Right: A trader's wares in the weekly bead market in Koforidua, Ghana. Beads remain of great cultural significance to the Krobo and neighboring peoples in this region, displaying the family wealth during the young women's *Dipo* initiation and other ceremonial occasions.

Duncan Clarke

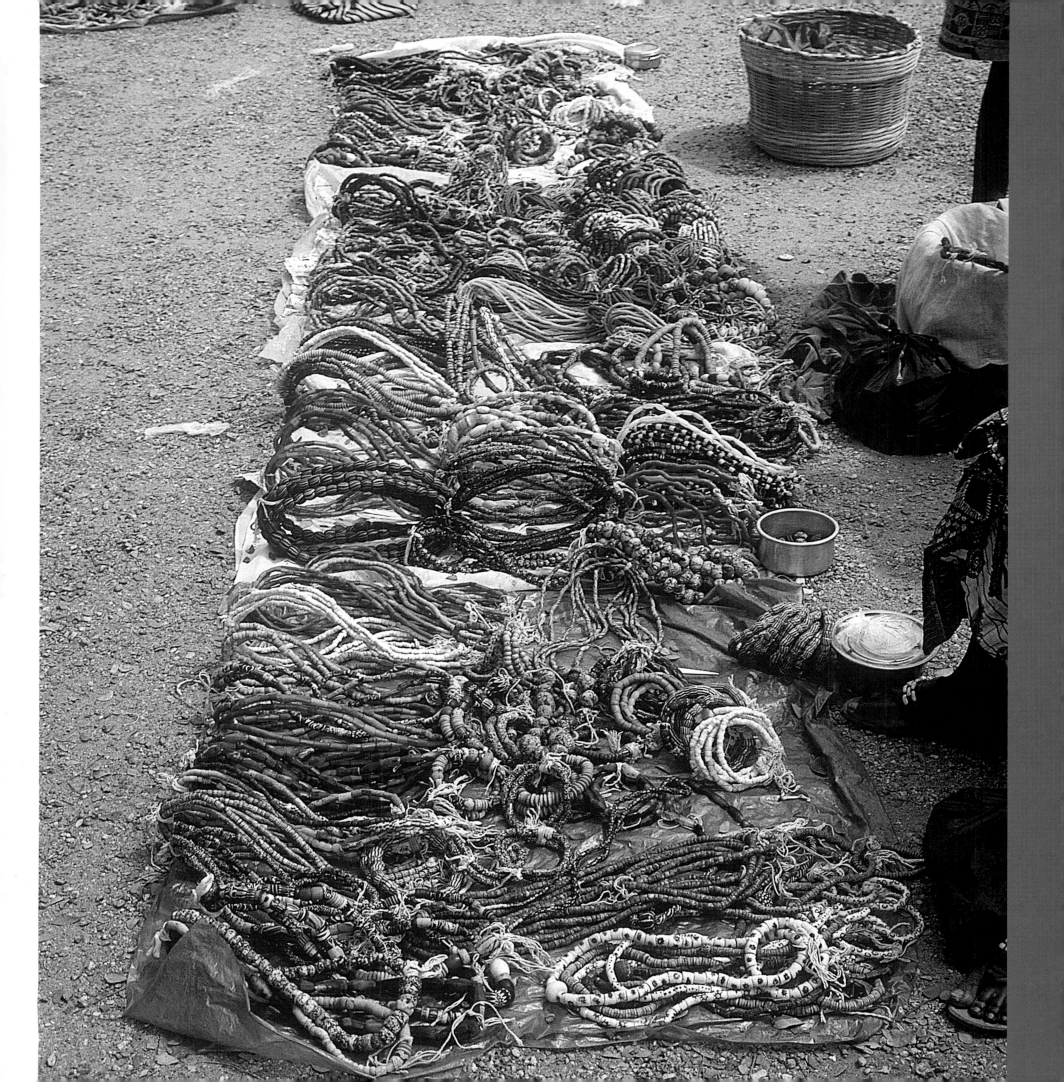

The Ancient Egyptians drew on an extensive trading network, both across the Sahara and throughout the Mediterranean world and beyond, to supply raw materials for the elaborate beadwork that adorned the pharaohs. These contacts across the desert, probably initially channeled via Nubia, continued over the following centuries, along with ship-borne trading down the East African coast, keeping sub-Saharan Africa linked to the extensive bead-trading networks of the Indian Ocean and the Mediterranean.

By the end of the first millennium, there were complex urban cultures in various parts of Africa importing beads along with other highly valued trade goods. In the southeast, large quantities of imported glass beads have been excavated at the sites of important settlements along the Limpopo river, notably Mapungubwe which flourished between the eighth and eleventh centuries C. E. as well as at Great Zimbabwe (circa twelfth to fifteenth centuries). In the fertile inland Niger Delta in Mali in the west, the urban society developed in the town of Jenne in the early centuries of the present era, from which period earlier beads from Ptolemaic and Roman Egypt have been excavated. In present day Nigeria over 165,000 mostly imported beads (possibly of Near Eastern origin) were uncovered, along with astonishing cast brass sculptures dated to around 900_1000 C. E. at Igbo Ukwu. Early evidence for glass, and possibly also stone bead making has been found at Ife, the town regarded as the birthplace of the Yoruba people, dating from around 800 C. E., although opinions among experts are divided as to whether glass could have been made locally or imported glass beads were being melted down and reshaped.

Glass does seem to have been manufactured by bead workers in the Nupe town of Bida until the early decades of the 20th century, although it has since been replaced with recycled glass bottles, which also supply the raw material for glass powder beads made today in Ghana, Mauritania, and parts of Nigeria.

The quantities of glass beads imported into Africa increased hugely with the arrival of European traders, following the Portuguese exploration of the African coastline in the 15th century.

Glass beads—mostly made in Venice, although important bead industries also developed in Amsterdam and later in Bohemia—were cheaply available in Europe, and if the right type was selected, attracted a high price in gold, ivory, palm oil, or even slaves in most parts of Africa. Factories in Europe became adept at catering for African tastes and preferences in terms of color, sizes, and shapes of beads, as well as attempting to imitate African-made beads. Sample cards were prepared and distributed so that traders in Africa and travelers visiting the continent could select the most suitable types from the

Right: An unusual Yoruba beaded hat, in the shape of hats worn by hunters and probably made late in the 19th century for a royal patron.

Christie's Images

96

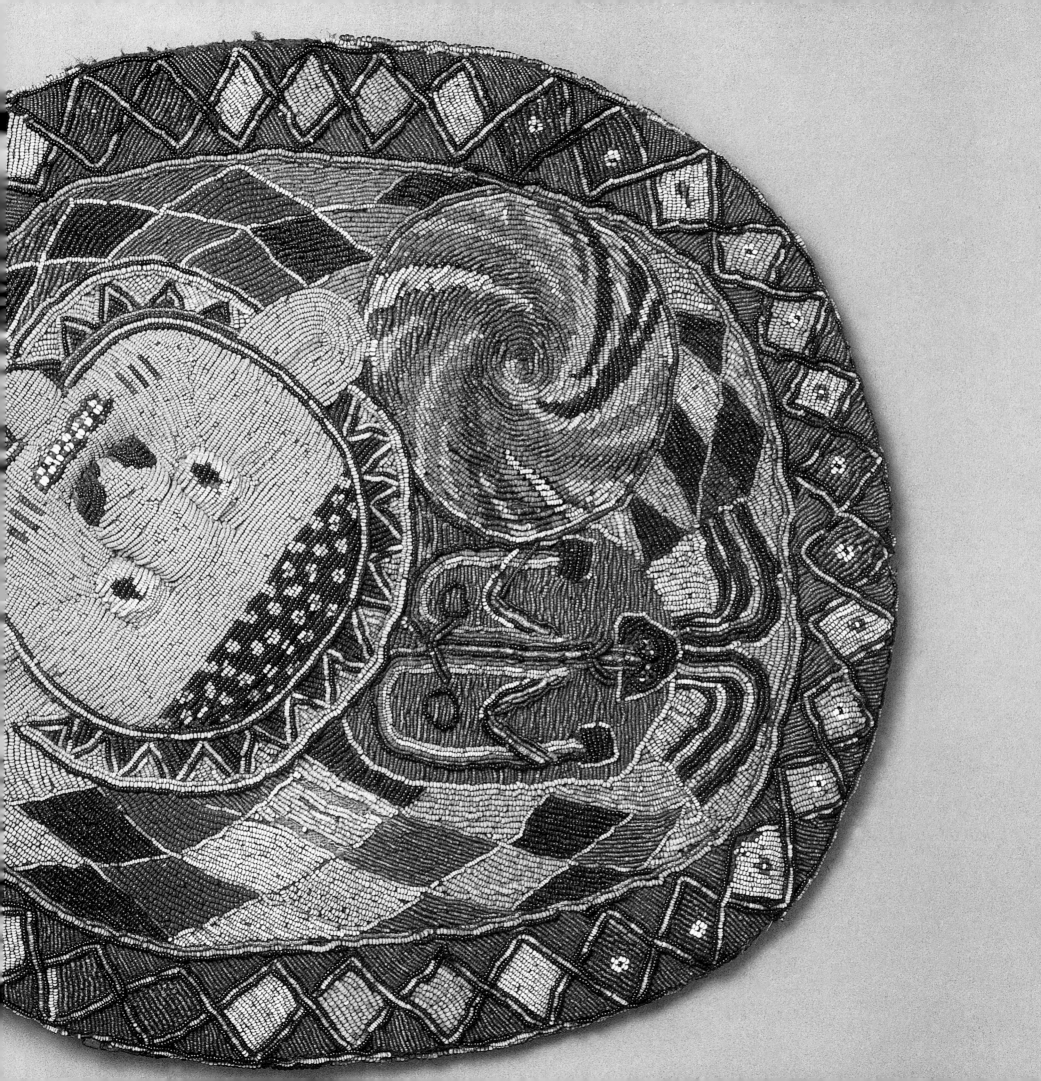

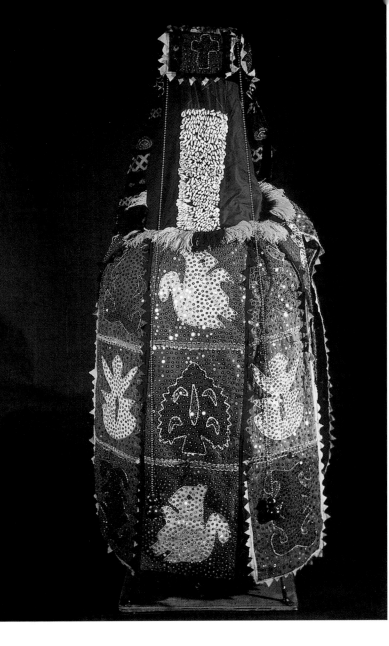

Right: A Fon egungum masquerade costume. The Fon share a tradition of masking that embodies ancestral spirits with the neighboring Yoruba.

Ben Hunter

African people across the continent used these newly plentiful imported beads alongside locally made ones to elaborate on older, more restricted styles of beadwork, and created new uses that ranged from a single strung bead, through simple and multiple strands to beaded regalia and furniture such as royal thrones. All of these were significant to the Yoruba of southwest Nigeria, where beads were particularly associated with the wealth and power of deities and kings.

The people who today regard themselves as Yoruba trace their ancestry to the town of Ife, where there is evidence of bead-making dating back to around 800 C. E., and finely cast bronze figures of kings and queens wearing what are clearly glass or stone beads have been dated to the twelfth to fifteenth centuries. The manufacture of red-stone beads called *lantana*, made from jasper and carnelian was one of the major crafts of Oyo, the successor to Ife as a power center in the region, with the trade transfering to the town of Ilorin following the collapse of the Oyo empire in the 1830s. These red beads were highly prized for chiefs' regalia along with imported coral brought from the Mediterranean by European traders.

Before the spread of Christianity and Islam to the vast majority of Yorubas in the twentieth century, Yoruba religious practice involved devotion to one of a large number of deities called orisa, each of which was subordinate to the supreme god Olorun. Every *orisa* had its own area of responsibility, and a shrine in each town where it was recognized, which was a focus for annual sacrifices by the king and town chiefs. Each shrine was served by its own priests and a larger or smaller group of devotees who expected their deity to provide the full range of benefits requested in their prayers, summarized by the Yoruba as children, money, and good fortune.

Among the ways in which a devotee of a particular orisa could be recognized would be the wearing of a certain color of beads as a necklace or bracelet. Thus, followers of the thunder deity, Sango, would wear alternating red and white beads; those of his wife Oya, goddess of thunder, wore maroon beads; while white represented the creator deity Orisala (whose name translates as the god of white cloth); black and white, the trickster and messenger of the gods Esu; and blue, the water goddess Yemoja.

Some scholars argue that these colors may be grouped as hot, dark, or cool, corresponding to the three primary colors of red, black, and white, and that these groupings are related to the characters of the deities concerned. Sango, god of thunder, for example, has a fiery "red" temperament.

As a result of wars between Yoruba kingdoms in the nineteenth century, large numbers of Yoruba crossed the Atlantic as captives in the final decades of the slave trade, providing a substantial input into the African-derived religions of the

thousands available. Detailed and up-to-date knowledge of what type of bead was in demand in particular regions was vital for would-be explorers and missionaries in the nineteenth century, since a miscalculation could leave them with a heavy sack of unusable beads and no means to trade for essential supplies.

When stocking up in Zanzibar from the shiploads of beads imported from Europe, the journalist Henry Morton Stanley, writing in 1872, calculated that he would need to take with him on a journey to Lake Tanganyika a total of twenty-two sacks of beads in eleven varieties. At one point on his journey, he saw white beads being thrown into Lake Tanganyika as a sacrifice to appease the god of the lake before a crossing was attempted.

Beads are traded widely within Africa, with specialist bead dealers and bead markets still found. Interestingly, one of the most highly valued beads in Africa to this day is the layered dark blue, red, and white chevron bead which, perhaps by coincidence, reproduces the three primary colors for so many African peoples.

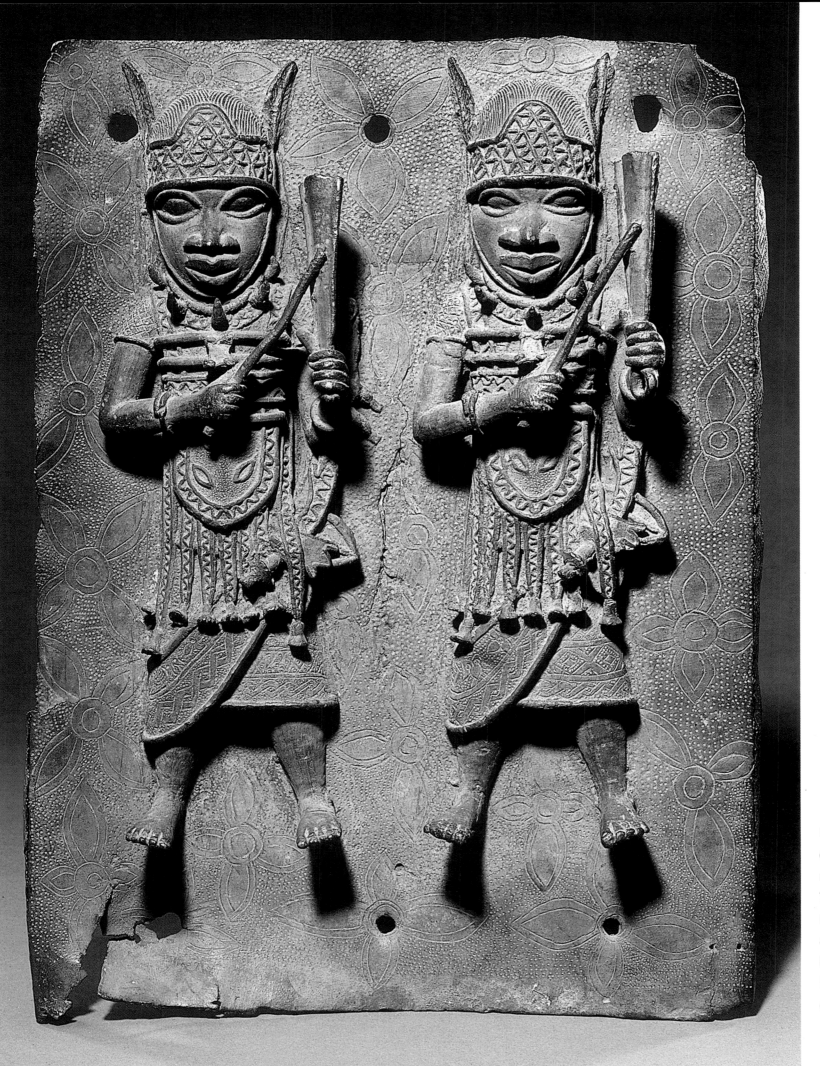

Left: A Benin bronze plaque depicting two court musicians playing gongs. Their costume includes necklaces of leopard tooth and headdresses of coral bead lattices. Circa 1600, Benin, Nigeria.

Christie's Images

99

Caribbean and South America. Yoruba *orisa*, along with the *vodu* of the neighboring Fon and Aja, have been blended with, or disguised by, Catholic saints to live on in religions such as Haitian *Vodoun*, Cuban *Santeria*, and Brazilian *Candomble*, where their followers, (who now far outnumber their remaining devotees in Nigeria) still honor them with beads in their favorite colors.

The sacred Yoruba city of Ife was, according to myth, founded by Oduduwa, who climbed down a chain from heaven to create the world. The sixteen sons of Oduduwa were sent out from Ife to found new kingdoms that constitute many of the major Yoruba towns today. Only rulers who are able to make recognized claims to direct descent from Oduduwa are entitled to wear beaded crowns. Conical crowns totally covered in an embroidery of tiny seed beads were made by specialist craftsmen working to royal orders, who traveled to live as guests of the king until their commission was complete.

The head is regarded by the Yoruba as the focus and embodiment of destiny, *ori*, and, as such, the royal head was protected, concealed, and honored by the crown. Itself a highly sacred object, the royal crown was decorated with beaded birds, rec-ognized by the Yoruba as a sign of supernatural powers. Its beaded fringe concealed the king's face, and especially his mouth, from his subjects, as it was believed that he had the power to kill through his speech. Other, smaller crowns (which lacked the beaded fringe) were made for use on lesser occasions and by kings not entitled to the full regalia.

Bead workers also produced beaded robes, cushions, staffs, and other items intended to demonstrate royal wealth and power. Diviners, known as *babalawo*, often carried a beaded bag as a sign of their office, while *ibeji* figures, carved to placate the spirit of dead twins, were also sometimes provided with beaded jackets.

To the southeast of the Yoruba lies the ancient kingdom of Benin. When Portuguese navigators reached the coastal ports of Benin late in the fifteenth century they found a flourishing state with a well-built capital which seemed to them in many ways comparable to those they knew in Europe. Formal diplomatic exchanges took place on a relationship of equality between the Oba of Benin and the Portuguese crown. Pepper and fine ivory carvings were collected and brought home to Europe as luxury imports. The Portuguese, in turn, supplied

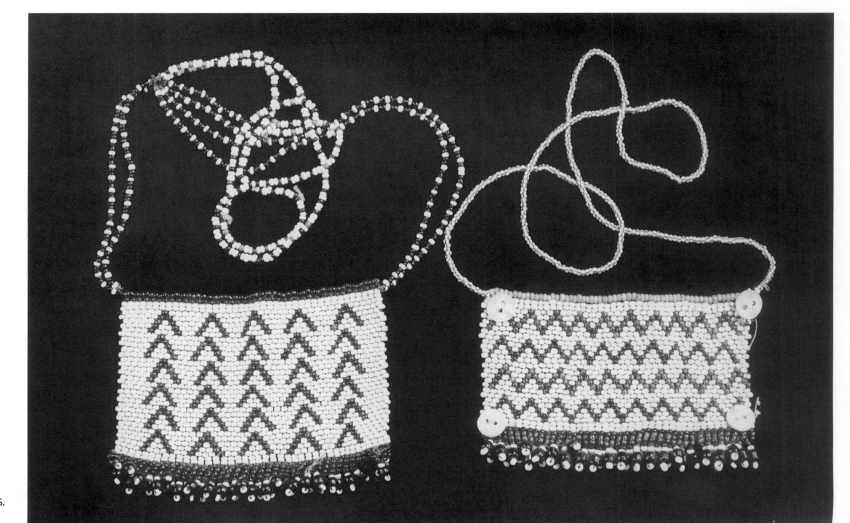

Right: **Xhosa beaded panels.**

Ben Hunter

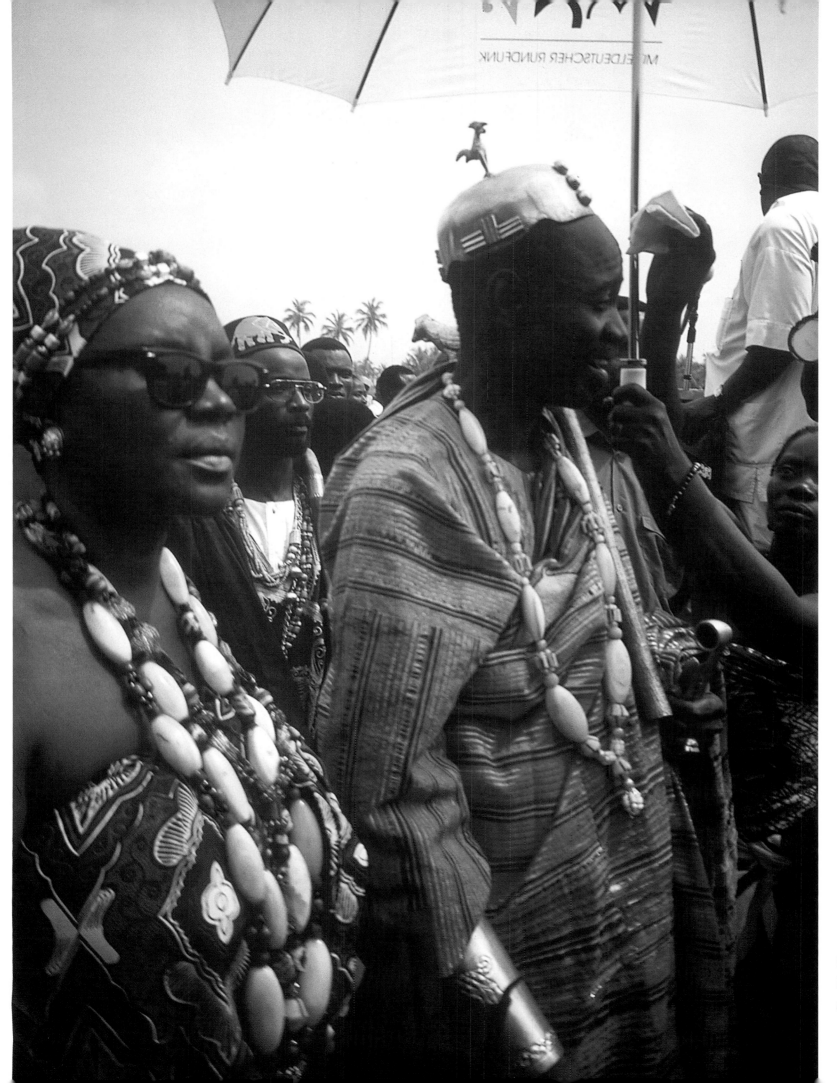

Left: An Ewe chief and
his wife, Togo, 1990's.

Ben Hunter

101

Above: A Zulu beaded apron dating from the second half of the twentieth century.

Ben Hunter

capital of the kingdom. All the coral beads of the king, his wives, and of the chiefs are gathered together on the palace altar of Oba Ewuare and refortified with the blood of a sacrificial cow, enhancing their mystical power for another year (Ben-Amos, 1995). At a later festival, *Emobo*, the king, in his full coral regalia, sits in a pavilion of red cloth, beating on an ivory gong. The threatening power of the red helps to drive away evil forces from the kingdom, while the white of the ivory signifies ritual purity.

While for Edo people red beads evoked the awesome and deadly power of the king, red beads could be a message of love for the Zulu in South Africa. One informant, quoted by J. W. Grossert, interpreted a shiny red-glass bead, called *umlilwane*, as recalling the bright red flames of the fire, giving it the meaning, "whenever I see you my heart leaps up in little flames."

Tourists in South Africa buy thousands of little beaded panels sold as "Zulu love letters." Although the color triad of red-black-white is not without significance for the Zulu, featuring in particular in rituals connected with diviners and spirit mediums called *sangoma*, Zulu beadwork draws on a wider range of colors within a complex set of conventional associations.

Beadwork is made by young women, often working in groups of age-mates, but is worn by children and adults of both sexes. In each area, there are widely accepted groups of color combinations and certain, quite specific, meanings associated with each color of bead, allowing messages that range from general greetings to quite intimate and detailed communications between lovers to be conveyed.

Glass beads have been imported into southeast Africa for much of the past two thousand years, with the Portuguese traders who entered the region bringing European beads in the sixteenth century displacing earlier Arab and Indian sources of the so-called "trade wind beads." Clothing was largely made from animal skins, with small quantities of glass beads used for ornamentation alongside locally made beads of materials such as shell, seeds, animal teeth and ivory. By at least the eighteenth century there were local preferences in terms of color and size of beads that were noted by traders and in advice to ships' captains and other travelers to the region. Little is known about the early uses of these beads, but by the first decades of the nineteenth century, when the Zulu empire was consolidating its power after the *mfecane* (Shaka's brutal campaign of conquest), beadwork costumes were documented by European visitors.

It is possible that there were common patterns throughout the newly established kingdom, bringing together the various clans, particularly as royal authority controlled the distribution of beads among the Zulu before mid-century. It has even been suggested that there were links between color choices and the

the Edo (as the people of Benin are known) with such previously scarce materials as brass and coral which were to become vital components of a complex system of court regalia and ritual. With a brief interruption following the British capture and looting of the city in 1897, Benin royal ritual has continued developing and evolving to this day, remaining an important part of the life of the Edo people.

Each year, the king, and his palace, and town chiefs enact a series of rituals, the successful completion of which is still seen as vital for the prosperity of the city. Red, white, and black remain the key colors deployed, both in these royal rituals and in the still flourishing shrines of non-royal religious cults. Red beads, in particular coral beads, are a central metaphor of royal power, representing the dangerous, and potentially deadly heat of the divine king. Coral beads, according to Benin legend, were first bought to the kingdom by the twelfth king of the present dynasty, Oba Ewuare, in the mid to late fifteenth century. He is said to have obtained them from the palace of Olokun, the god of the sea who, in Benin mythology, mirrors the Oba himself in his role as ruler of the land. Only the Oba wears a complete outfit of coral beads, including a beaded crown and waistcoat, and in the past anyone who wore coral beads without royal permission could be punished with death.

One of the major annual festivals is *Ugie Ivie*, the bead festival, which commemorates a conflict between the sixteenth-century ruler Oba Esigie and his brother for ownership of a royal coral bead, which conveyed the right to proclaim the

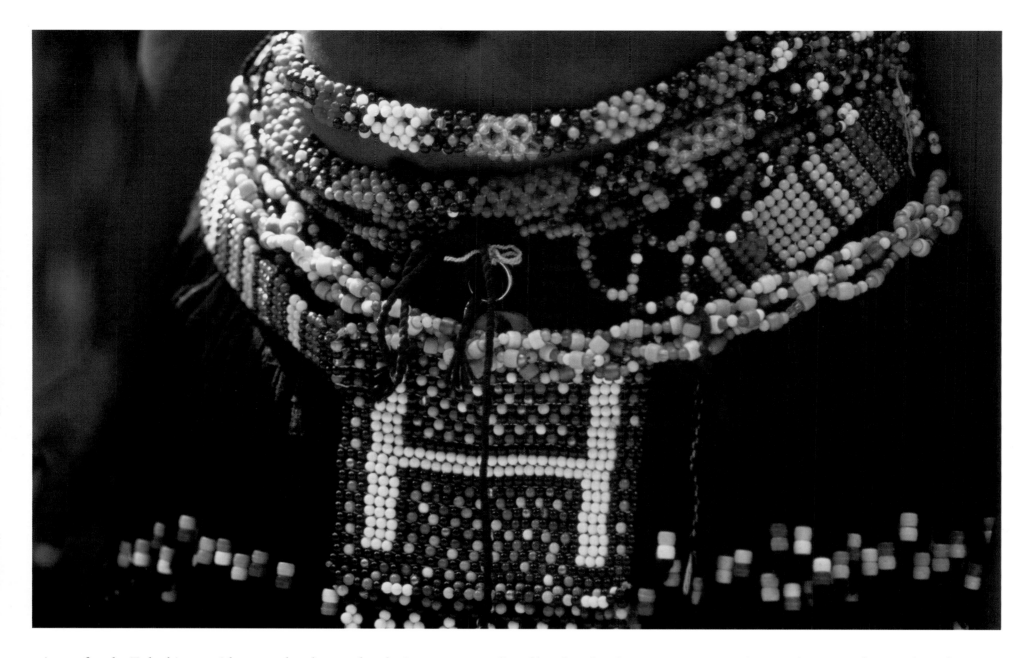

reigns of early Zulu kings, with green beads popular during the reign of Dingane, and a switch to blue, red, and white in the time of his successor Mpande.

By the twentieth century, however, the supply of relatively cheap imported beads had vastly increased, stimulating a sophisticated new esthetic in which each clan developed their own favored combinations of color and pattern expressed in the creation of a huge range of beaded attire. Between about 1940 and 1980, depending on the remoteness of the region, these designs were, in turn. modified by the spreading fashion for what were regarded as "modern" colors and color combinations, and the introduction of plastic beads.

Very little is known about the meanings and associations of nineteenth-century Zulu beadwork, since the ideas and opinions of its creators were of little interest to the museums and missionary collectors of the period. It seems probable though that aspects of older color associations were extended into the

new media of beadwork. The Cape Nguni preference for red beads, for example, has been linked to their use of red ocher as a body cosmetic. It is, however, clear that, while designs changed in the early decades of the twentieth century, quite complex ideas about beads and their meaning must already have been in place.

Although beadwork can be worn by small children and by elderly people, in general it is after the completion of puberty ceremonies at about age fourteen that interest in wearing beads becomes most intense and continues into young adulthood. The reason for this is that the vast majority of Zulu beadwork items are primarily associated with courtship and relations between the sexes.

Large quantities of beadwork are rarely part of everyday dress, which today is mostly European attire, but they are worn for any kind of ceremonial or religious occasion. A huge range of named beaded garments may be worn on the head, neck,

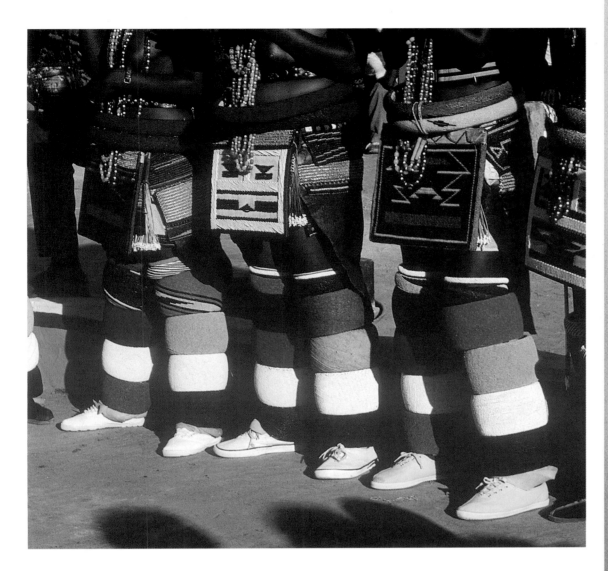

Above: Young Ndebele women wearing beaded leg and waist bands, with beaded aprons, at ceremonies to mark their coming of age.

Struik Image Library

Right: Ndebele married women wearing blankets, beaded aprons, and leg bands.

© *Massimo Falloni/Swift Imagery*

chest, back, waist, arms and legs, most taking the form of threaded bands or panels of beads, some of which are sewn on to a backing of cloth or leather.

Among the more significant of these is the *ucu*, which in its standard form, was a single string of white beads about ten feet in length, worn looped several times around the neck until a single loop hung at the chest. Small beaded loops are attached to it so they can slide up and down. In this form it can be regarded as an engagement ring, since it was given by a young woman to her betrothed on the day that she accepted his proposal, and according to H. S. Schoeman, worn only on that day. Once at least some of the cattle that make up the *lobolo*, or bridal gift, had been given to the woman's father, the single string *ucu* would be doubled over and twisted together, with the intertwining bead strands signifying the joining of the lovers in marriage. Both the man and the woman would wear an identical *ucu* during the betrothal period.

Usually the beaded loops were of blue and white, conveying a standard expression of marital fidelity, but Schoeman documented one with opaque red, yellow, black, and blue loops which was interpreted for him as follows. The opaque red

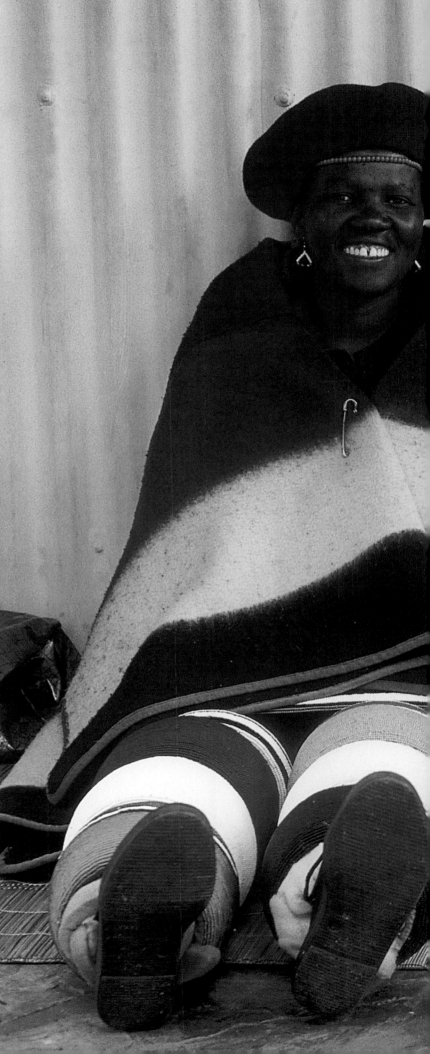

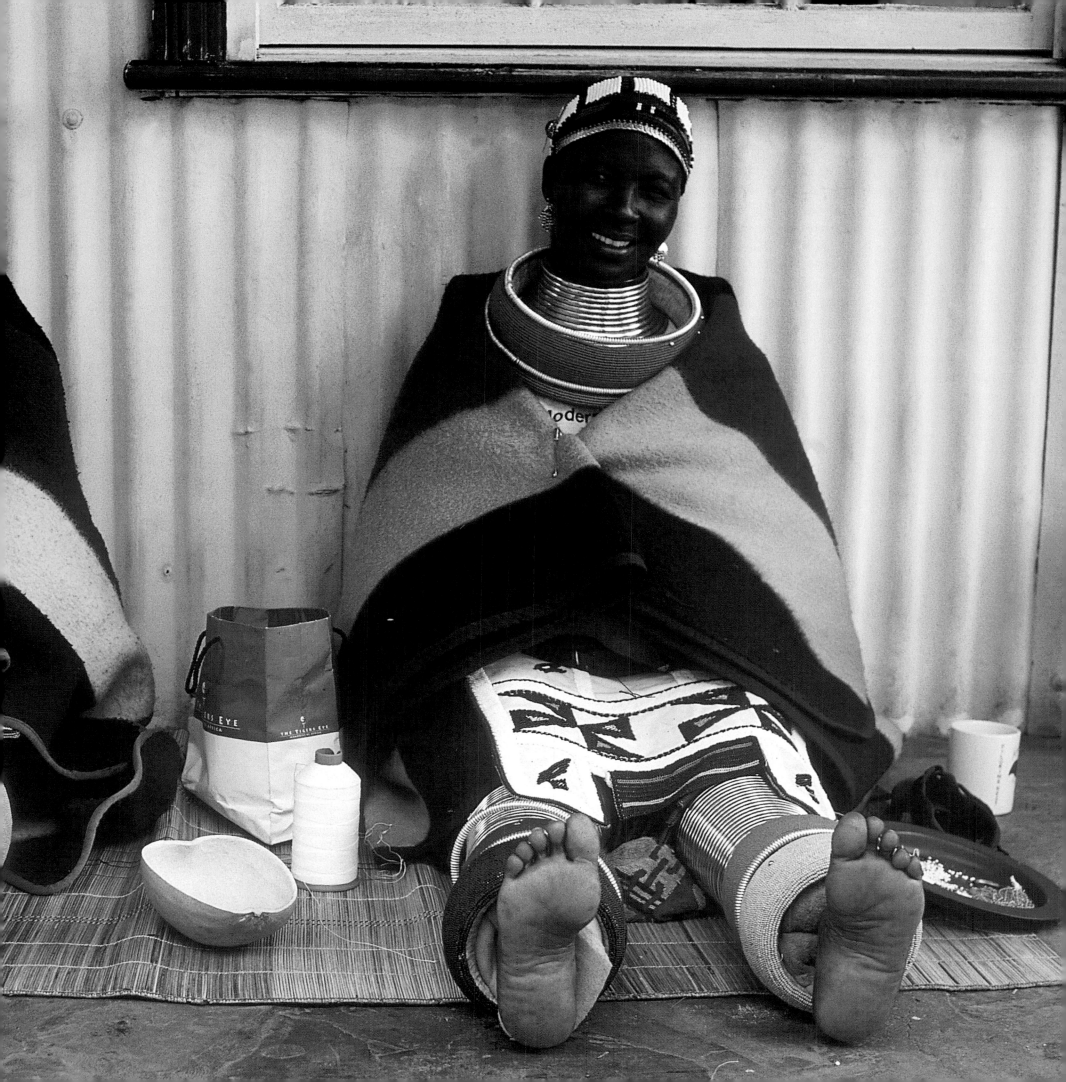

indicated an angry heart, meaning, according to the wearer, "I am displeased, for the progress of my marriage is being questioned;" yellow, "I am wilting away because of your continued absence;" black referred to the black leather skirt of a married woman, which the wearer hoped she would soon put on; and blue indicated, "this is my request, please reply." As this example indicates, an apparently straightforward and simple beaded necklace could convey a quite specific message that would be understood both by the recipient and his family and age mates. The way this was done was through the interplay of colors, patterns, and local design conventions.

The Zulu are divided into numerous, often quite small clans, each of which had its own favored color combinations and conventions, although similar or identical sets could be found in other groups, and not all beadwork made within a clan had to conform to its established conventions. These could change over time due to factors such as fashion and shifts in the cost and availability of certain colors of bead. Often these color combinations were named.

According to Frank Jolles, the leading authority on Zulu beadwork, in the Msinga area there were four named types of color combination in use before the spread of "modern" fashions in the 1960s. *Isishunka* had seven colors—white, light blue, dark green, pale yellow, pink, red, and black. *Isithembu* was five colors—light blue, grass green, bright yellow, red, and black. *Umsanzi* had four colors—white, dark blue, grass green, and red, while the name *isinyolovane* was applied to any other combination.

Among the Mkhwanazi clan, Schoeman found only two conventions. The first combined green, blue, black, and white, while the second consisted of red, yellow, blue, black, and white. Enough of these colors needed to be present for the intended convention to be recognized, but some could be omited and other colors substituted, if desired. Messages could be conveyed by means of these modifications, since substituting a different color for the one expected, or leaving out a conventional color altogether, served to draw that change to the attention of an informed viewer instantly.

Even a piece of beadwork that contained all the expected colors could have perhaps one or two different colored beads in a plain area. In general, the more variation from the normal color set, the more specific, and therefore personal, the message it could convey to the recipient. In apartheid South Africa, Zulu men were often obliged to work many hundreds of miles from home as migrant laborers in the mines and factories, and only permitted to visit their girlfriend and family perhaps once

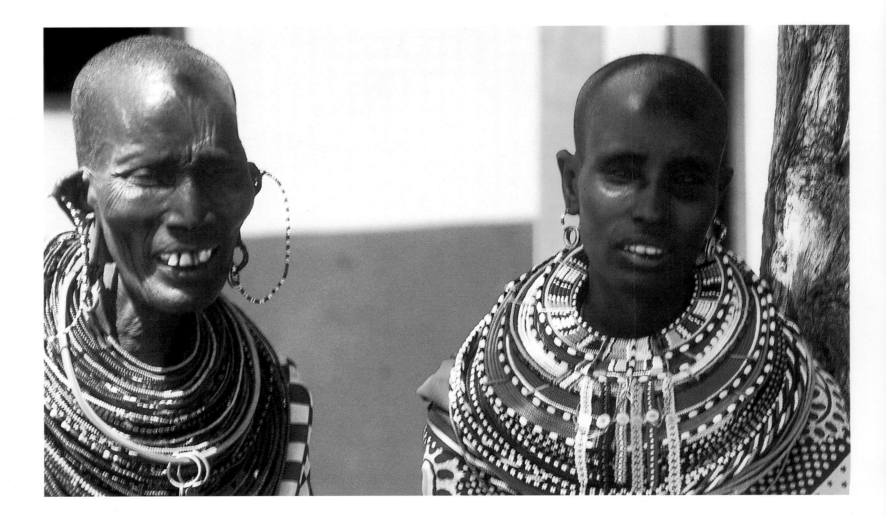

Right: Elderly Samburu women still wear their beadwork regalia on special occasions.

Ben Hunter

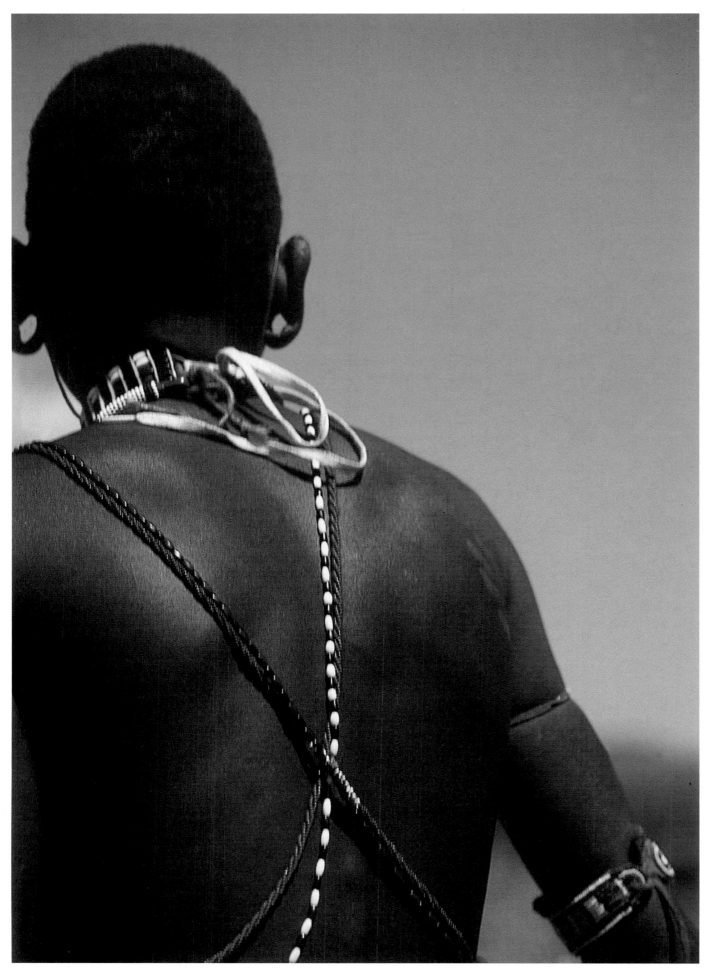

Left: **Sumburu beadwork.**

Ben Hunter

107

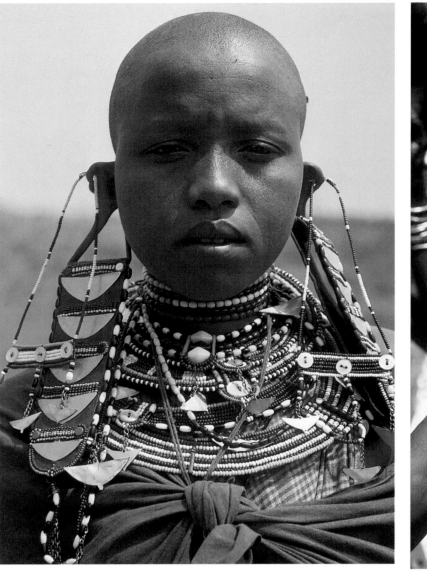

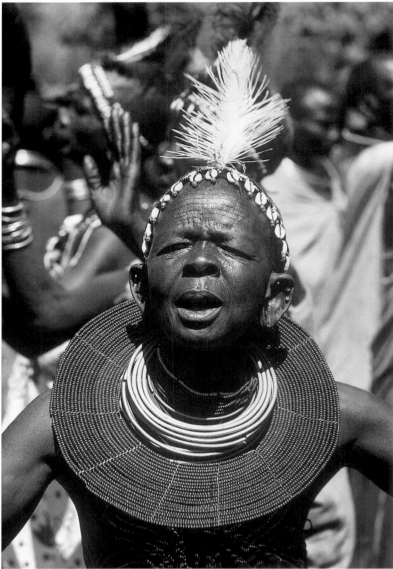

a year. Beadwork messages sent back with other workers returning from leave took on new saliency as young women used them to communicate in these difficult circumstances.

The interplay of the color conventions and the expectations they established provided what could be seen as a locally understood grammar of bead communication, within which the ideas associated with the colors themselves provided a limited, but expressive vocabulary. These associated ideas were undoubtedly influenced by a far older Zulu cosmology in which the familiar red-black-white triad played a part, but more specific, and perhaps locally variable nuances of meaning came to be linked with beadwork colors.

Schoeman's findings for beadwork of the Mkhwanazi are typical. White beads, which were sometimes called bones, could indicate purity, love, goodness, good luck, happiness, or children. Black beads could have the positive meaning of marriage because of their association with the black color of a married woman's leather skirt, but could also mean darkness, disappointment, or sorrow. Royal blue beads could mean

fidelity, ill-feeling, or a request. Medium green beads could convey contentment, domestic joy, discord, or sickness. Red beads could mean love or any strong emotion: a burning heart, intense longing, impatience, anger, or heartache. Yellow beads could mean wealth, a garden, domestic industry, thirst, withering away, or badness. Since in Zulu society wealth was measured in ownership of cattle, a number of yellow beads could be used to refer to a number of cattle in a bridal payment.

Clearly a single color of bead could not convey a clear message by itself, since, with the exception of white, each color has a number of different, and often contradictory, connotations. Messages were expressed through the interaction of colors, and the context, supplied both by other colors and the color conventions familiar to the sender and recipient, and, perhaps equally importantly, by the wider context of the relationship between them. Departures from the expected conventions of the area were a recognized means of drawing attention to a color, or colors, and of indicating that a specific message was being conveyed.

With the spread of new beadwork fashions, called *isimodeni*, or modern style, since the 1950s, many of the nuances of meaning that could be indicated within the older conventions were lost. Plastic beads in a broader color range became widely used, and new combinations, beaded writing, and other novelties were introduced, with new fashions coming into—and disappearing from—vogue on a regular basis. Despite these changes, however, beadwork remains central to Zulu ceremonial dress, with a tradition that has provided one of the most sophisticated elaborations of ideas about color in Africa continuing to adapt and evolve.

It should be stressed that beadwork is primarily the regalia with which Zulu men and women adorn themselves, as part of an esthetic of dress in which they present themselves as both beautiful and correctly dressed on occasions of ceremonial importance. The fact that beadwork is made by young women and presented by them to young men they admire or hope to marry by itself conveys meaning to the giver, and recipient, and to the wider society. A man might wear these gifts himself, or lend them to his sister to wear, implicitly acknowledging in public his relationship with the giver, while a refusal to wear them would also convey a clear meaning.

Not all beaded articles are coded texts which can be deciphered to reveal meanings beyond this, although some of them are. In these messages not all colors are significant, the placing of colored beads in relation to conventions may indicate those which are simply completing the design as opposed to those which are also conveying private information.

To an informed observer familiar with the color conventions of various areas, the beadwork might also convey information about the clan identity of the wearer, but this is unlikely to have formed part of an intended communication by the beadwork. Aside from the colors, the set of beaded garments worn may themselves convey information about the marital status of the wearer. Even the act of wearing a ceremonial "traditional" costume in a particular context may convey meaning, as occured with the political rallies of Zulu people staged by the pro-government Inkatha Freedom Party and the then opposition ANC as the apartheid era drew to a close. Earlier, Nelson Mandela had demonstrated the political significance of indigenous attire when he appeared in a full set of the blankets and beadwork of his Xhosa people on the day he was to be sentenced to life imprisonment at the end of his treason trial.

The beadwork of the Cape Nguni peoples, such as the Xhosa, developed along similar lines to that of the Zulu, with an early period in which limited supplies of beads were available followed by an expansion of their use in the nineteenth and twentieth century. At first, it seems, red beads were worn by chiefs, with white often ornamented with black designs

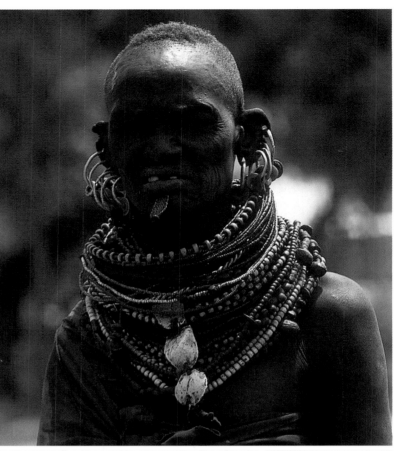

Left: **An elderly Turkana woman wearing a labret or lip plug.**

Ben Hunter

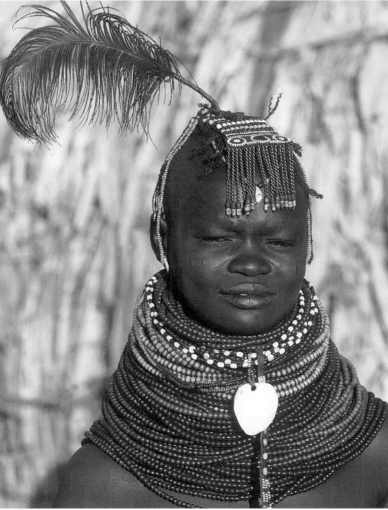

Left: **A married Turkana woman wearing neck and hair beads and an ostrich feather.**

© *David Keith Jones/Images of Africa*

Photobank

109

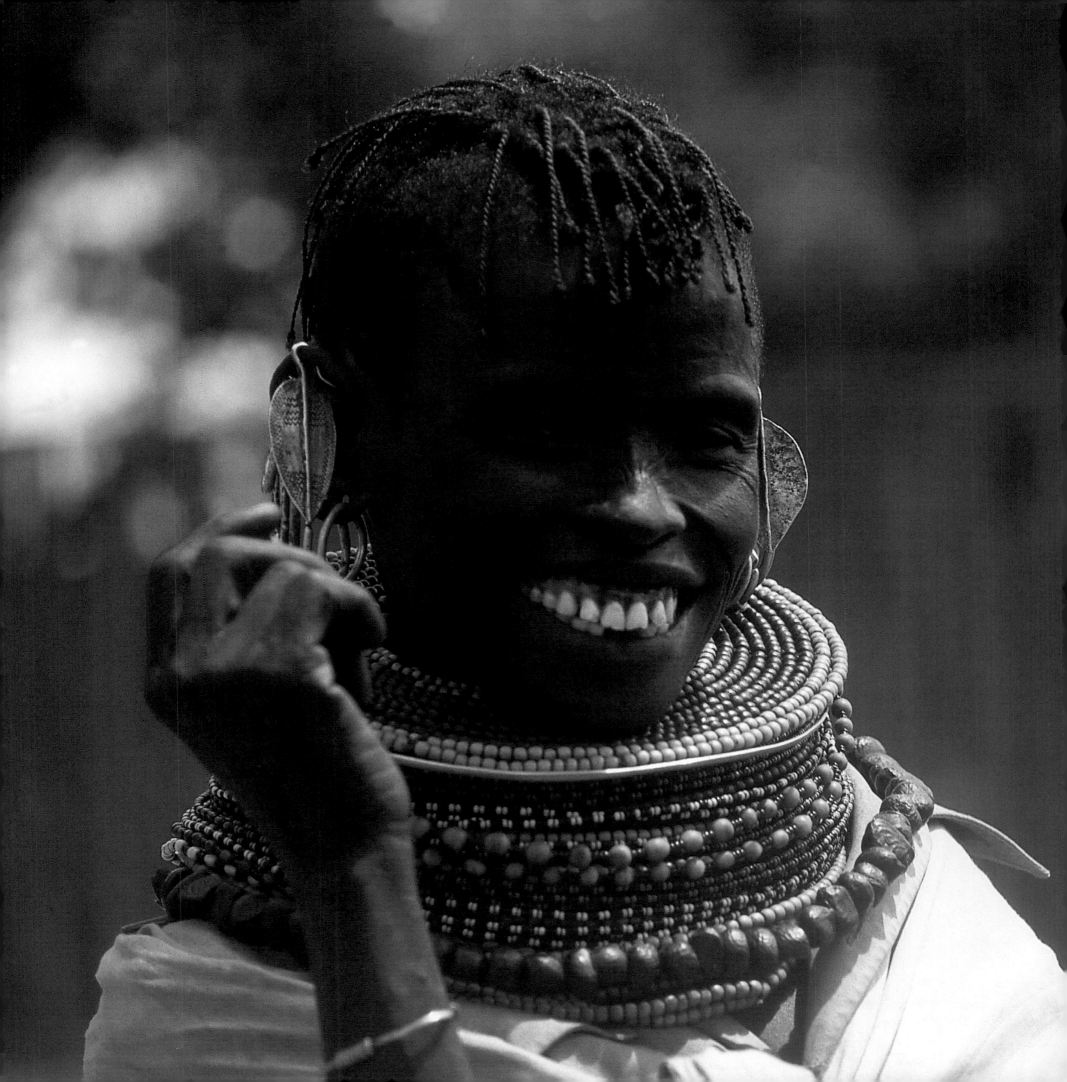

linked to healers. By the twentieth century, distinctive color preferences could be observed among the different Cape Nguni peoples, with the Thembu favoring dark turquoise beads, often in combination with white and pink; the Mpondo and Mpondomise preferring white and sky blue, etc. Stylized human figures in rows on a white ground were a popular motif among the Xhosa and others.

Although much more research is needed on the beadwork of these peoples, it would appear that they lacked the more complex communicative aspect found among the Zulu. There were similar love-tokens sent by women to migrant workers, in the form of beaded panels on necklets but it was the items themselves, rather than any color coding that conveyed a simple message of affection. One of a set of beaded headbands was in the shape of a miniature woman's apron worn under her skirt, while a second was called "to sleep with him." One source explained these references by noting that most beadwork was actually made for youths and adult men by their girlfriends or mistresses, not their wives.

When young men are initiated prior to marriage they take off all their bright-colored beadwork, replacing it as adults with a gradually accumulated second set in more subdued colors, although in terms of sheer quantity, an older married man may wear the most beads of all.

As among the Zulu, long-established color preferences have been displaced over recent decades by an influx of cheap plastic beads in a wider range of colors, with the most fashionable and bright combinations being favored by young migrant workers and unmarried women.

Ndebele beadwork draws on different esthetic preferences again to provide a medium for women's creativity focused on marking life-cycle stages and, like their mural art, expressing concerns with aspects of ethnic identity. Although some Ndebele beadwork in museum collections dates from the second half of the nineteenth century, there is very little data or photographic documentation from before the 1930s. The earliest photographs to show beadwork were taken among the Manala Ndebele near Pretoria, leading some accounts to suggest that they may have originated the tradition as a result of their greater proximity to the nineteenth century trade routes along which European beads were supplied. However, the origin myths and oral recollections of both the Manala and the better-known Ndzundza Ndebele indicate that bead working, perhaps with indigenous shell beads, or earlier imports was a long standing tradition. In any event, although both groups still practice beadwork, it seems to have been among the Ndzundza that it was most important in the twentieth century.

The reason for this difference may lie in the history of the two clans. While the Manala were not directly attacked and

Left: A Turkana married woman.

Ben Hunter

111

were integrated relatively peacefully into the colonial system, the Ndzundza were defeated in battle by the Boers in 1883 and forcibly resettled as virtual slave laborers on white farms. This dramatic collapse in Ndzundza power may have stimulated the need to refocus on cultural institutions such as the initiation of young men and women as a limited area in which a sense of group identity could be rebuilt and expressed. The earliest stages of Ndebele mural art could also have arisen out of a need to re-establish a sense of control over domestic space at this period, although, as with the beadwork, it is likely that this, too, was drawn in part from more limited earlier traditions.

It is clearly significant that both beadwork and house decoration were female arts likely to have been dismissed as of no importance by the white farm owners of the period if they were noticed at all. Beadwork, like the distinctive murals, could have served, both for the Ndzundza Ndebele themselves and for outsiders, as a means of asserting an identity under continued threat.

In support of this theory of a close link between the two forms, it is worth noting that the main stylistic change in Ndebele beadwork in the mid twentieth century seems to have coincided with the flourishing of mural art in the 1940s and 1950s. Early Ndebele beadwork, dating to the late nineteenth century and the first few decades of the twentieth, was predominantly white, with small design motifs worked in a limited palette of colors, usually red, green, blue, and orange. It is not clear whether the choice of white backgrounds was due to these being the most plentiful and cheapest bead supplied by the early traders or, more interestingly, if it was related to older ideas about white as a marker of transitions.

As with the murals, the other colors do not seem to have had any particular meaning or symbolism beyond general associations. From about the 1940s, the colored motifs became larger, with recognizable images drawing on the material aspirations of the women, such as houses, car number plates, telephone poles, light fittings, boats, and planes. Similar designs were noticeable in the mural art of the women at the "Ndebele Village" of Kwa Msiza at the same period. A further change occurred in the 1960s, with the range of colors used shifting to shades of dark green, blue, purple, and black. In the 1970s, there was a fashion for reproducing the designs of beaded aprons in a simplified form using colored electrical tape, but this does not seem to have lasted, as fully beaded regalia is still being made today.

Unlike the other South African peoples we have been discussing, Ndebele men do not usually wear beadwork. The main exception to this is that young men wear beadwork crossbands, necklaces etc. when they return to their village after the conclusion of the period in an initiation camp that marks their transition to adulthood. On the same occasion, the mothers of the initiates wear long, narrow beaded bands, called *linga koba* or "long tears," which are attached to a headband and trail down to the ground at their feet.

For Ndebele women, a series of beadwork garments accompanies their progression through life. Young girls and boys wear a *ligabi*, a small beaded panel with a tasseled fringe that serves as a pubic apron. Puberty is marked by a period of seclusion, called *iqhude*, where the young women are taught the responsibilities of adulthood and aspects of Ndebele culture including beadwork and mural painting. For the coming-out ceremony at the end of this period, they will put on stiff rectangular beaded front aprons called *isiphephetu*, as well as numerous thick beaded bands around their waist, legs, and neck. These bands, called *isigolwani*, are made by stringing beads around a thick pad of grass, and are said to mimic the rolls of fat appreciated in a prosperous adult woman. At her wedding ceremony, a Ndebele bride may be wrapped in a red blanket, to which she will later add rows of beadwork each year of her marriage. She may also wear a bead veil over her face, and a long beaded train (*inyoga*) up to five feet in length. Her maiden's apron will be exchanged for a bridal apron, *liphotu*, with two side flaps and a tasseled fringe at the center, said by some accounts to represent the expected children between the two partners in the marriage. Once she has borne children, she will be entitled to wear the five-paneled *ijogolo* apron. Married women also wear metal neck, arm, and leg rings in addition to the beaded *isigolwani* of the unmarried sisters. The successful culmination of the marriage, represented by the initiation of her eldest son into adulthood, is marked by the *linga koba* or "long tears."

It is clear that although the Ndebele, Cape Nguni, and Zulu are culturally and linguistically related peoples, living in the same nation-state, in broadly similar economic and social circumstances, they appear to have developed their shared esthetic of beadwork body decoration in different directions, taking in both different color ranges and, it would appear, very different ideas about the communicative possibilities of colors. The suggestion that these differences are, at least in part, due to the women artists' responses to the different historical experiences of the various groups in the dramatic changes of the nineteenth and twentieth centuries is an attractive one, but still requires further research, both into the role of beadwork in each group, and into the extent and nature of interactions between them.

As we return to the pastoral peoples of East Africa and their neighbors for the concluding part of this chapter we will see that there, also, a shared esthetic that focuses on beadwork body adornment interacts with considerable ethnic variation

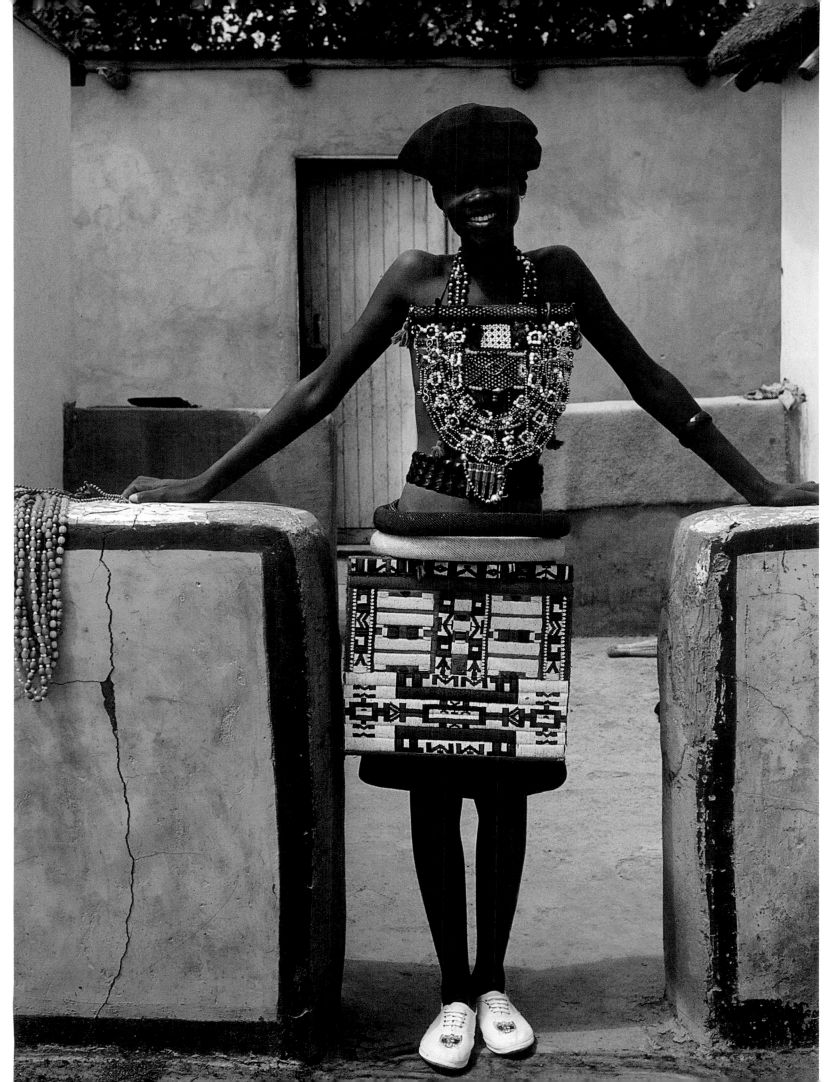

Left: Young Ndebele woman displays a beaded apron and necklaces.

Struik

113

familiar triad of basic colors, red, white, and black, becoming elaborated early in the twentieth century as a wider range of colored beads became available. In some cases, a particular color became primarily identified with the beadwork of one group, so that Kikuyu work can be distinguished by the prominent use of pink, and that of the Kipsigis or Nandi by the use of turquoise. No one individual color indicates Maasai beadwork in this way, however. Instead, like the Zulu, they have a number of favored color sets, based, in this case, on juxtaposing contrasting and complementary color pairs.

The first and most important of these sets is the original red-white-black triad of basic colors, which is named *narok* and refers to the black aspect of God, Enkai Narok. The second set divides the end colors of the red-white-black triad into complementary pairs to give red-green-white-orange-blue, creating the first of two sets called "beautiful colors." The third, making the second set of "beautiful colors" is yellow-red-white-black-orange, while the final set, red-yellow-black is a recent adaptation of the colors of the Kenyan national flag. Colors from one of these sets, used in the correct order, determine the placing of beads on a particular article. However, the field of color should be broken up, or "cut," by lines of beads in another color, apparently because Maasai regard a continuous color field, like other unbroken activity, as a characteristic of God alone. Colors should also balance light and dark, with ideas about the appropriate balance probably being related, according to Klumpp and Kratz, to the patterns on cattle coats. Each set of colors is itself regarded as "black" or "white," and in placing ornaments on the body, Maasai women aim for a symmetrical alternation of items from black or white sets.

If a woman wears a red-white-black bangle on one wrist, for instance, she must wear a green-red-white-blue-orange bangle on the other. Then there is the correlation between beadwork items and the male and female life-cycle, with the repertoire of ornaments worn by an uninitiated girl differing from that of a young married woman, and further additions and changes taking place after childbearing and at certain stages in the life of a woman's husband or sons. A certain type of beaded earring, for example, may be worn only when her eldest son is married.

By correctly demonstrating her mastery of these complex rules, the nuances of which vary between different Maasai clans, a woman not only shows that she understands Maasai beadwork, but implicitly that she appreciates the superiority, as they see it, of Maasai culture and the pastoral lifestyle it upholds. Not surprisingly, when women from other groups, such as the Okiek, make and wear beadwork they regard as Maasai, they generally fail to follow Maasai conventions in their full complexity, resulting in what, from a Maasai perspec-

in details such as the colors, designs, and appropriate uses of the beadwork. Unlike in South Africa, here we do have some clue as to the complex interactions that underlie the present situation, thanks to recent detailed research by the American anthropologists Donna Klumpp and Corinne Kratz.

Focusing on the relationship between the beadwork of the Maasai and that of the Okiek, a group of hunting and hunter-gatherer people influenced by Maasai dress and beadwork styles over many years, they found that apparently close similarities masked key differences and were a revealing indicator both of aspects of Maasai beadwork esthetics and of attitudes toward them in the two groups. Beadwork provides a medium for female input into issues such as ethnic identity and shifting patterns of clan interaction previously analyzed in terms of male behavior and transactions in cattle and women.

Color, and the use of color in appropriate combinations, turns out to be a key indicator of identity as Maasai. The use of color by all Kenyan peoples seems to have its origins in the

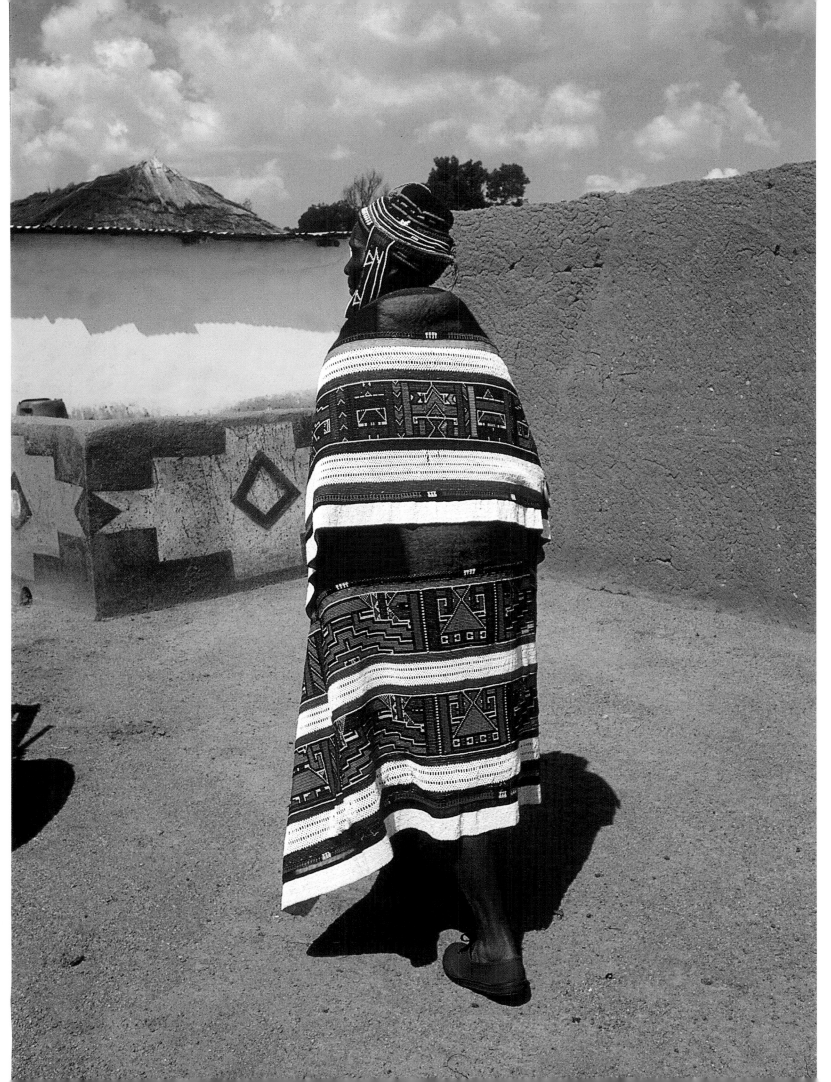

Left: Married Ndebele women wear capes made from elaborate beadwork sewn onto imported blankets.

Struik

tive, are minor but crucial mistakes. The arrangement of colors on a bracelet may be subtly "wrong" to a Maasai viewer, or the way it is balanced by another piece, or even the combination of beadwork items put together "inappropriately," although to the Okiek they may be both beautiful and like the Maasai. Yet this interplay of similarity and difference reflects and responds to the fluidity of ethnic identities in the region.

Okiek and others can "become Maasai," whether by intermarriage, or by blending into a general Maa-speaking group in an urban context, while Maasai themselves are increasingly being forced to abandon the pastoral way of life they regard as the defining characteristic of Maasai identity.

Other pastoral groups appear to have their own preferences in terms of bead color and combination within a broadly similar aesthetic, although insufficient research has been carried out to establish whether there are equally complex design programs at work. Black, yellow, and red beads are often predominant in the beadwork of the Pokot, while Turkana favor dark blue, red, white, and yellow in bold contrasts. Young Turkana women wear skirts and capes of goat skin which they decorate with rectilinear patterns of ostrich eggshell and red, white, and blue glass beads. Strings of black beads are tied round the neck, wrist, or ankle of infants to protect them against illness and evil spirits. The Turkana, according to Nigel Pavitt, attribute magico-medicinal properties to the colors of their beads, with red beads warding of the spirits of the recently deceased, orange helping them to commune with the ancestors and protecting warriors against injury, blue associated with fertility, and white with the color of animals sacrificed to mark peace treaties. Turkana also use blue beads in medical procedures, wearing two blue beads on a giraffe's tail hair as a cure for nosebleeds, and burying an extracted tooth with two blue beads.

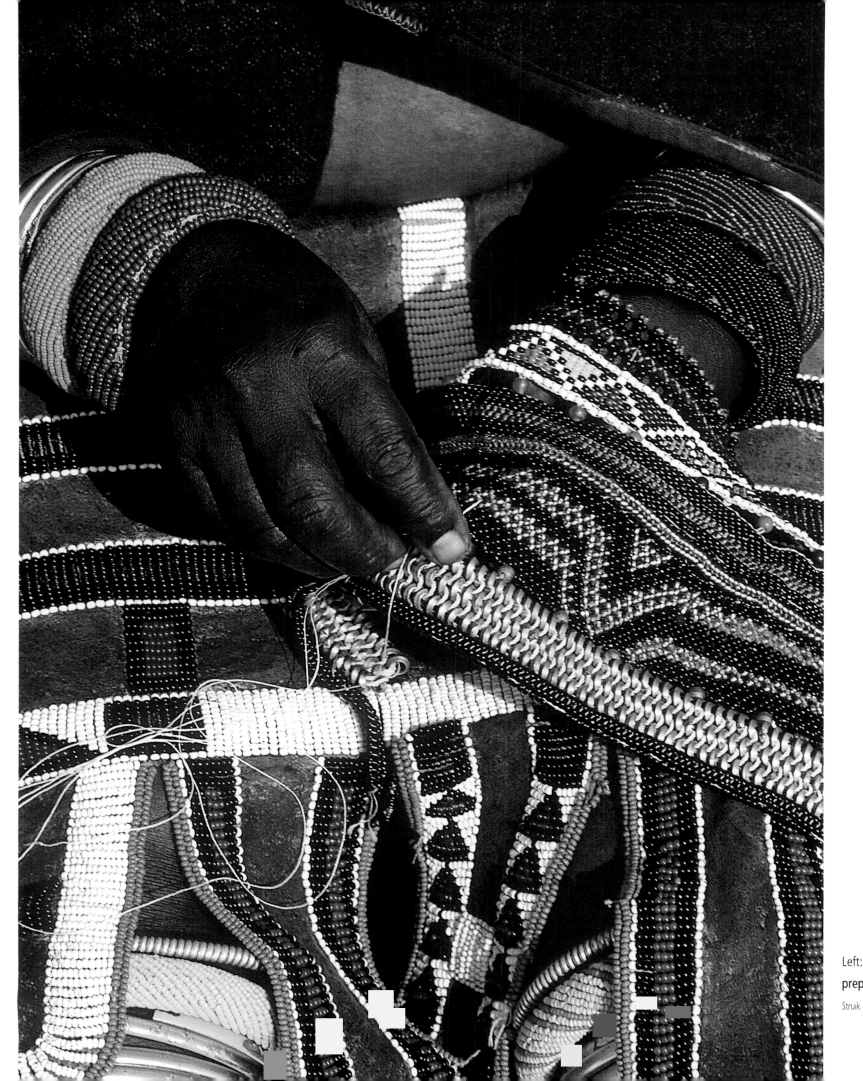

Left: A Ndebele woman
prepares a beaded belt.

Struik

DRESSING IN COLORS

Textiles and Clothing

Like beadwork, textiles and dress provided a medium through which a wide range of ideas about status and identity were created and displayed throughout Africa. Not surprisingly, color and concepts of color meaning were often an important aspect of these dress traditions. However, as we focus on color throughout this chapter, we should not forget that it is one dimension of textile use among others that may include materials, textures, ornamentation, way of wearing, origin (local or imported), to name just a few. Moreover, we should note, as was the case with beads, that not all uses of color are intended to be significant. Sometimes a color is just a color. The fact of wearing a cloth at all may be what is important, or only a limited range may be available because of trading conditions or the limitations of local dyes. Or, as is often the case with Yoruba ceremonial cloth today, the fact that a color is recognized as novel, and therefore fashionable, may be important without any particular meaning attaching to the color itself. Nevertheless, color and ideas about color meaning have had, and continue to have, an important role in textile traditions in many areas of Africa.

In many areas, aspects of the familiar basic color triad of black-red-white can be traced. For centuries, the deep blue-black of indigo was the predominant color of dress across much of West Africa. The Tuareg nomads of Mali and Niger were known to European travelers as "Blue Men," after their characteristic flowing indigo gowns and turbans. The excess indigo dye beaten into their cloths rubbed off to leave a blue sheen on the skin which the Tuareg believed had protective and medicinal qualities.

Mud from iron-rich lakes was used by the Bamana in Mali to create negative-patterned *bogolan* cloth in shades from red to black which, when worn by hunters and young women undergoing circumcision, protected the wearer from the release of dangerous mystic energies. White cloth too, although sometimes mundane, was often a potent symbol of spiritual forces. In most areas, however, multicolored imported fabrics

and fibers provide a huge range of colors. Where local weaving and dyeing remain important, as they do in much of West Africa, these imports have been incorporated into, and transformed by, indigenous esthetic systems. However, even among some of the best known and most flamboyant of contemporary weaving traditions, such as Yoruba *aso oke* and Asante *kente*, we can see remnants of what may well be older ideas about color meaning.

Our knowledge of the history of textiles in Africa remains extremely limited. Climatic and soil conditions in most areas do not favor the preservation of textiles, and in any case, with the exception of the Nile valley, archeological research has been sporadic. For sub-Saharan Africa written evidence is available only from isolated remarks in the second-hand accounts of a few scholars, such as Herodotus in European antiquity, from the chronicles of Arab travelers over the last millennium, and from the occasional European visitor since the fifteenth-century Portuguese exploration of the African coastline.

Spindle whorls and other evidence of weaving have been found at Meroë in the Sudan. Two of the oldest known textiles from Africa are a red, green, and blue tunic and a shawl, both embroidered with what appear to be small, stylized human figures, that were excavated recently at a burial site in the Republic of Niger. These cloths, dated to the eighth century C. E. were found in a region criss-crossed by long-distance trade routes and may perhaps be a pointer to the importance of trade in the later history of African textiles.

Small fragments of woven raffia or grass fiber dated to the ninth century C. E. were found with a treasury of cast brass objects in what appears to have been a royal burial at Igbo Ukwu in southeastern Nigeria. Larger quantities of fragments of what seem to be both locally made and imported cloths dating back to the eleventh century have been recovered from burial caves along the Bandiagara cliffs currently inhabited by Dogon people in Mali. If these discoveries tell us little about

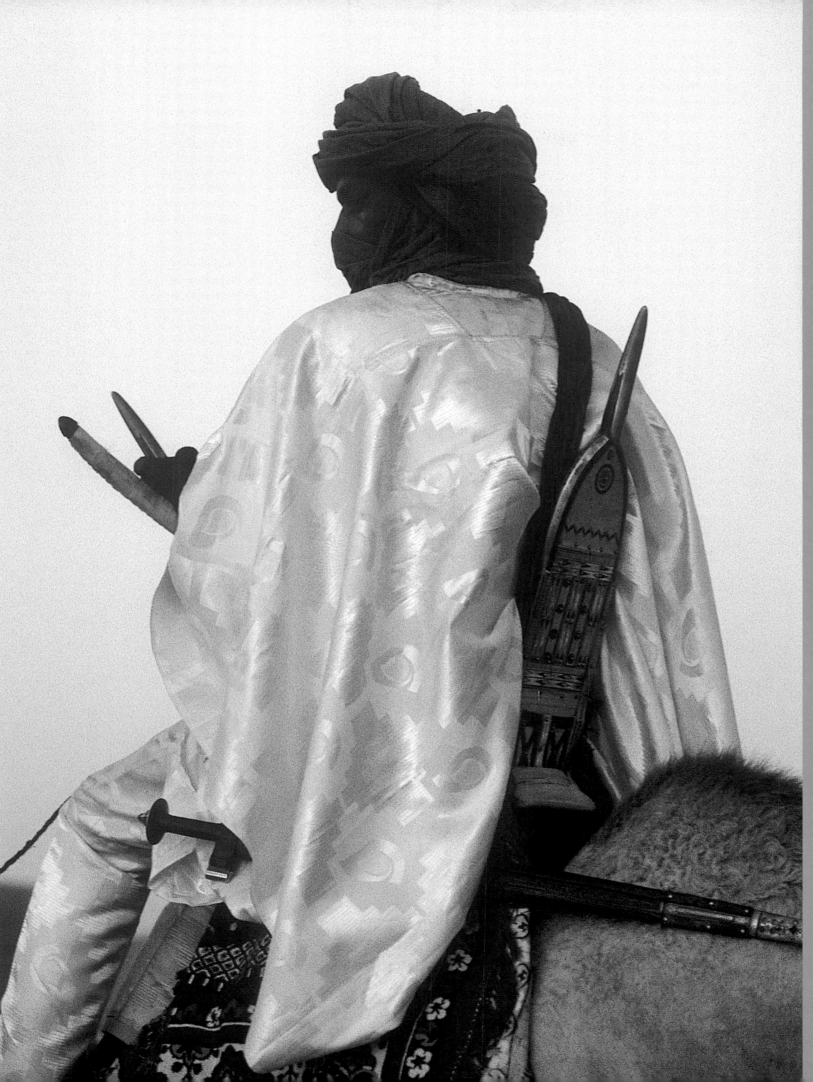

Left: Imported fabrics such as this brocade outfit worn by a Tuareg man have replaced locally woven cloth in many areas.

Ben Hunter

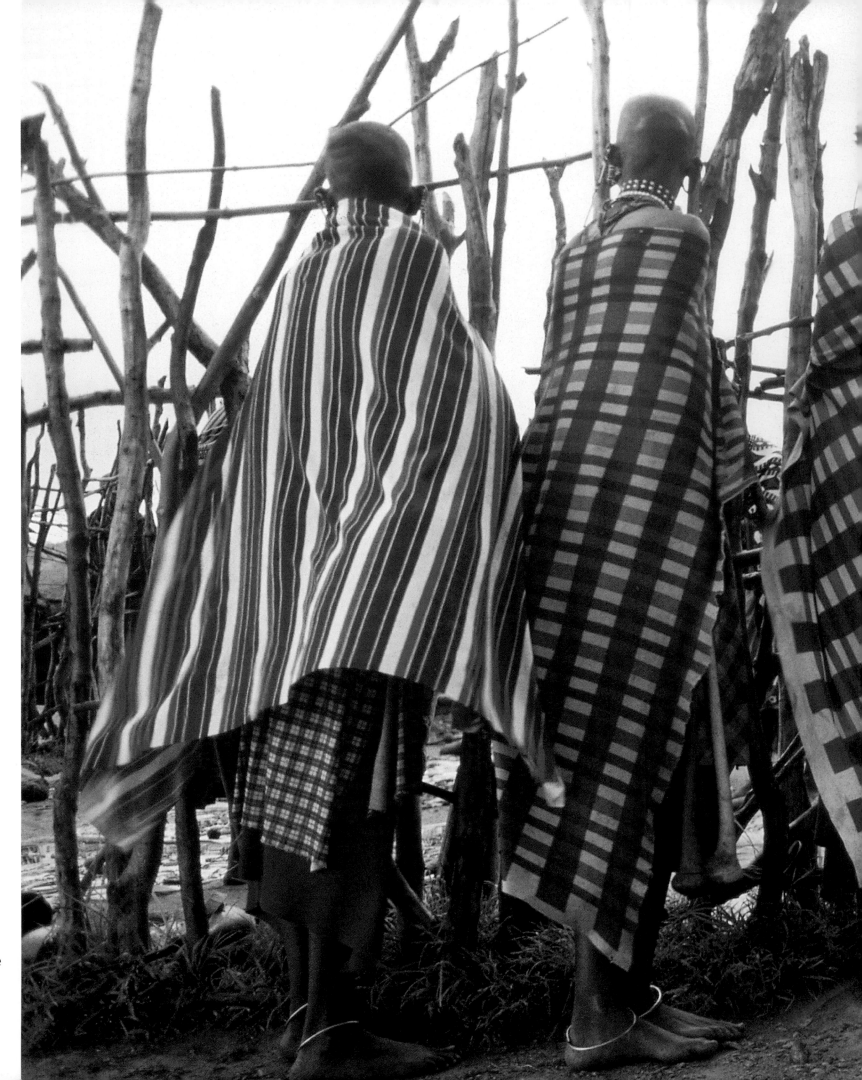

Right: The Maasai are one of the few African peoples who have carried over a preference for red and white into contemporary dress.

© Massimo Falloni/Swift Imagery

120

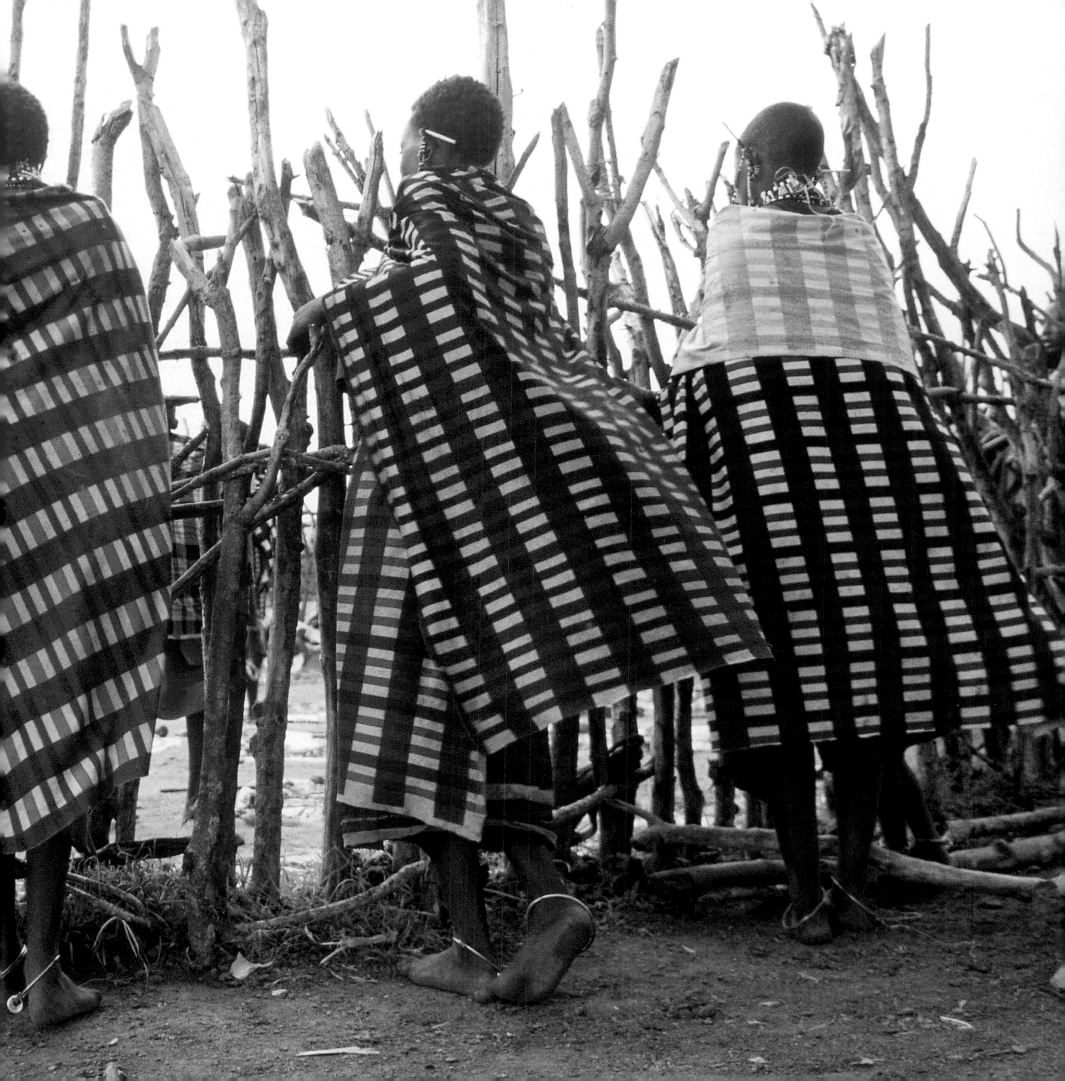

the role of cloth, one of the earliest eyewitness accounts made it clear that clothing was already in use as an important marker of rank.

Writing in the eleventh century, the Arab traveler al-Bakri noted that in the court of the ancient empire of Ghana (which ruled large areas of present-day Mali and Mauritania from around the sixth century) only the king and his heirs were permitted to wear tailored garments, while nobles were restricted to loose robes of cotton or (imported) silk, and court slaves were naked.

Just as with wall painting and body decoration, earth pigments were one important source of colors used in textile production, in combination with plant extracts to produce certain dyes used in the Kuba raffia cloth of the Kasai region in Congo, and for dyeing Dida raffia cloth in Côte D'Ivoire. Dida women weave raffia cloths without using a loom, and dye them with mineral and plant dyes in a tie-dye process that creates extraordinary, almost organic, patterns in brown and red on a black ground. However, the best-known example of the use of earth pigments was in the *bogolanfini* of the Bamana in Mali, where cloths that balanced black, white, and sometimes red, had important ritual uses in controlling dangerous forces.

Bogolanfini, which translates as "mud cloth", is a long-established tradition among the Bamana, who inhabit a large area to the east and north of Bamako. Islam has been a major force in Mali for many centuries but did not make significant inroads in most Bamana regions until recently, and many aspects of ancestral religious and cultural traditions are still thriving, albeit in modified forms. As a consequence, they are well known to anthropologists and African art enthusiasts following numerous studies of their artistic and religious heritage, including a rich variety of masquerade forms. It is only in recent years, however, that the techniques of cloth dyeing have been researched and documented. The production of *bogolan* cloth involves a unique and lengthy procedure, which we can only outline here.

Although *bogolan* is made throughout the Bamana area, and even by some women from other ethnic groups such as the Dogon and Fulani, the acknowledged experts who produce the best designed and finest cloth come from the Beledougou Bamana area to the north of Bamako. Our description of the technique will be based on research there in the 1970s by Pascal Imperato and Marli Shamir, and more recent data collected by Tavy Aherne.

The raw material is provided by plain white cotton cloth woven by men on the local version of the narrow strip loom found throughout most of West Africa. The undyed cloth strips, about five inches wide, are still sewn up into shirts and robes and used as everyday dress by men in the country areas,

although factory-produced cloth is increasingly widely used instead. The plain cloth that is to be turned into *bogolan* is first sewn up into a woman's wrapper cloth, or whatever other garment the customer requires. There are, apparently, four recognized colors of *bogolan* produced in Beledougou: black, gray, red, and white, but we will concentrate here on the "white" cloth, where white patterns are isolated on a black background, as this is by far the most common.

Although men in Bamako have taken up *bogolan* dyeing in recent years, in the Beledougou area it remains primarily a women's craft passed on from mother to daughter. The cloth is first washed in water and allowed to dry so that it can shrink to its final size. It is then soaked in a brown solution made from the pounded leaves of certain trees. Although the main leaves used are widely known, specialists have their own precise, closely guarded recipes to give the best results. Once the cloth has been soaked in the mixture, it takes on a deep, even yellow color which fades only slightly when it is spread out on the ground to dry in the sun. It is now ready for the mud dye to be applied.

The mud used is collected from the very deepest sections of the ponds which become exposed for a few months at the height of the dry season. This mud is left to ferment in a covered pot for about a year, during which time it becomes black. When it is needed, some mud is taken from the pot and diluted with water. Small pieces of bamboo and flat metal spatulas of various widths are used to draw the design on to the cloth using the mud solution.

There are several stages to the design process. First, the woman marks off the main sections of the design she has in mind, dividing up the cloth into areas to be filled in with patterns. This is done with the cloth spread flat on the ground, but for the next stages of more detailed work, she sits and draws the part of the cloth to be painted over a large calabash in her lap. Next, she outlines the designs in the section, using a very thin spatula to draw the edges of the required patterns. When all the designs in that section have been drawn in outline, she then uses a wider implement to fill in the mud dye over the spaces left between them. One of the unique features of high quality *bogolan* is that it is the background, not the designs themselves, that is painted on to the cloth, leaving the design in the remaining undyed areas.

It can take several weeks of slow and painstaking work before the whole cloth is covered. The cloth is then washed with water to remove any excess mud, leaving a black background from which the yellow designs stand out. The whole process of dipping the cloth in the leaf solution and outlining the designs with a layer of black mud dye is then repeated, giving the cloth a second coating of dye. The final stage is to apply

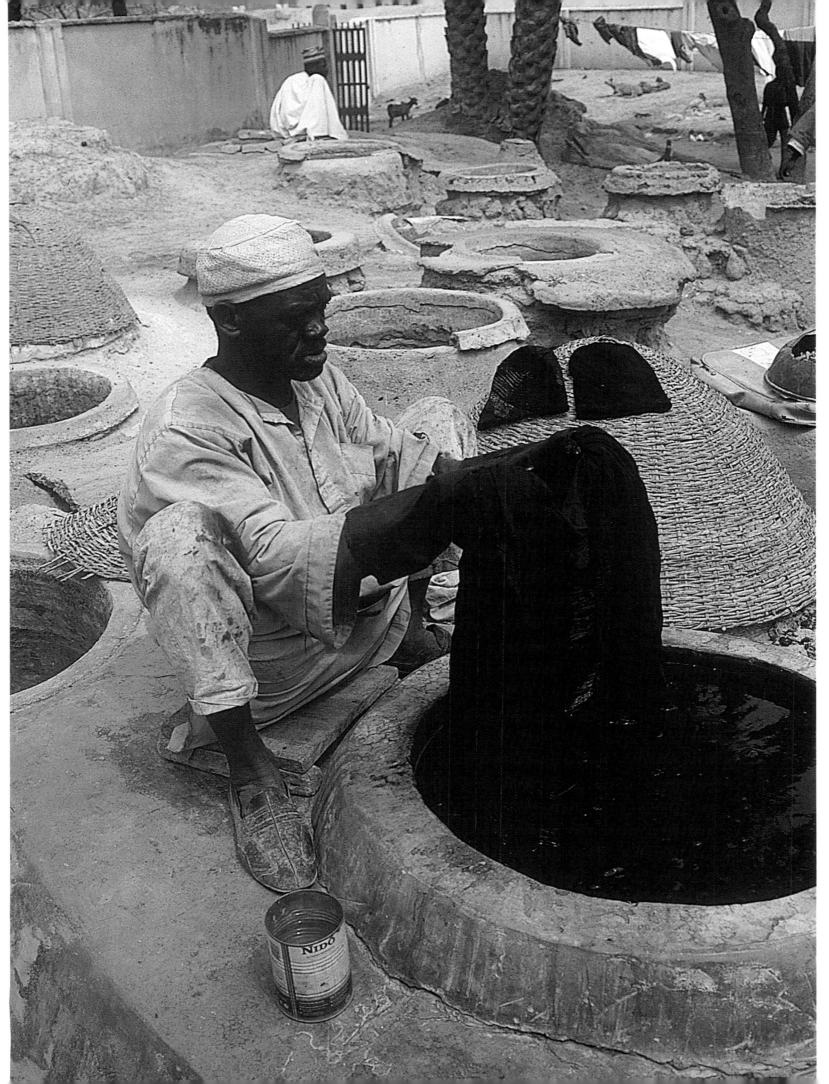

Left: Indigo dyer in Kano, northern Nigeria. Little remains of a craft that once employed thousands of specialist dyers and cloth beaters making glazed indigo robes and turbans exported throughout West Africa.

Duncan Clarke

123

a solution that includes caustic soda to the yellow areas so that they are bleached to the desired white. The solution is carefully painted on to the undyed sections of the cloth, turning them first to a shade of brown. It is only when the cloth is left out in the fierce sunlight for a week that they become white, and the cloth is completed.

There are various aspects that allow a well-executed *bogolanfini* to be distinguished from a more hurried job, or the work of a less skilled artist. These include the balance of the overall composition, the deepness and fastness of the black color, the sureness of the lines, and the absence of tool marks and unevenness in the dyed areas. Local experts are apparently able to distinguish the individual style of certain artists, and these women may become well known and attract clients from a considerable distance. By contrast, much of the *bogolan* now made in Bamako for the tourist trade and the export market is hastily produced using stencils and simplified designs, often with the addition of chemicals to the dyeing process.

It would seem strange to begin with a white cloth, dye it to yellow, then finish up by treating the yellow areas so they become white again. The reason for this apparently paradoxical procedure lies in the chemical reactions at work in the dyeing process. The active ingredient in the mud dye is iron oxide, which is converted by tannic acid in the leaf solution into a fast dye of iron tannate. The yellow stage is therefore essential, although as a color it is not present on the finished cloth.

Within the local tradition of *bogolan* cloth making in the countryside, it does not appear that artists were usually expected to produce innovatory designs. Rather, the mark of a successful design was the reproduction of existing designs clearly, and perhaps in some novel but appropriate combination. Many of the individual motifs applied to sections of the cloth, or combinations of these motifs, have names, which are apparently quite widely known. Some of these names are based on the appearance of the pattern, such as "fish bones," "little stars," or "square."

A few refer to historical events—according to recent research by Tavy Aherne, one complex design that is named after the "fighting ground between the iguana and the squirrel at the Woyowayanko river" recalls a battle fought between the French colonialists and the Bamana leader Samory. A common pattern of a cross shape set diagonally within a square is called "Mauritanian woman's head-cushion" after the expensive embroidered leather cushions such women own, and has implications of both femininity and wealth. A few designs have names which refer to aspects of women's daily experience, in particular to issues such as co-wives' rivalry within polygamous households.

It is important, however, not to overstress the role of these

names, which may in many cases be subject to local or regional variations. Although the designs may be recognized as named patterns, recalling the individual, object, or event, in question, in the majority of cases they do not seem to be symbolic in a deeper sense bound up with the use of the cloth. Nor can the overall designs of most cloths be "read" to form a coherent text. Nevertheless, it has been suggested that in some of the most important contexts of local use, notably in the cloths designed to be worn by young women in the period of confinement following excision ceremonies, the design of the cloth can be understood as related to their use.

Two specific designs of cloth were worn by these women to help protect them from hostile spiritual forces during the potentially dangerous stages of transition into adulthood before being entrusted to the care of the elderly woman who had looked after the initiates. According to the art historian Sarah Brett-Smith, these two cloths, called *basiae*, are examples of red *bogolan*, given a reddish-orange hue by the addition of an extra ingredient to the leaf solution. These "red," notionally blood-colored cloths absorb the dangerous forces unleashed by the process of circumcision, just as they literally absorb blood and sweat from the wearer. At the same time, the women may wear a plain white cloth folded on their head to prevent headaches.

Other sources have reported that "white" *bogolan* is worn during excision and that the red cloth is more appropriate to hunters. Different, but related ideas about protection from danger and the absorption of potentially harmful powers underlie the use of *bogolan* by hunters when confronting and killing powerful animals in the bush. The cloth is fashioned into shirts to which are attached leather amulets containing verses from the Koran, and medicinal packages which will protect the wearer from both the physical and metaphysical dangers he will encounter in the wild.

Remarkable though it is, mud cloth is found in only a relatively restricted area of West Africa. Indigo, on the other hand, which has been crucially important in the history of textile production worldwide, provided a deep blue-black pigment that formed the basis of dyeing technology across much of the continent. Blue and white, providing two of the basic color triad in the interplay between indigo blues and plain, undyed white cotton, whether created in the weaving process or by subsequent resist dyeing, was the basis of almost all long- established textile traditions in West Africa. Red was rather more difficult to obtain, and satisfactory red thread had to be imported.

Perhaps the best-known users of indigo cloth in Africa are the Tuareg. A semi-nomadic people of ancient Berber origin, Tuareg live in the arid Sahel semi-desert and in the Sahara

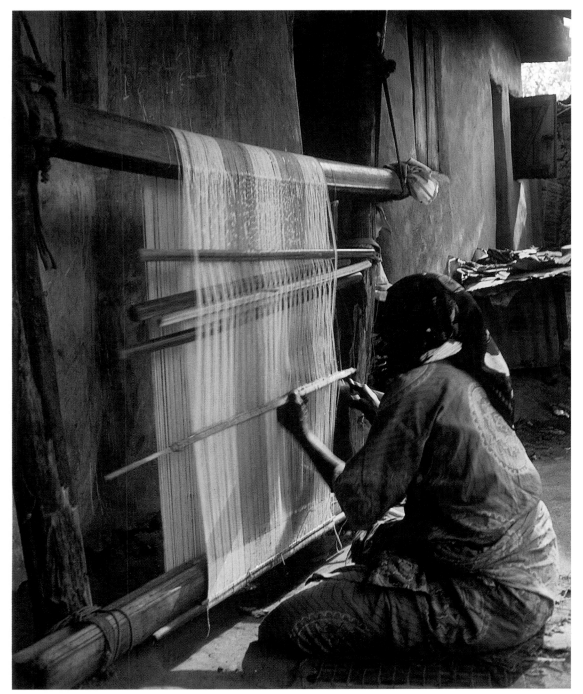

Above: A Nupe woman weaving on a type of upright loom once widespread in Nigeria and western Cameroon but now increasingly rare. Bida, Nigeria, January 2000.

Duncan Clarke

themselves is as "People of the Veil." Unlike other Muslim societies, however, it is adult men not women who must cover their head and face with long flowing veils of gauzy indigo or white cloth. This requirement is attributed not to Islamic doctrine but to earlier Tuareg notions of the significance of the head.

According to the anthropologist Susan Rasmussen, for the Tuareg, the head serves as the seat of intelligence, but all of its orifices are both sources of pollution to others and vulnerable points through which a person may be afflicted with misfortune. For men, in particular, it is therefore important to veil the face both as a sign of respect to others and to cover up potential points of access from the dangers posed by such threats as gossip and the evil eye. The precise position of the veil may be altered depending on whether a man is in the presence of his seniors, or his wife's relatives, or simply with junior men, or strangers. For women, especially married women, it is important to cover the hair with a head scarf as a sign of modesty, but concealing the face is not usually considered necessary.

However, the indigo cloth used by the Tuareg for these crucial garments was not woven by the Tuareg themselves, or like many of their necessities, made for them by their subordinate clans. Instead, it was imported over vast distances from the Hausa city of Kano in northern Nigeria, which in the eighteenth and nineteenth centuries owed much of its wealth to the hand weaving and dyeing of high-quality textiles for long-distance trade caravans.

The Hausa associate indigo dyeing with the origins of the urban culture, although linguistic evidence suggests influences from the older Kanuri civilization to the northeast. The Hausa word for indigo dyeing, *rini*, can be traced from Kanuri to an Arabic root and an ultimate origin in Sanskrit, where it also supplied the root of the English dyeing term *aniline*.

The best-quality cloth used for turbans and veils was a fine white gauzy cotton woven in strips as narrow as a half inch in width by weavers in a town close to Kano called Kura. This "*yan Kura*" cloth was bought by merchants who sent it to be dyed an intense blue-black with repeated immersions in indigo by specialist male cloth dyers at one of the clusters of dye pits within the walls of Kano itself. After that, it was handed over to full-time cloth beaters, who pressed and folded the cloth, working in pairs either side of a smoothed-off log. Extra indigo was beaten into the cloth in the form of a prepared paste called shuni, adding a metallic glaze to the finished cloth which was highly prized. This excess indigo rubs off on to the body of the wearer, giving the skin a blue sheen which the Tuareg believe has medicinal properties. Tuareg women also apply indigo paste to their lips as a cosmetic. Today, however, relatively few Tuareg can afford the expense of a glazed, hand-

itself, with communities in Niger, Mali, Burkina Faso, and further north in Libya and Tunisia. Supported by subordinate groups of slave origin settled in farming villages, the Tuareg for many centuries controlled long-distance trade routes across the Sahara. Today, however, their nomadic lifestyle is increasingly under threat from government intervention and conflict with farming populations for scarce water and other resources.

Indigo-dyed cloth supplies the most essential component of Tuareg dress, the robes and especially the veils. To generations of European travelers and explorers, the Tuareg were known as "Blue Men," not only because of their constant use of indigo cloth, but because of the blue sheen the excess indigo imparted to the skin. One of the names by which the Tuareg refer to

woven turban, and although they are still in demand, the weaving and dyeing industries of Kano are much reduced.

Belief in the medicinal efficacy of indigo cloths was widespread. Forty years ago, Yoruba women in Nigeria might have worn a new indigo-dyed *kijipa* cloth to promote fertility if they were having problems with conception. Among the Dogon in Mali, married women still wear indigo-dyed wraparound skirts of hand-spun cotton cloth with resist-dyed white patterns. Here, too, there is a link to ideas about fertility, as the cloths of elderly, non-fertile women are plain blue, while for those worn by female medicinal specialists, the cloth strips are joined by multicolored threads.

Similar homespun, indigo-dyed cloth with simple resist patterning was once the main form of attire in many parts of West Africa, but today it is confined to comparatively remote regions and regarded as the dress of the elderly and of rural people. Although imported cloth has been a significant factor in African dress for many centuries, it was only in the late nineteenth and early twentieth centuries that cloth was imported in large enough quantities, and at low enough prices, to become the everyday dress for ordinary people. In many cases, this flood of cheap imports destroyed indigenous textile production. This was what the colonial authorities, keen to sell the output of their home textile factories, anticipated, and they were largely successful in much of East and Central Africa. However, the impact was not entirely negative. Imported cloths were adapted and modified to meet local esthetic preferences, with Yoruba women, for example, using imported cotton shirting material as a basis for a highly successful trade in starch-resist, indigo-dyed cloth called *adire*.

Above: Yoruba men weaving *aso oke* on the narrow strip loom found throughout West Africa. In many areas young women are taking up this type of weaving in growing numbers. Iseyin, Nigeria, 1995.

Duncan Clarke

Right: Bogolan mudcloth, created by painting designs using iron-rich mud on a hand-woven cotton cloth in the Beledougou region of Mali.

Duncan Clarke

Right: Detail of a Yoruba man's embroidered robe woven from hand-spun sanyan wild silk, one of three prestige *aso oke* cloths among the Yoruba.

Duncan Clarke

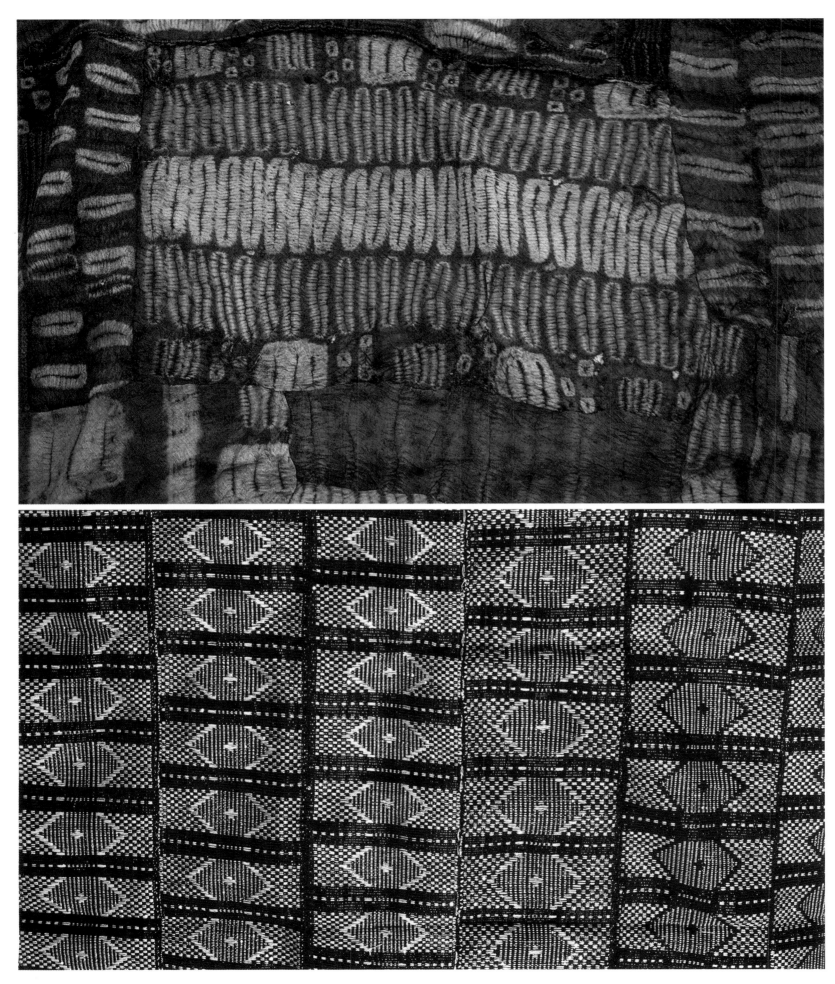

Left: Detail of a Dida palm-fiber cloth tie-dyed with natural pigments. Such cloths are worn as sashes and skirts for ceremonial events among the Dida of Côte d'Ivoire.

Duncan Clarke

Left: A recent Yoruba *aso oke* fashion has been for wider strips of cloth with complex weft float patterning introduced to Nigeria by Ewe weavers from Ghana.

Duncan Clarke

Where local weaving traditions have survived the twentieth century, this has been because they are able to adapt, and respond to needs not filled by imported substitutes. In particular, there is a continued demand for locally woven cloths for use on ceremonial occasions. Newly emergent senses of ethnic identity and of the importance of dressing in ways seen as "traditional" at times set apart from the everyday routine certainly contribute to this. As with Yoruba *aso oke* and Asante *kente*, the two most successful contemporary weaving traditions in West Africa, despite the widespread use of multicolored imported threads, traces of older ideas about the significance of color may still be found.

For the Yoruba, cloth is still one of the main indicators of social status and wealth, ranked with children and good health as the markers of a life fulfiled. The significance of cloth is stressed by an account of the origin of clothing in the texts memorized by the diviners of the Ifa system, regarded today as the core of Yoruba cultural heritage. It tells how there was dissension and strife in a family that went about naked. Finally, the father consulted Ifa and was told to make sacrifices to Esu,

the messenger of the gods. Esu then taught the man to harvest cotton and have it woven into clothing. Once his family saw him dressed, they were respectful of his orders and social harmony was restored. Cloth, the verse tells us, is the basis of a civilized and correctly ordered society.

The Yoruba-speaking region of Nigeria is one where two forms of weaving technology overlap, and both the upright single-heddle loom and the narrow-strip double-heddle loom are found. The evidence suggests that the upright loom is of great antiquity in the area, while the narrow-strip loom is one of several aspects of Yoruba culture probably introduced into the Oyo kingdom via contacts with northern trade routes. Weaving on the upright loom was the work of women who mobilized their daughters and junior sisters as spinners and trainees to produce large quantities of indigo-and-white striped cloths for everyday use.

From the seventeenth century, European traders brought Yoruba cloths from Ijebu and Benin middlemen and shipped them for resale in the Gold Coast, Congo, and even to clothe the slave population of Brazil. As well as the *kijipa*, weavers on

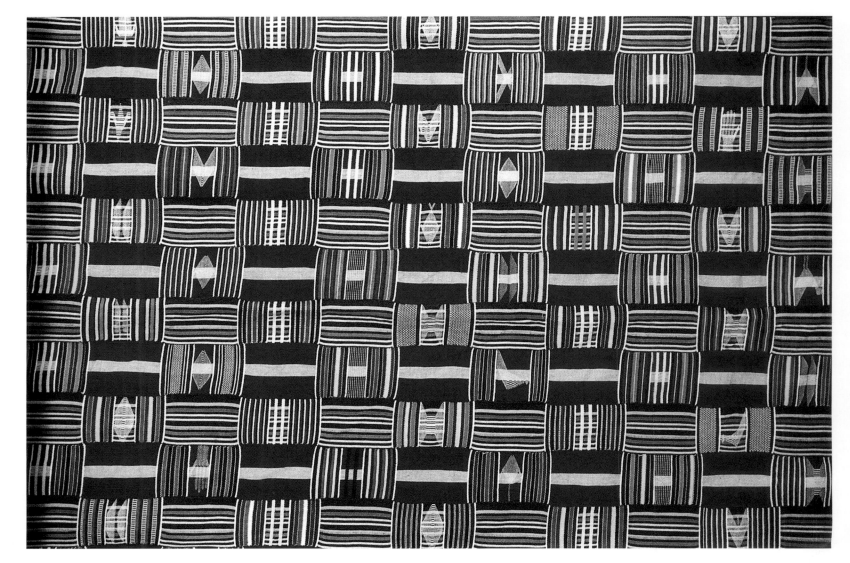

Right: Predominantly red, white, and blue or black cloths, such as this Ewe man's wrapper from the 1960's, are quite rare, despite the widespread interest in the these colors.

Duncan Clarke

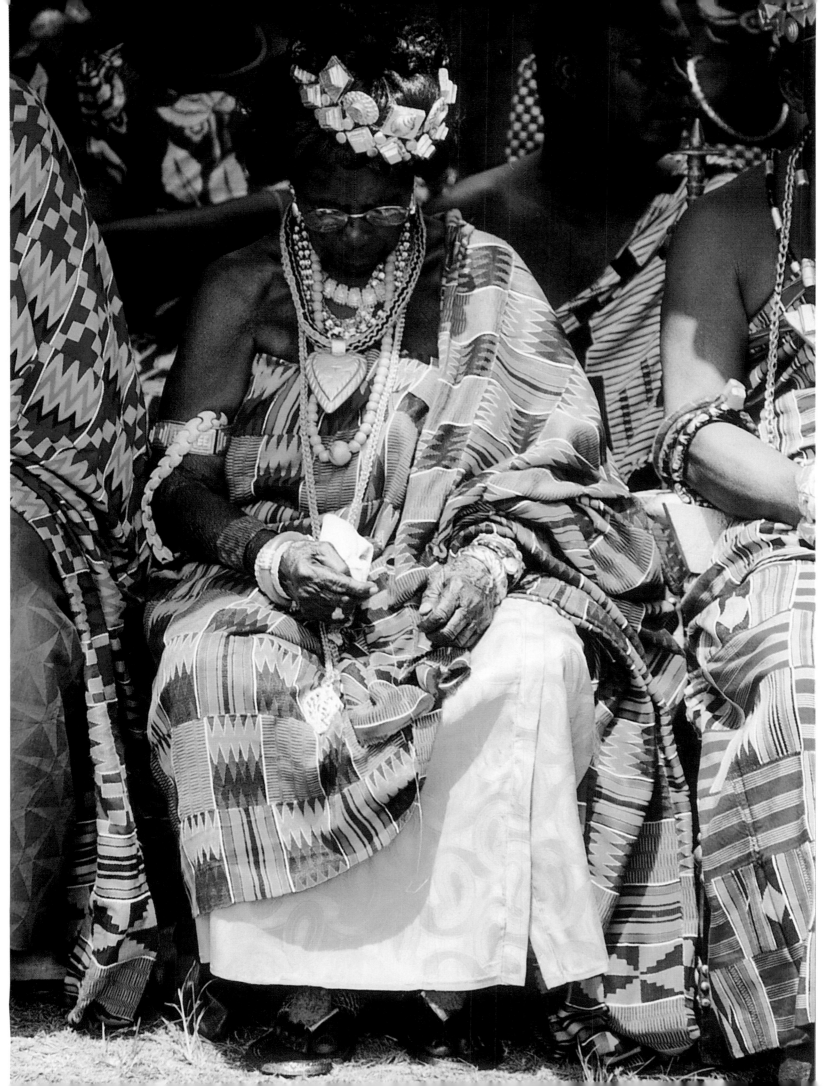

Left: An elderly Asante lady wearing a blue *kente* and traditional gold jewelry.

Richard Thorn

Following pages: An Asante king enthroned in state at a recent festival, beneath ceremonial umbrellas.

Richard Thorn

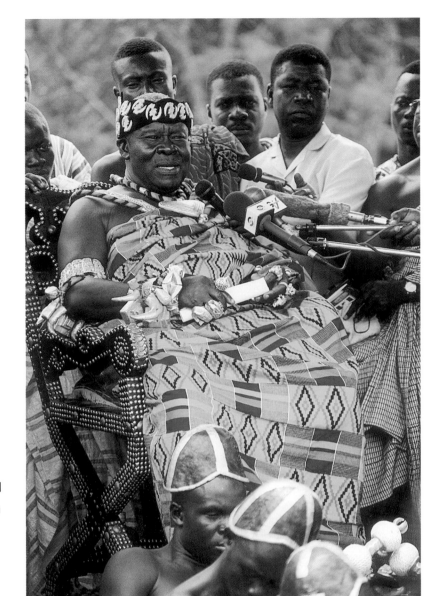

sciousness of identity as Yorubas, although they have long since been supplanted by more recent fashions. *Etu* is a deep blue, almost black, indigo-dyed cloth, so dark that a costly dyeing process involving numerous immersions in the pot of indigo was needed. The dark blue is offset by very thin warp and weft stripes, often only a single thread in width, of lighter blue. The name *etu* means guinea fowl, and the cloth is likened to the bird's speckled plumage. A verse from a Ifa divination text describes *etu* as the father of all cloths, while proverbs note the respect it inspires in viewers, asserting, for example, that a man whose head has worn an etu cap should never again carry a load. *Sanyan* is woven from pale beige silk obtained throughout Nigeria from the cocoons of the Anaphe moth, forming a rather uneven light brown cloth, often with a narrow white stripe down the center of each strip. *Alaari* is the Yoruba name for cloth woven using the magenta waste silk imported across the Sahara from Tripoli, supplying a vivid purplish "red" that couldn't be satisfactorily obtained from local dyes. Cloths woven entirely with this silk were extremely rare, and it was more usual to weave it as stripes of weft float decorations into an indigo-dyed cloth.

In the nineteenth and early part of the twentieth century, these three cloths were an important part of an inter-regional trade network that extended northward far beyond the Yoruba to encompass Nupe weavers and embroiderers, Hausa embroiderers and tailors, and aristocratic Fulani patrons in the supply of prestige robes and trousers to kings, emirs, and chiefs throughout a huge expanse of West Africa. The Islamic-influenced dress styles, elaborated by the Yoruba into a huge range of types of robes and trousers, gradually supplanted the earlier form of men's dress based on tied and wrapped cloths. Women, however, retained the older style, modifying it with additional cloths and the introduction of a sewn blouse in the twentieth century.

It should be apparent that the three prestige cloths, *etu*, *alaari*, and *sanyan*, correspond to the triad of basic color terms, i.e. the *etu* is black, *alaari* is red, and *sanyan* is white. The three terms in the Yoruba language are *pupa* (red, yellow, orange), *funfun* (white, all pale shades, including beige), and *dudu* (black, dark blue, dark brown, dark green). One might expect that their use would be governed by conventions related to some widely shared sense of color meanings, but this is not in fact the case. Color meaning in Yoruba is dependent on the context. While in some situations indigo-dyed cloth is associated with high status, as with *etu*, in others it is linked with concealed dirt and pollution. A Yoruba proverb warns, "When you give cloth to a lazy man, you should dye it with indigo." Similarly, the red cloth of Sango, the god of thunder and lightning, whose praise names include "owner of the red gown,"

this type of loom in the various parts of the Yoruba region created numerous more localized styles of more highly decorated cloths for a variety of ritual and ceremonial uses.

In the twentieth century, a variety of factors, including declining demand, the new access to education for young women, and alternative employment opportunities, have contributed to a dramatic decline in upright loom weaving among the Yoruba. A few weavers still make some of the ceremonial cloths, but the tradition has become virtually defunct. In marked contrast, however. Yoruba *aso oke* weaving on the narrow-strip loom is, without doubt, one of the most vibrant and successful artistic traditions in Africa, employing many thousands of full-time weavers.

Today, the tradition of *aso oke* weaving, inherited from the nineteenth century, centers around three prestige cloths: *etu*; *sanyan*; and *alaari*; although, in reality, a far wider range of designs were woven in the past. These three cloths are still associated with a deep sense of respect for tradition and a con-

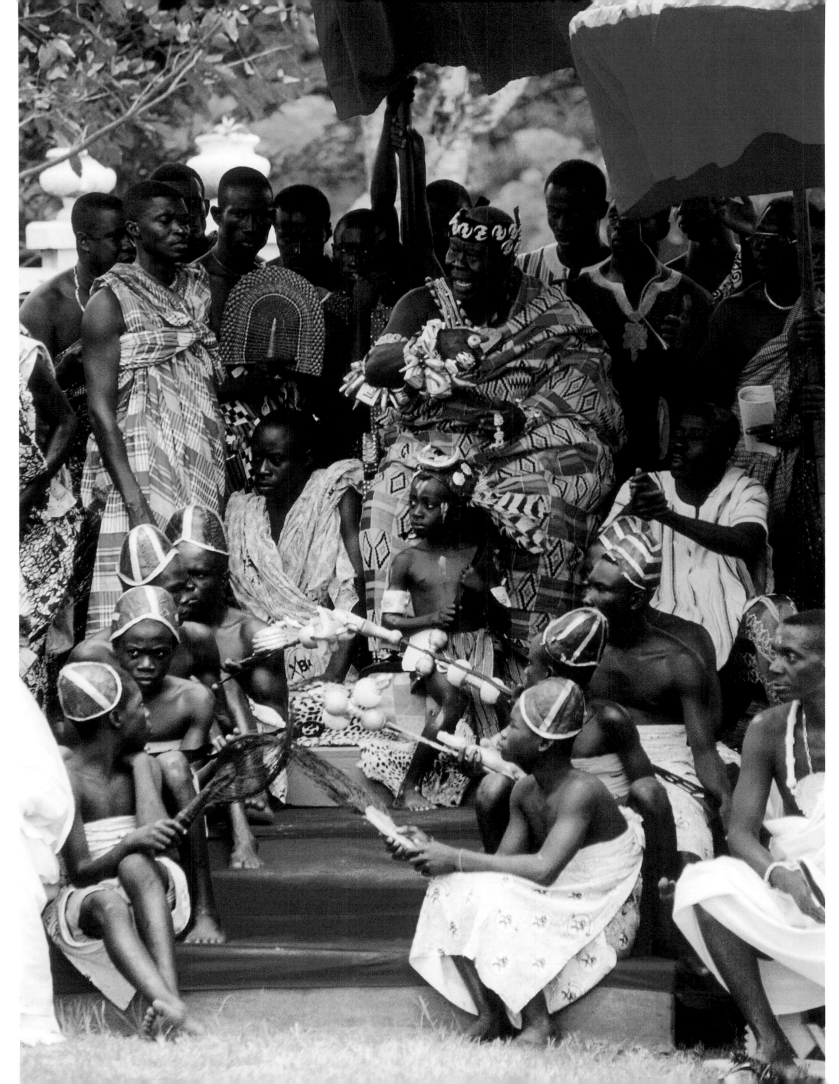

Left: Gold jewelry and fine *kente* cloths demonstrate the wealth and prestige of an Asante king. At the king's feet young attendants carry the gold-handled royal swords.

Richard Thorn

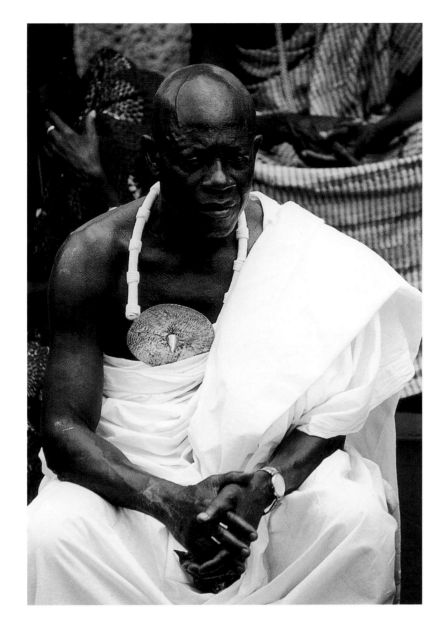

The Bunu are a remote Yoruba-affiliated people where older women's weaving traditions that long predate the spread of men's *aso oke* weaving can still be researched. In one of the first in-depth studies to focus on the use and meaning of cloth in a single African culture, Elisha Renne found that imported fabrics were universally used for everyday dress but that for certain special hand-woven cloths color symbolism was a crucial aspect of their meaning. White was particularly associated with water and water spirits. Women who had been born after several stillbirths, or who themselves had problems conceiving, were regarded as "children of water" who were troubled by water spirits. Special white cloths of handspun cotton had to be woven and worn at all-night spirit-possession ceremonies to placate these spirits. Another type of white cloth represented a link between ancestral spirits and their rebirth in children. Black, indigo-dyed cloths carried in a black basket, drew on the Bunu association of black indigo with fertility and rain-bringing clouds as the cloth for traditional marriage ceremonies. Red cloth, on the other hand, was linked with funerals and ancestral masquerades. A series of red cloths, woven in a distinctive style using red wool unraveled from imported hospital blankets, were placed on the house roof to mark the death of high status individuals. This *aso ipo*, used as part of second burial ceremonies for titled chiefs, was associated with blood sacrifices and was formerly interred with the corpse. As a result of this link, Bunu mothers and young children should never wear red cloth. Among mainstream Yoruba, in contrast, babies and the cloth used to carry them were smeared red with camwood, and red cloth was explicitly excluded from use in funerals.

may be dangerous, but this does not apply to the red camwood-stained cloth with which mothers wrap their babies. The three prestige cloths certainly have the potential to be used as symbols with reference to their colors, but this is not, in fact, how they are usually used. Instead they have a more diffuse association with high status and the celebration of important and joyful occasions.

There is, however, one reported exception, in the form of a ceremony that marked young women's puberty in the eastern Yoruba town of Ondo. During the *Obitan* ceremony, "an initiate would tie a white wrapper of *sanyan* around her waist on top of which she would wear an expensive *alaari*, while her body would be marked with black." While local informants said that the cloths were to "treat her like a royal person," the author Jacob Olupona suggests a color symbolism where red and white correspond to blood and semen, arguing that the initiates are treated as if they are pregnant at the conclusion of the rite.

Although *sanyan*, *etu*, and *alaari* remain at the center of the Yoruba *aso oke* tradition, in the last century the shift in power from kings and chiefs to new élites has been mirrored by a shift in the centers of patronage for *aso oke* weavers. Today, the weavers' most important customers and the leaders of fashion are the wealthy educated élites of cities such as Lagos and Ibadan. Particularly important for the future of *aso oke* weaving was a custom called *aso ebi* which became popular in Yoruba cities by the 1920s. This involves groups of celebrants at any event expressing their sense of group or family unity by dressing in the same pattern of fabric. Depending on the tastes and wealth of those involved, and the fashion of the day, this fabric could be imported wax prints, velvet, or lace, but most often it was *aso oke*. By the middle of the twentieth century, the pattern for wearing *aso oke* as a special cloth for important and ceremonial occasions had been set. By this time, locally woven cloth had been almost entirely displaced from everyday wear by imported, factory-produced textiles (two exceptions will still persist today are men's caps and the cloths which

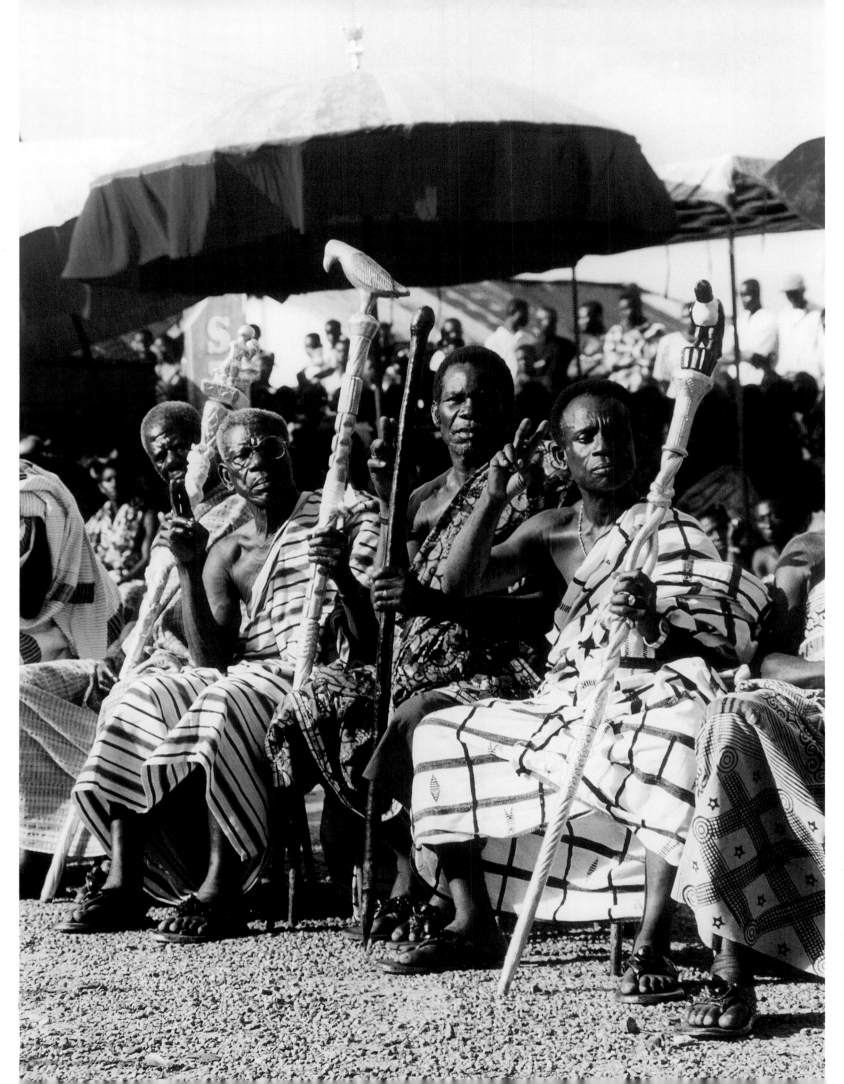

Left: The king's official
spokesmen, carrying their
gold-covered staffs of office,
wear a range of popular
cloths including hand-woven
narrow strip cloths, factory-
made resin-resist "wax"
(center), and *adinkra*
(right edge).

Richard Thorn

137

mothers use to support babies on their backs.) *Aso oke* is worn at life-cycle events such as naming ceremonies for babies, engagements, weddings, important birthdays, chieftaincy title ceremonies, and funerals, as well as the major festivals, and Christian or Islamic holy days.

In the selection and ordering of new *aso oke*, a continuous process of incremental design change takes place. Although some people will choose a popular existing design, most prefer to wear cloth which is sufficiently like the latest new designs to be identifiably in fashion, but has been modified so as to be a novel combination of color and pattern. They will select an existing design, and ask for a color to be changed or a stripe to be widened, or they may propose an entirely new combination, sometimes sketching it on paper. Weavers, traders, and cloth consumers all contribute to this ongoing change. Since the mid 1970s, the appearance of *aso oke* has been transformed by the increasing use of Japanese lurex, a metalized plastic fiber which can be woven into the cloth in a variety of ways to create a glittery, light-catching effect. This has proved extremely popular with Yoruba customers and is particularly effective under artificial lights at the huge all-night parties that accompany many Yoruba celebrations.

The adaptability weavers have displayed in matching the changing tastes of a sophisticated and fashion-conscious patronage has been demonstrated again in the 1990s when weavers have responded to competition from Ghanaian Ewe weavers moving into Lagos with further innovations, including a shift toward weaving wider strips and the introduction of a technique of warp float decoration.

The role of color in this rapidly shifting situation is twofold. Firstly, the color serves to distinguish major groups among the celebrants at a large event. The woman organizing the ceremony, such as the mother of the bride, will notify guests of the color of the *aso oke* she has selected for her guests. Those who choose not to, or cannot afford to, buy the new *aso ebi* cloth will instead wear another piece of *aso oke* of the same color from their wardrobe. So all the bridegroom's family and their guests may be in blue, while another group, such as his personal friends, might choose green, the bride's family, fuchsia, the bride's friends, orange, etc.

Apart from a European-derived preference some people have for choosing colors such as blue for the bridegroom, and lighter colors such as pink for the bride, there is no particular meaning associated with these color choices. In one instance, the bridegroom's mother chose yellow for her guests simply because she wanted to wear some yellow shoes she had bought on a recent trip to London.

The second important consideration when choosing a color is fashion. Fashion in colors changes rapidly, with new shades such as fuchsia, salmon pink, turquoise being the height of fashion one year, but distinctly passé the next. A novel and successful color choice may be commented on and admired by guests, while a tired and over-familiar one will attract considerable criticism.

The cloths woven in the nineteenth century for the court of the Asantehene, the king of the Asante empire which extended over much of the present-day state of Ghana, were probably the ultimate achievement of the West African narrow-strip weavers' art. Their successors today are certainly among the most colorful and spectacular cloths to be seen anywhere in the world. The Asante court, based at Kumasi, was undoubtedly amongst the wealthiest and most elaborate in Africa. Some idea of its splendor may be gained from this excerpt from the first impressions recorded by T. E. Bowdich, an English visitor to Kumasi in 1817, in his book *Mission from Cape Coast to Ashantee*: "…an area nearly a mile in circumference was crowded with magnificence and novelty… The sun was reflected, with a glare scarcely more supportable than the heat, from the massy gold ornaments, which glistened in every direction… At least a hundred large umbrellas, or canopies, which could shelter thirty persons, were sprung up and down by the bearers with brilliant effect. The caboceers, as did their superior captains and attendants, wore Ashantee cloths of extravagant price… They were of incredible size and weight, and thrown over the shoulder exactly like a Roman toga; a small silk fillet generally encircled their temples, and massy gold necklaces intricately wrought, suspended Moorish charms…" Although the wealth and temporal power of the Asantehene are much reduced today, the Asante court is still capable of mounting similar elaborate and spectacular ceremonial displays on important occasions such as annual festivals and anniversaries.

The Asante empire arose in the seventeenth century under the leadership of the first Asantehene, Osei Tutu, with an expanding kingdom based around the capital of Kumasi deep in the forest zone. It is likely that bark cloth rather than woven textiles had formed the mainstay of local dress over previous centuries, with weaving introduced from the cotton-growing areas of the savannah belt further north. Bark cloth subsequently became regarded as the dress of poor people and slaves, but is still worn by the king at one stage of the annual *Odwira* yam festival. An Asante weavers' origin myth recalls that the first weaver, Otah Kraban, brought a loom back to Bonwire after a journey to the Bondoukou region of Côte D'Ivoire. An alternative legend recalls that during the reign of Osei Tutu, the first weaver learnt his skill by studying the way in which a spider spun its web. The spider, Anansi, is an important figure symbolizing trickery and wisdom in Asante folk-

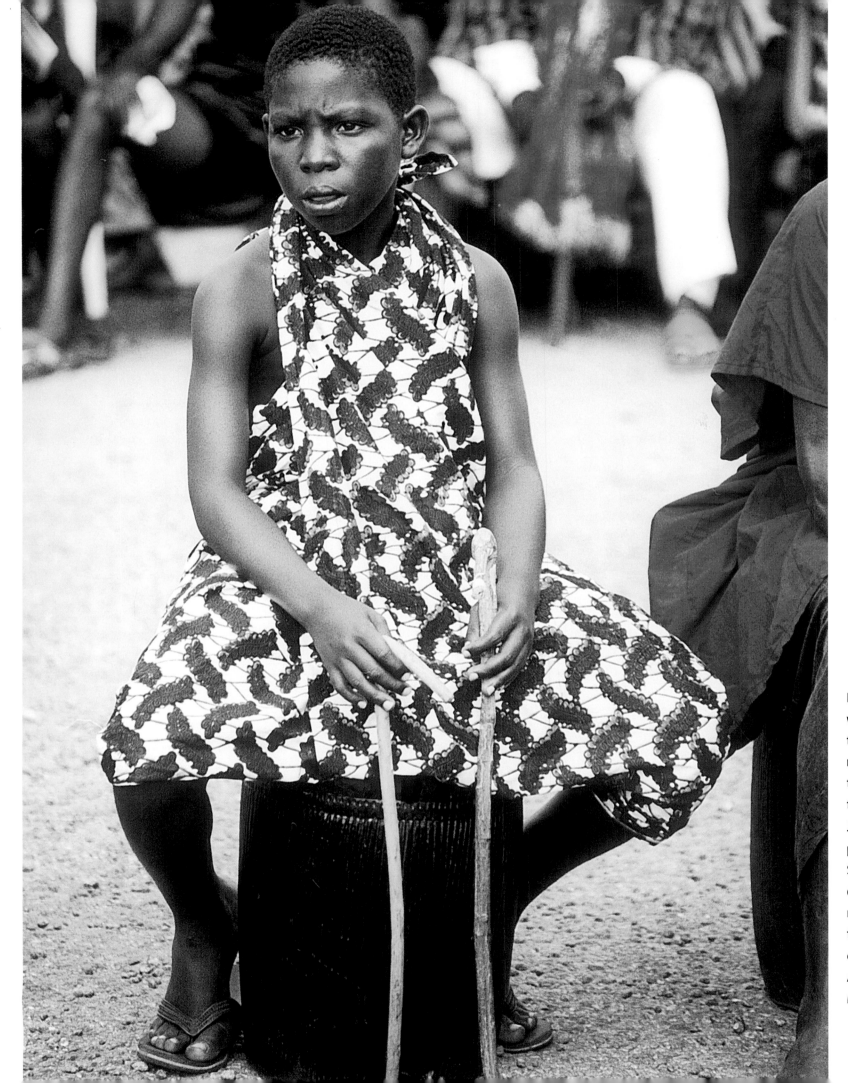

Left: A young drummer wears a "wax" cloth, of a type original produced in nineteenth century Holland to compete with batik in their Indonesian colony of Java, but now widely popular throughout sub-Saharan Africa. The same design of cloth is often made in different color runs to cater for variations in color preference in different African countries.

Richard Thorn

139

lore. Away from the court, cotton-weaving supplied much of the everyday dress for the Asante people, in the form of striped, patterned cloths, mostly of indigo blue and white, until it was largely displaced by wax prints and other imported textiles in the present century. The king's weavers were, and still are, grouped in a village called Bonwire near the Asante capital of Kumasi, part of a network of villages housing other craft specialists including goldsmiths, the royal umbrella makers, stool carvers, *adinkra* dyers, and blacksmiths.

One of the first accounts of Asante royal silk weaving comes from the 1730s, when a man sent to the court of King Opokuware by a Danish trader observed that the king "brought silk taffeta and materials of all colors. The artist unraveled them… woolen and silk threads which they mixed with their cotton and got many colors." Silk was also imported into Asante from southern Europe via the trans-Saharan caravan trade. Many *kente* cloths, including, most probably, the earlier ones, utilized silk for a range of decorative techniques on a background of warp-striped cotton cloth, but some of the finest cloths prepared for royal and chiefly use were woven wholly from silk. The unraveled thread was re-woven into narrow-strip cloth on looms that utilized two, and in some cases even three, sets of heddles to multiply the complexity of ornamental design. In most *kente* cloths, the design effect is achieved by the alternation of regularly positioned blocks of pattern in bright-colored silk with the more muted colors of the warp-striped plain weave background. Interestingly, it is the background designs, the configurations of warp stripes of varying widths, that provide the basis for most pattern names. As might be expected in a culture so interested in proverbs and verbal wordplay, there is a large vocabulary of pattern names still remembered by elderly weavers. Some of these names, such as *Atta Birago* and *Afua Kobi*, refer to the individuals, in these cases two queen mothers, for whom the designs were first woven. Others referred to historical incidents, to household objects, to proverbs, or to certain circumstances of the cloths use. For instance, Rattray recorded in 1927 that a design known as *Nyawoho*, (he has become rich), was supposed to be worn only by men who had more than a thousand pounds worth of gold dust. More recently, designs have been developed that were named after prominent figures in independent Ghana, such as Fathia Nkrumah, the Egyptian wife of the first President.

Although the high-point of the Asante royal weavers' artistry seems to have passed with the conquest of the kingdom by the British at the end of the century, and its subsequent incorporation into the Gold Coast Colony and later the state of Ghana, *kente* cloth remains an important contributor to African dress today. Recognized worldwide, it has taken on a new role as a symbolic affirmation of African identity and Pan-African unity that has struck a particular chord with African-Americans and exiled Africans everywhere. In Ghana itself, it is worn primarily for celebratory occasions such as anniversaries, presentations, weddings, official events, and annual festivals.

Kente cloth is undoubtedly colorful, but the answer to the question of whether or not the colors have meaning is not as clear as might be hoped. The patterns are named, but it would appear that, at least in recent years, there is no firm connection between the name of a pattern and the individual wearing it, or the event to which it is worn. Something similar may be true in relation to color. There are clearly diffuse ideas and feelings about the associations of certain colors which are perhaps widely shared by Asante people. The first attempt to codify these was made in the 1960s by the Akan writer Kofi Antubam, who noted that white called to mind joy, purity, and spiritual entities; black melancholy, old age, and death; red melancholy, death of a relation, war, violence. Blue was related to love, womanly tenderness, and the crescent moon; green to newness and fertility; gray to ashes, degradation and shame. Gold, in a society where, in pre-colonial days, gold dust was used for money, and kings and chiefs still wear huge quantities of gold jewelry, was not surprisingly related to royalty and kingship. Yet Antubam gave few examples of these ideas in context and hardly related them to *kente* cloth.

It was only in 1993, with the publication of a chart illustrating *kente* cloth designs by Kwaku Ofori-Ansa, that an explicit link was made in print between these ideas of color meaning and the use of *kente* cloth. Ofori-Ansa elaborated on and extended the color associations listed by Antubam and claimed, "these are generally applicable to color symbolism in the esthetics of *kente* cloth." The chart was extremely popular in Ghana as well as America, and began to be used as a sales aid by weavers and cloth traders who had regular contact with foreign tourists. Several scholars have noticed that subsequent inquiries to weavers about the meaning of a particular color have been answered by reference to Ofori-Ansa's account on the chart.

Meanings are, of course, not a fixed property of objects, rather they are something that human agents read into, or out of, things as it suits them. However, it is by no means clear that this explicit color symbolism is an accurate account of the way *kente* is used. Leaving aside the fact that most *kente* combine one dominant background color (presumably the one doing the signifying) with numerous others in the warp stripes and weft patterning, a consideration of the festive occasions at which *kente* is worn raises serious doubts. Unlike with Yoruba *aso oke*, an Asante festival will be attended by men and women

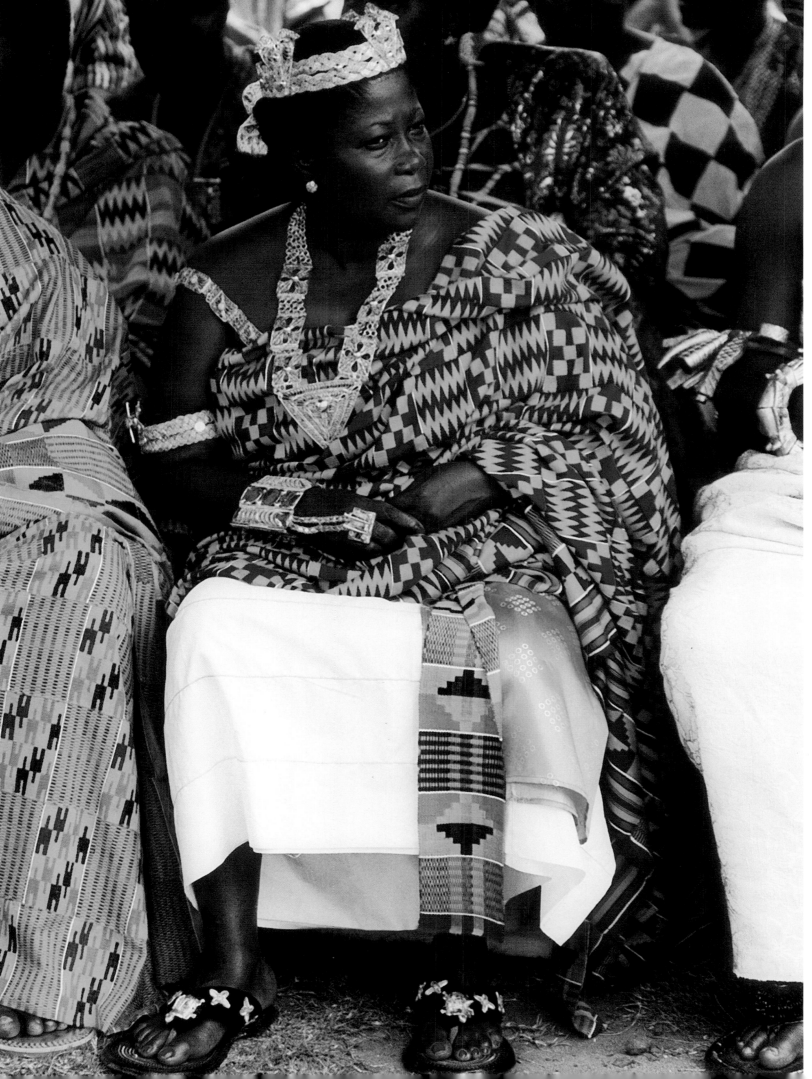

Left: A senior Asante lady wearing a kente cloth with a pattern called *Fathia Nkrumah*, named after the Egyptian wife of the first president of independent Ghana, Kwame Nkrumah. Nkrumah popularized kente cloth worldwide in the late 1950s through his leading role in the Pan-Africanist movement.

Richard Thorn

wearing beautiful *kente* cloths in the whole range of colors available—blue, yellow, white, red, maroon, green, etc. Is it likely that each attendee has his or her distinct feelings about the event which his cloth has been chosen to express? It seems far more plausible that any fine *kente* cloth is appropriate and that nothing more than wealth, prestige, and appreciation of Asante culture are being communicated by wearing them.

It is worth noting that when Asante people do wish to communicate something through the color of their cloth, the impact is immediately apparent. Any Saturday throughout southern Ghana, large groups of people can be seen wearing black, dark brown, dark blue, or dark red cloths as they attend a funeral. Some of them will be wearing *adinkra*, a distinctively patterned cloth made by stamping a dye made from boiled plant extracts on to a plain background. *Adinkra* is in origin a cloth of mourning. Asante legend has it that the cloth was first seen in the early nineteenth century when Adinkra, the defeated king of Gyaman, wore it as he was paraded in captivity through Kumasi, although this cannot be the whole story, since Bowdich purchased *adinkra* there in 1817 before the defeat of Gyaman. Each design has a name, and in some cases a proverbial reference, but these do not add up to a text that is to be read or decoded in use. Instead, it is the wearing of *adinkra* of a particular color that conveys meaning. Early accounts seem to indicate that all a*dinkra* was associated with mourning in the past, but over recent decades at least, white and other light-colored *adinkra* has been worn, like *kente*, for festive occasions, while dark colors, especially red, are worn for funerals.

Right: *Adinkra* seems originally to have been worn as a mourning cloth, but today light-colored *adinkra*, such as the white cloth worn by this dancer, is considered appropriate for festive wear.

Richard Thorn

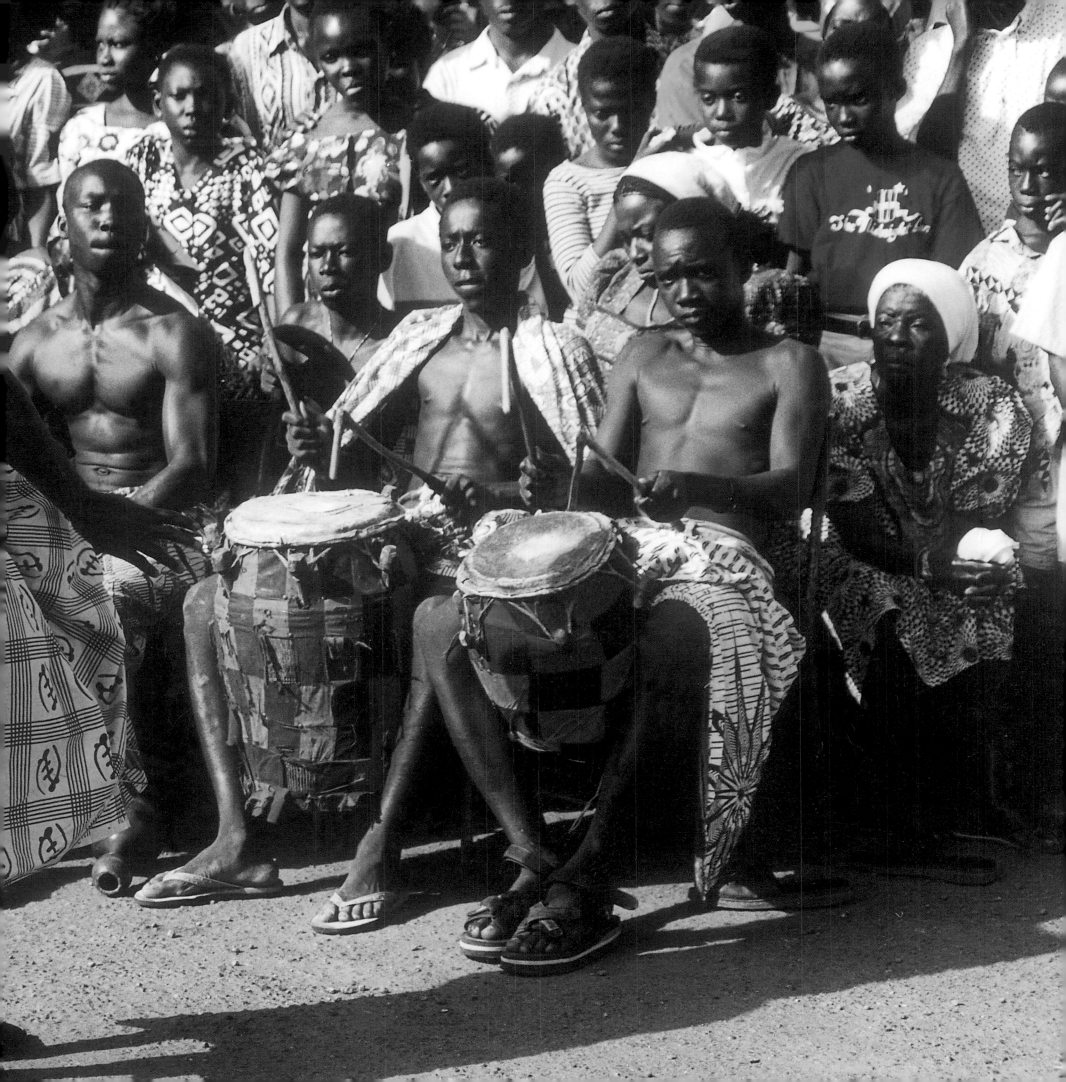

PERFORMING COLORS

Color in Masquerade

Color does not provide a unique key to unlock hidden meaning in African art. Ideas are often associated with particular colors, but these ideas are normally complex and often ambivalent. Any understanding of meaning requires an exploration of the context within which the colors are deployed as well as an awareness of the nature of the processes of continuity and change at work. Only in extremely rare cases, such as that of Zulu women's beadwork, is there evidence that color is, or was, deployed intentionally to communicate nuanced messages containing previously unknown information to cultural insiders. More frequently, its use seems to be as much or more about evoking and affirming a particular sense in participants, via the dark red adinkra cloth worn by Asante mourners or the white chalk pigment smeared directly on the bodies of initiates in many African cultures. Marking on the body some extra-social phase of transition, or the changes in beadwork that mark off different life-cycle phases involve a transformation in those involved and the visible affirmation of that change which is only secondarily concerned with communicating this information, which, after all, will already be well known to most within a small-scale society.

Differences in the way of marking these processes through beadwork, body decoration or dress occur between different peoples, but only in certain circumstances of heightened awareness of group identity that seem to have largely developed in the twentieth century is a conscious intention to express these differences apparent. In general, people dress as Maasai, or as Yoruba, or as Asante, far more to enhance and communicate prestige to those within their own culture, in part through demonstrating their knowledge and appreciation of that culture, than to communicate something about their identity to outsiders. Indeed the concept of "dressing as a Maasai," or whatever, only makes sense at all in a situation where a range of choices about dress and cultural identity have opened up.

Even where there are explicit ideas about color meaning circulating in a culture, we cannot just assume that every time a color appears, the associated meaning is intended on even an unconscious level. In the case of the ceremonial dress of the Asante, it appears that it is the act of wearing a fine kente cloth that marks someone out as significant rather than the color of the cloth itself. Even where the basic color triad of red-black-white occurs, as it does in the three prestige cloths of the Yoruba aso oke tradition, there is not necessarily any association with color meanings in their use. Nevertheless, ideas about the meanings associated with color are widespread in Africa, recurring with local variations and nuances in an extraordinary variety of media across a huge range of cultures. In many cases, the red-black-white triad does serve as a means of ordering and classifying ideas and phenomena into threes, while encompassing contrasting pairs such as black-white, or red-white, allowing aspects of the given world to be manipulated and transformed through ritual and performance. Superficially similar views about color may be discerned in such apparently diverse phenomena as the preparation of Kongo medicinal nkisi and the appropriate arrangement on the body of Maasai beadwork jewelry, although detailed local knowledge would be required before one could begin to understand why white chalk powder rather than red pigment was needed as the basis of a particular medicine, or how a particular combination of colored beads was worn.

Despite its evident importance, it would clearly then be a mistake to view the red-white-black triad as a fixed template from which meaning can be determined without reference to local and contextual variation. Although there is not the depth of historical data to prove it, the same is almost certainly true for variation over time, so that it cannot simply be assumed that ideas associated with colors in the distant past were the same as those researched more recently. It is perhaps more productive to view the color triad as a way of

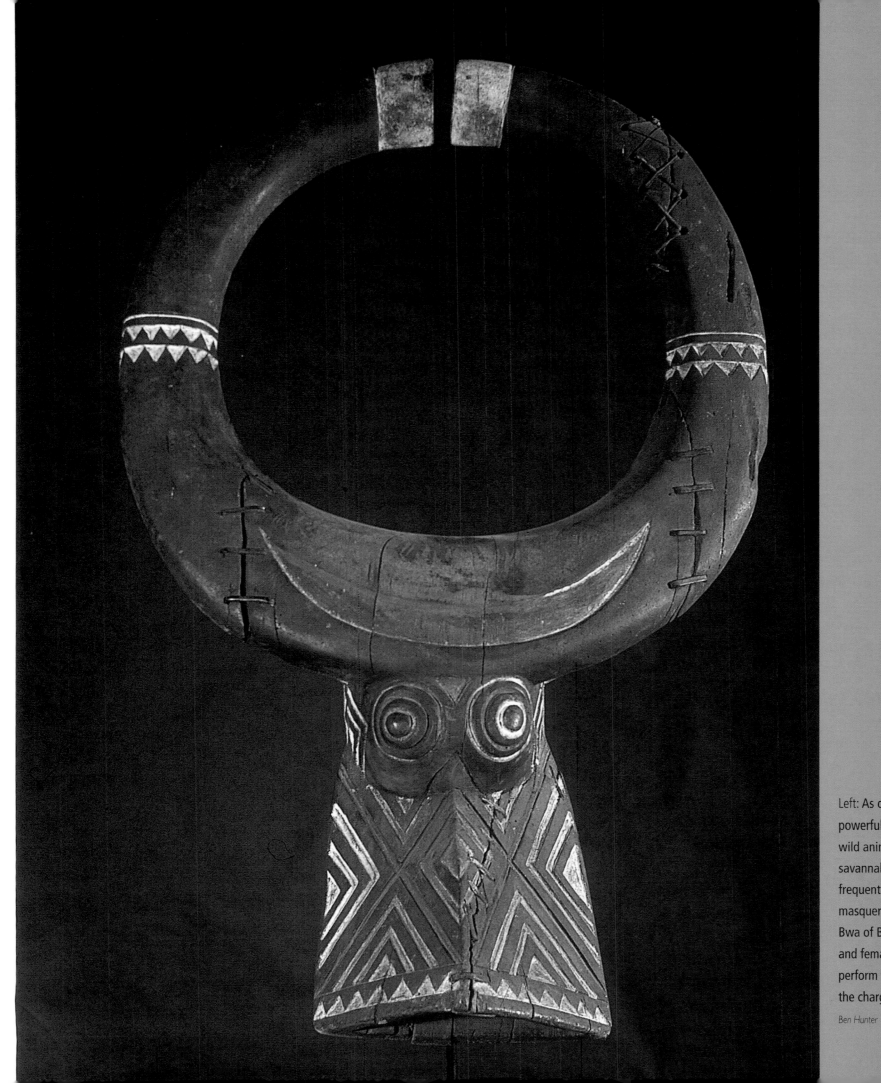

Left: As one of the most
powerful and dangerous
wild animals of the
savannah, the buh cow was
frequently represented in
masquerade. Among the
Bwa of Burkina Faso a male
and female mask would
perform together, imitating
the charging animals.

Ben Hunter

145

Both the Bwa and the neighboring Bobo also danced in these spectacular masks, almost three meters in width, that mimicked the flight of the butterfly.

Christie's Images

thinking about aspects of the world which displays considerable flexibility and adaptability over both time and distance.

African cultures have changed through a combination of internal and external factors for as long as we have evidence and continue to alter today. As in other parts of the world, the twentieth century was one of particularly rapid change which was accompanied by both gains and losses. It would be a mistake to accept the widespread but overly romanticized view of African life that sees these changes as a corruption of a previously untainted and unchanging traditional life. Instead, new ideas and new objects are incorporated into older world views and older cultural practices in ways that display active and creative responses to changing circumstances. Images of Hindu deities have expanded the pantheon of vodu in coastal Togo and Benin without altering ideas about the role of white chalk pigment in marking out initiates. The importation of cheap glass beads from Europe enabled the development of new esthetics of beadwork that drew on older ideas about both life-cycle stages and color associations in both South and East Africa.

A similar picture emerges with masks and masquerade. In many, but by no means all areas, red, black, and white pigments were used in masquerade. In some cases these uses continue, while in others the range of colors has increased as part of wider processes of change. When we consider masquerade among the Dogon, it will become clear that to view this change as a decay or decline of a previously fixed "traditional" practice would vastly oversimplify a complex situation. In previous chapters of this book we have explored some of the ways in which people in different regions of Africa have used ideas about color through both architecture and personal adornment to express and embody aspects of personal and group identity, social status, gender, authority, beauty, and esthetics. Masks and masquerading are further means through which some African peoples have used and continue to use their bodies as a medium to construct and display these concerns. Although they are often intended to be, at least in part, a form of entertainment, masks in Africa cannot be seen as simply actors dressing up and performing a role as we have come to understand this process in the European theatrical tradition. Rather they are complex and still powerful phenomena that actively participate in a variety of important aspects of social life. Often they involve troubling and apparently paradoxical reconfigurations of the masker's personal identity, touching on difficult issues of secrecy and local understandings of metaphysical or spiritual agency.

Masquerades in Africa take a wide variety of different forms and involve a huge range of concerns. This has led some scholars to question whether we are, in fact, dealing with a single topic, or one that merely appears so to outsiders conditioned by the intellectual history of the ideas of masking in Europe to focus on certain types of activities that involve covering the face while ignoring other related areas.

European ideas about masking have two key sources. The terms mask and masquerade are derived from an Arabic verb meaning to mock, or make fun, as is the word mascara. The second source is the theater of ancient Greece and Rome, where actors performed wearing masks that were called persona. From this root evolved ideas relating masks to person and identity. Although these hint at issues which may be involved in African ideas of masquerade as well, we need to ensure that they are actually relevant in specific instances, not simply assumed on the basis of the connotations of the words in English. Moreover, there are other things going on in Africa, from the veiling of the face by Muslim women, or Tuareg men, to spirit possession, to aspects of body decoration, that may have features in common with the use of masks.

Not all African societies use masks, and contrary to the superficial assumption that they are always ancient traditions, in many that do they have only adopted them over the last century or so. There can be no doubt, however, that masquerading has been an important part of the cultural life of some African societies for many centuries. Images interpreted by scholars as masked figures have been found among the ancient rock paintings in the Sahara region. The fragmentary remains of a wooden animal head found far to the south in central Angola and carbon dated to around the eighth century C. E. have been tentatively identified as a helmet mask in the form of an aardvark. Nevertheless, even in West and Central Africa, where the use of masks is most widespread, there are important groups, such as the Asante of Ghana, that have no masks. Masquerading is not common in the southern part of the continent, while in the east, aside from a few well-known instances such as among the Chewa of Malawi and the Makonde of Mozambique and Tanzania, it seems to have declined in popularity in the colonial period. Sometimes this was the result of official prohibitions—in Tanzania, for instance, the German colonial government banned many men's societies that used to stage masquerades following a rebellion in 1905.

In areas where masking is practiced, it may take on a variety of new meanings and roles as the wider social context has been transformed. Sometimes this has involved masks that were previously of great ritual significance being reduced to acting as secular entertainment, but perhaps equally important has been the spread of masquerades reputed to be effec-

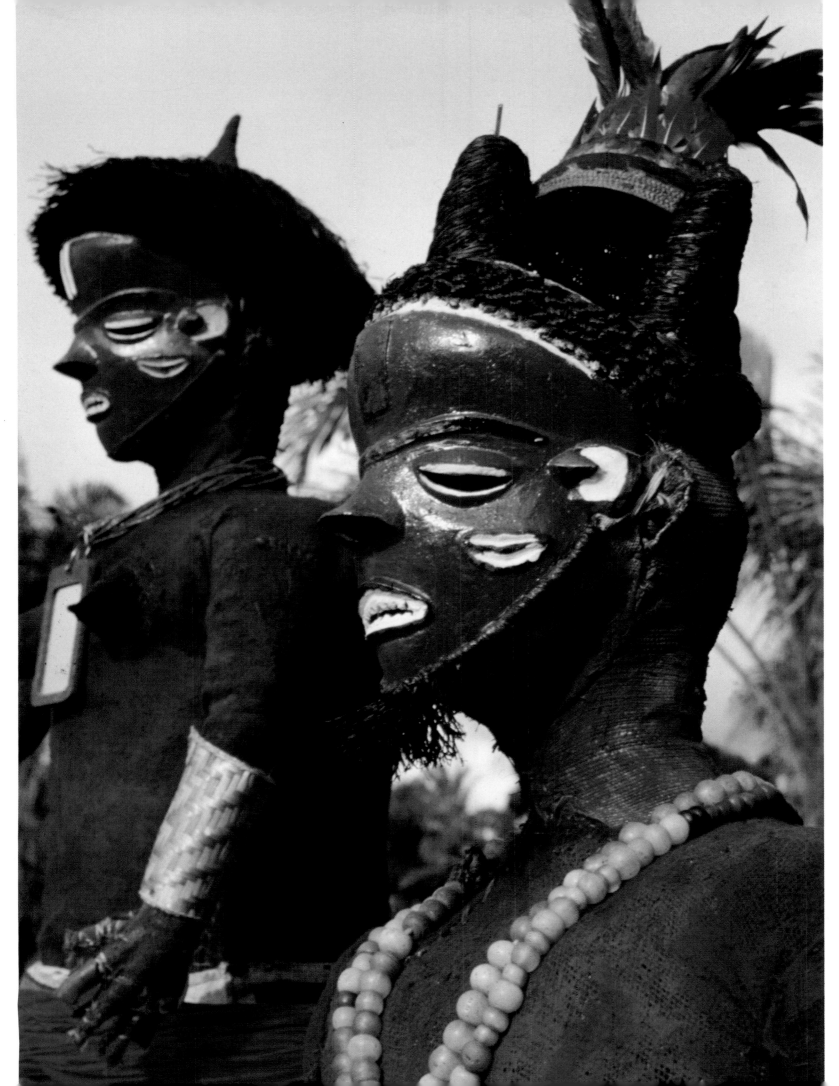

Left: Pende masqueraders from central Congo. The red costumes and faces represent the redwood paste with which the Pende formerly softened and oiled their skin.

© Studio Patellani/CORBIS

149

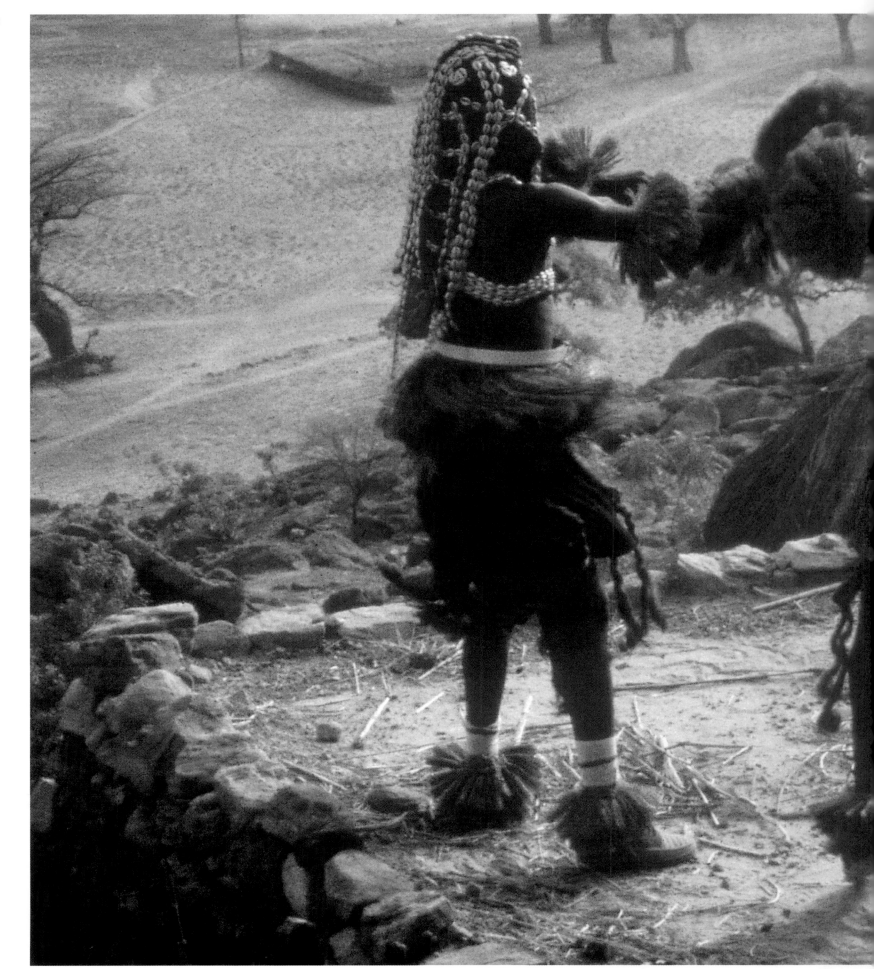

Right: Dogon Bedye masks dancing on the roof of the house of a deceased man in his honor.

Polly Richards

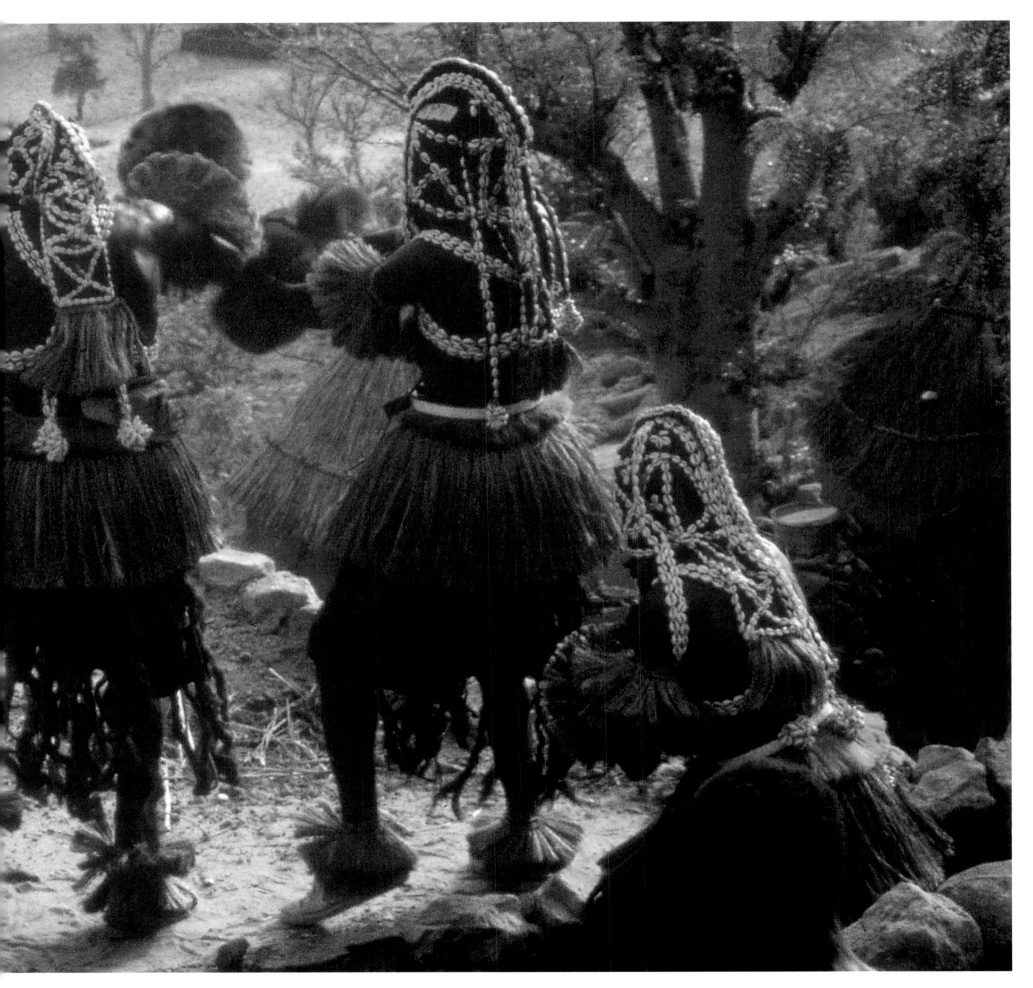

Right: Baga serpent masquerade head pieces called *A-Mantsho-na-Tshol*, formerly one of the most powerful spirits.

Christie's Images

tive in combating witchcraft in areas where the upheavals of the twentieth century have led to a loss of faith in older remedies. Although the increasing popularity of Islam and Christianity has led to the abandonment of some masquerade traditions, this is by no means always the case. There are even masquerades in some parts of Mali that perform on Islamic festivals such as the end of the Ramadan fast.

The mask itself, usually, but not always, a carved wooden face covering or head-dress, is only a small part of the masquerade costume, let alone of the whole performance. Only the sculptor, or the mask's owner, is likely to see it as the separate object we can display in a museum. The mask in use is part of a cloth or fiber assemblage that usually covers the wearer's entire body, often also concealing medicines that can protect the performer against rivals and witches, or enhance his dancing skills. Its final appearance involves much more than just the work of a carver. The mask may be painted by the performer or his colleagues, the cloths making up the outfit contributed by his mother or wives, the final look assessed by a senior official. The collaborative nature of masquerade is even more apparent in performance, which usually involves musicians, often including women singers, interpreters, guards with sticks to control or excite the crowd, and a variety of other attendants. A few masquerades are solo performers, but most will appear in sequence with others as part of an elaborately staged event. It is the process of masquerading and the ideas locally associated with it, rather than the isolated carved wooden artifacts foreigners have collected and admired, that provides clues to an understanding of the phenomenon.

Although virtually no research has been done to explore the perspective of actual maskers, and to understand what it feels like to participate in this potentially disturbing transformation, it is clear that there are complex ideas of secrecy and partial knowledge involved. While on some level the men organizing even the most sacred of masked performances know that there is one of their number actually wearing the mask, it is too simplistic to see this as only a deliberate deceit to fool the gullible women and uninitiated. The evidence suggests that it can be seen both as a trick and an involvement of a very real and powerful spiritual agency at one and the same time. Women watching and interacting with the mask may also know that it is a man dancing, and perhaps even recognize that their husband or brother is the dancer, but still believe that spiritual retribution would follow if they spoke of this knowledge. The relationship between men and women is often an important issue that people address and attempt to reconfigure through masked performance. Although masquerades that express male views of the role of

women are not unusual, and myths that ascribe the origin of masks to their discovery by a woman are common, the vast majority are organized, controlled, and worn by men. Women may play important roles in supporting the performance and interacting with the maskers, but the masks themselves in Africa are in the hands of men.

There are numerous cases involving women in practices such as spirit possession, body decoration, and other activities in many ways analogous to aspects of masking, but only one significant area where women themselves cover their faces with wooden masks. Among the Mende, Vai, Sherbro, and neighboring groups in Sierra Leone and Liberia, a women's society, called Sande by the Mende, organizes the training and initiation of young women into socially correct adult status. Sande provides a female counterpart to the local men's society, Poro, and has a number of masquerades that are danced by senior women. The Sande masker, or *sowei*, wears a gleaming black wood helmet mask that usually depicts the idealized beauty of a young woman, complete with an elaborately carved depiction of a fashionable hairstyle. This is not the place to explore this issue at greater depth but it is worth noting that if we abandoned our Eurocentric concentration on wooden face masks, and broadened our account to take in anything which covers or conceals the face, or more broadly still, any performance locally named as a mask we would uncover numerous other examples mostly related to young women's initiation, such as the grass face masks worn by Sotho women initiates as part of outfits interpreted as analogous to aspects of house forms.

Ideas of spiritual agency are clearly important in many mask events, and provide one of the key differences from European theatrical performance. Sometimes the spirit involved is thought to be ancestral and therefore, at least in a sense, from within the lineage and within society. More commonly though, the spirits are conceptualized as being from outside the bounds of everyday life in the village or town, usually as spirits of the bush, the forest, or the river. It is noticeable that these are almost always comparatively minor figures in local belief systems, and it is very rare for major deities to be represented in mask forms. These spirits are brought from outside, from the wild, into the domain of the village, usually to effect some kind of transformation. Although there are numerous exceptions, it is frequently the case that masquerades perform on occasions that anthropologists have characterized as liminal, that is when individuals or groups are in the process of transition from one stage to another, perhaps from youths to adults, or from elders to ancestors via a funeral. Not surprisingly, both the wooden face masks and the costumes worn with them to effect these processes of transition are often painted with red, white, or black pigments. Numerous examples could be cited from Central Africa. The masks of the Nkanu of southwestern Congo (formerly Zaire) are large wood, resin, and raffia structures painted with red, black, white, and sometimes yellow motifs, with the three primary colors said to refer respectively to: life and fertility; ordeals and dangerous powers; and in the case of white to ancestors and nature spirits. Masks among the Chokwe, who live on both sides of the Angola/Congo border, represent powerful ancestral or nature spirits called *akishi*. Among them is a large fiber and resin mask called *cikungu*, painted red and white, which could only be worn by the chief, the *mwanangana*, or his heirs. A mask called *ngondo*, used in the circumcision and initiation of young boys, had two concave gourd eyes, one painted red, the other white. *Pwo*, a red-pigmented face mask, depicted idealized female beauty and promoted fertility. At a ceremony held in a secret place at night no mask is needed to represent the *akishi* but the bodies of the performers are painted white and red, the white representing good fortune, while the red is associated in this context with evil and witchcraft. Both the Songye and the Luba use a type of expressively carved wooden face mask called *kifwebe*, which dances both for entertainment and as part of a once politically powerful regulatory society. Primarily

Left: A Baga mask, representing a composite of human face, crocodile jaws, a snake body, antelope horns, and the tail of a chameleon. Although once said to have been extremely sacred, today this mask is danced by the Baga of coastal Guinea only for entertainment.

Christie's Images

153

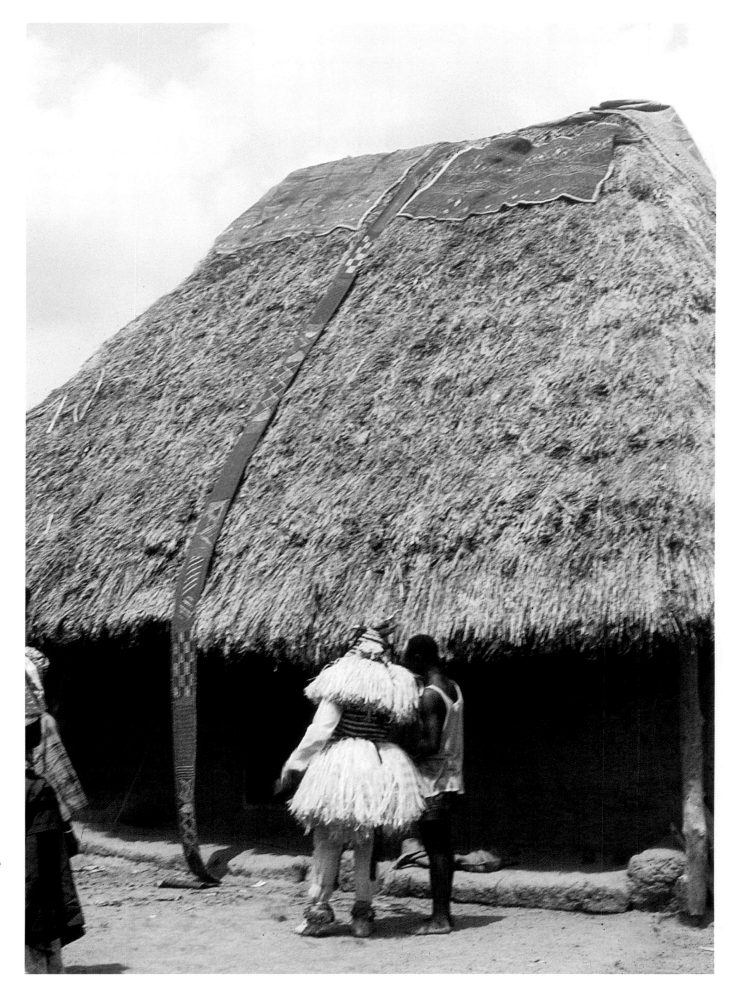

Right: Red funerary cloths displayed on the roof of the house of a deceased Bunn chief indicate his status. A masquerader visits the house.

John Picton

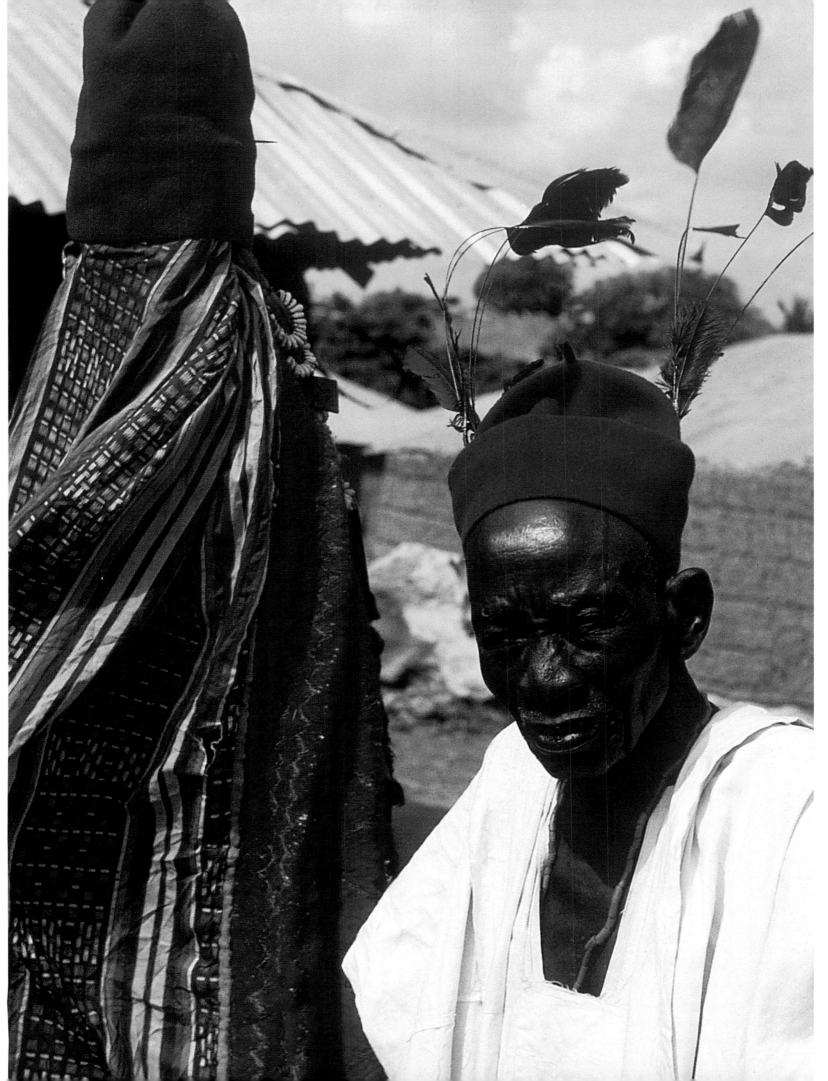

Left: An Ebira ancestral masquerade representing a named senior ancestor and containing relics from his body. Red funerary cloth from the nearby Bunu people was often used in the costume of ancestral masks. The red felt hat indicates senior titled status.

John Picton

white masks are considered female, while red predominates in male masks (both of which are danced by men). The leading authority on the Songye, Dunja Hersak, notes that white is pervasive in ritual and "signals goodness, health, purity, reproductive capacity, peace, wisdom, and beauty, and is in turn associated with the moon, light, manioc flour, mother's milk, and sperm." Its source in powdered clay found in riverbeds and forests links it to the domain of the ancestors. Red is used less frequently in ritual and has an ambivalent power: "it denotes strength, courage, knowledge, completion, and achievement, but it also encompasses the malevolent aspects of witchcraft and sorcery, blood, and flesh." Black on its own has no meaning, but in combination with the other two colors, it is a sign of impending danger. Among the Luba the emphasis is slightly different, with black associated with witchcraft and sorcery, and figuring on masks as a protection against these threats.

A different perspective again emerges from the Ebira (sometimes written Igbirra) people of central Nigeria. The Ebira have a saying: a person is white before he is red. White in this context connotes suffering and struggle by reference to the dried sweat that lightens the skin after a man labors on his farm under the hot sun. Red denotes maturity and achievement, alluding to the red feathers, red cap, and other insignia that are markers of success as elders and ritual leaders after the years of suffering. Red cloth obtained from the neighboring Bunu people, along with indigo blue and white cloths used by the Ebira for funerals, form the costumes of ancestral masquerades and *eku-ecici* maskers which represent servants of the world of the dead.

What happens to these ideas about color symbolism as a contacts with a wider sphere of different cultures increase, new audiences are drawn to watch masquerades, and numerous new pigments and other materials become available? They are not likely to continue unchanged, but nor would one expect that will they be simply discarded as no longer relevant. The Dogon people of Mali provide one of the few cases where there has been sufficient research over an extended period to begin to look for answers to this type of questions. The Dogon, who number around 400,000, have lived along the dramatic escarpment of the Bandiagara cliffs in southeastern Mali since at least the fifteenth century. Despite long contacts and regular conflicts with the surrounding Muslim peoples such as the Tukolor, Mossi, Fulani, and Bamana, conversion to Islam on any scale did not occur until the mid-twentieth century, and adherence to indigenous religious traditions remains strong.

The Dogon occupy a prominent place in the history of anthropology because of the decades of research in the region since the 1930s led by the French anthropologist Marcel Griaule. After documenting the culture at great length over many years, Griaule and his team were led to a deeper level of understanding through a

Right: A circular white-faced mask representing a nature spirit. The mask was commissioned when a boy was born and would accompany him when he was initiated in the bush in his late teens. Kwele people, Congo.

Christie's Images

series of talks by a Dogon elder, Ogotemmêli, setting out a rich and complex set of myths that apparently underlie

document despite doubts as to their validity expressed by some subsequent researchers who have been unable to access similar ideas. The combination of publicity attracted by Griaule's work, the dramatic location, and the apparently exotic mythology has attracted significant numbers of tourists who since at least the 1950s have witnessed specially staged masquerade performances.

Dogon masquerades were described by Ogotemmêli as providing a world view: "For the society of the masks are a picture of the whole world, for all men, all activities, all crafts, all ages, all foreigners, all animals can be represented in masks, or woven into hoods." Griaule documented sixty-five different mask types in the 1930s, which he categorized as representing birds, mammals, Dogon people, non-Dogon people, reptiles, and things. Since then, the number in use in each village has fluctuated as new forms have emerged and others have been discarded—in the late 1960s, Imperato counted 78 types. Masquerades are organized by a society called *Awa*, which in the past was open to all males except smiths, leather workers and griots, plus certain women known as "sisters of the masks." A mask called *sadimbe*, meaning "great woman," with a carved wood female figure standing over the face covering, recalls the origin myth of Dogon masquerading, in which masks created by bush spirits were found by a woman in the village of Yougo. She wore the mask to scare her husband until an old woman revealed her secret allowing men to take over the use of masks for themselves. The woman on the *sadimbe* is dressed as one of the masks "sisters," a group of women born during the *Sigui* masquerade festival, whose responsibilities include bringing beer and water to the maskers in their shelter in the bush. The *Sigui* festival takes place only once every sixty years, marking the completion of a ritual and generational cycle. In the intervening period, the masks dance at funerals of Awa members who participated in the previous *Sigui*, at periodic festivals called *Dama*, and when requested by visiting tourists or government officials.

the surface explanations they had previously received. The publication of these myths attracted worldwide attention to the Dogon, and they remain a unique

According to Griaule and his colleagues, Dogon mythological thought places color symbolism at the center of masquerade. In a recent article, Germaine Dieterlen noted: "When seen in performance, the masks bring to life 'ancestors' that may be human, animal, or vegetal. In form they resemble their subjects, seen from the perspective of the Dogon esthetic. The colors with which they are painted, their costumes, and their ornaments reveal the presence of the four basic elements. Black refers to 'water,' red to 'fire,' white to 'air,' and yellow or ocher to 'earth.' These 'four things' (*kize nay*), as the Dogon call them, are the 'same;' that is, they are the matrixes with which the Creator Amma

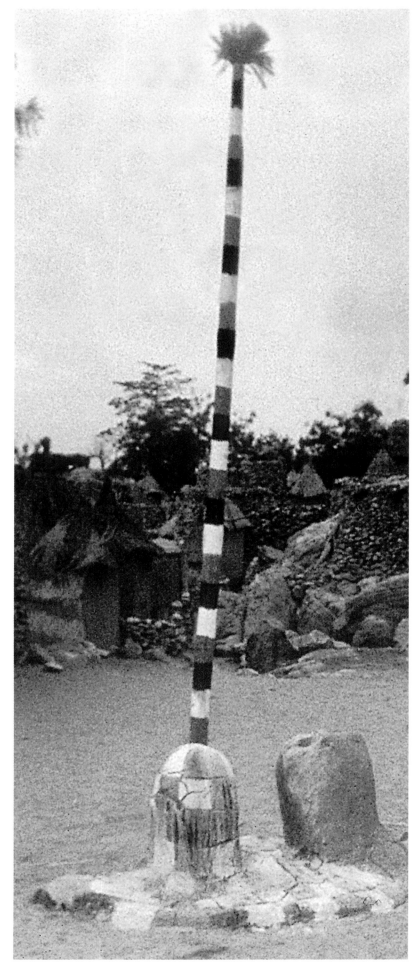

brought the universe into existence. For the Dogon, a mask that is not painted brilliant colors—or not repainted if it had been carved and used for a previous Dama—is nothing but a piece of wood, elegantly sculpted but devoid of life, without any value." Particularly important are the red-dyed hibiscus fibers that adorn the headpiece and circle the waist and arms of the dancers, the color of which is said to allude to the menstrual blood of Yasigi, the first "sister of the masks." The fibers are called *èmna*, the same name as the masks themselves, and could be used alone to prohibit the presence of women in the same way as a complete ensemble.

From the early years of his research in the 1930s, Griaule commented on what he saw as a "deterioration" in the mask festivals due to the presence of tourists. Over the following decades, declining rainfall in the region combined with new opportunities to increase the number of young Dogon men who spent long periods as migrant laborers in urban centers such as Bamako and Abidjan. Conversions to Islam and Christianity increased, particularly in villages away from the cliffs. At the same time, Dogon villages, especially Sanga where Griaule's team was based, became a regular stopping point for tourists in West Africa. By the 1960s, groups of youths in the most visited villages were dancing the masks for tour groups as often as three times a day at busy seasons. Not surprisingly, aspects of these everyday performances for strangers became very different from the masquerade dances held intermittently at the funerals of *Awa* members and at *Dama* festivals staged only every few years. Tourists saw edited "highlights," the most spectacular masks and dances compressed into a fifteen-minute show, rather than the several hours dancing spread over days that followed weeks of preparation for a *Dama*. Audience interaction took the form of photographs, payments, and even attempts to buy the masks, rather than knowledgeable appraisal and recognition of individual dancers. Changes also occurred in the performances staged for an indigenous audience, while in some villages participation has declined to levels where the society is no longer viable at all. New materials are incorporated—for example, Polly Richards, the researcher who took the pictures accompanying this chapter, noticed "the crest of a *pulloyana* (Fulani mask) is, for instance, bedecked with pill packets and recycled monosodium glutamate wrappers, its tresses sparkling with cut-up strips of sardine cans in a manner imitative of the ornate hairstyles of the Fulani women today."

Until recently, commentators tended to follow Griaule in seeing these changes as a regrettable decline as once-pristine traditional rites sanctioned by an unchangeable mythological charter were contaminated by contact with outsiders. Yet

Right: *Dani*, a pole altar said to represent a plant which grows every 60 years in the village where Dogon masks originated. Established at the moment in the *Dama* ritual that marks the end of mourning for the deceased, the pole is still decorated red, white, and black with indigenous pigments and the blood of a sacrificed animal.

Polly Richards

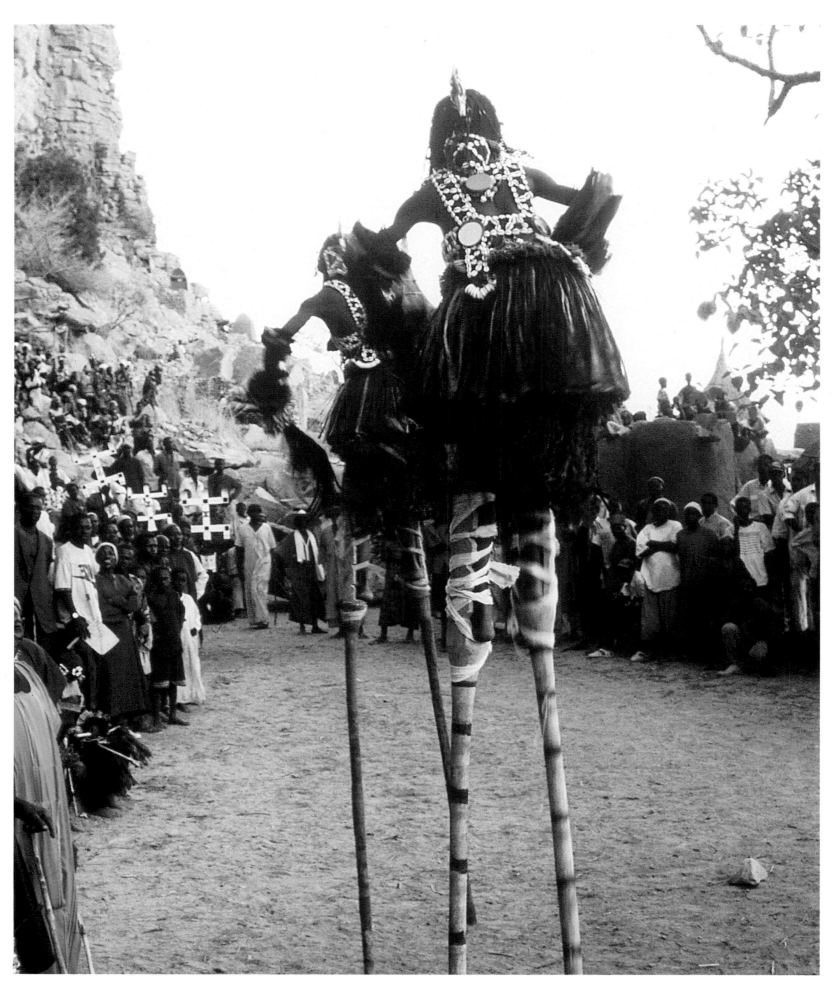

Left: Tingetange stilt mask, said to mimic the movements of the sago wading bird.

Polly Richards

159

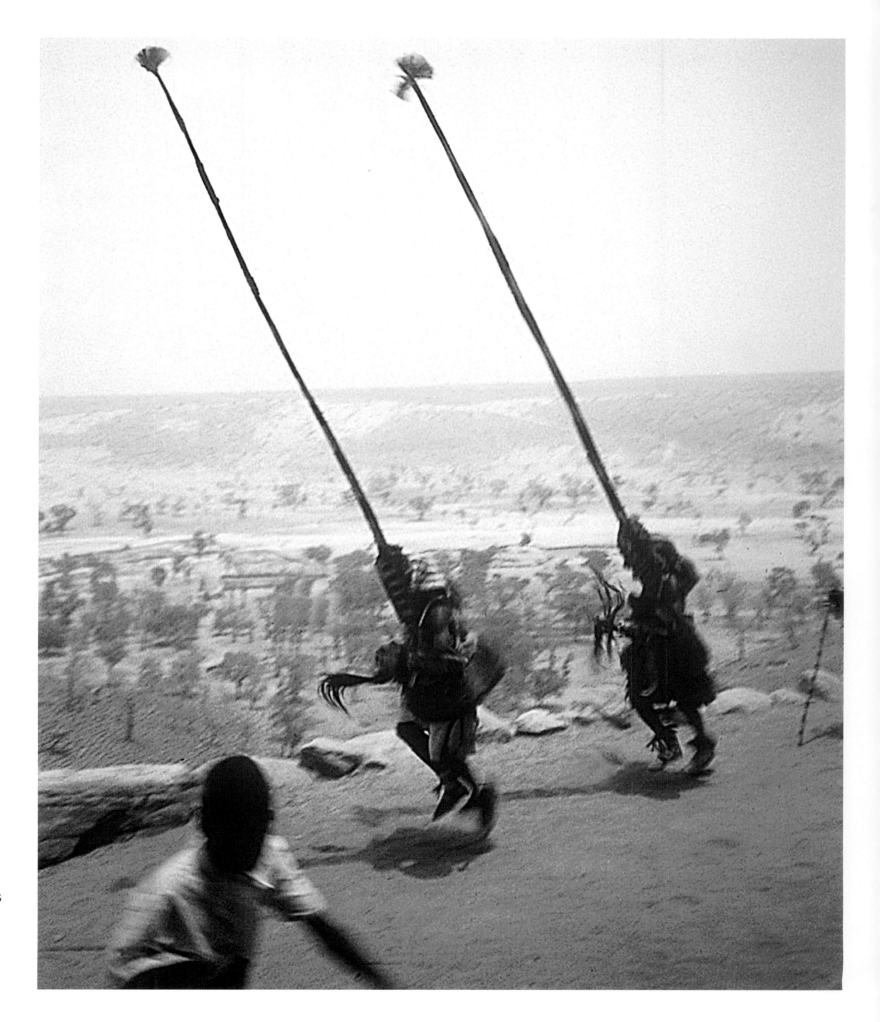

Right: Dogon *sirige* masks represent the multi-story *guinna*, house of the first ancestors.

Polly Richards

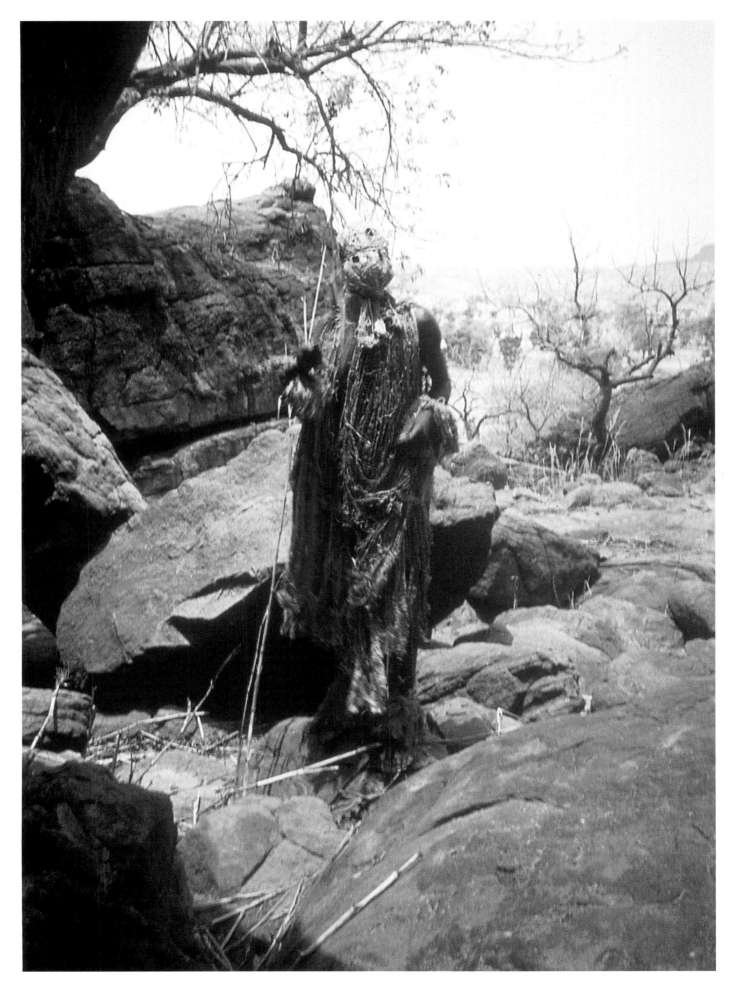

Left: The Dogon *saku* mask, made entirely from the bark of the sa tree, is said to have been the first type of mask found in the bush.

Polly Richards

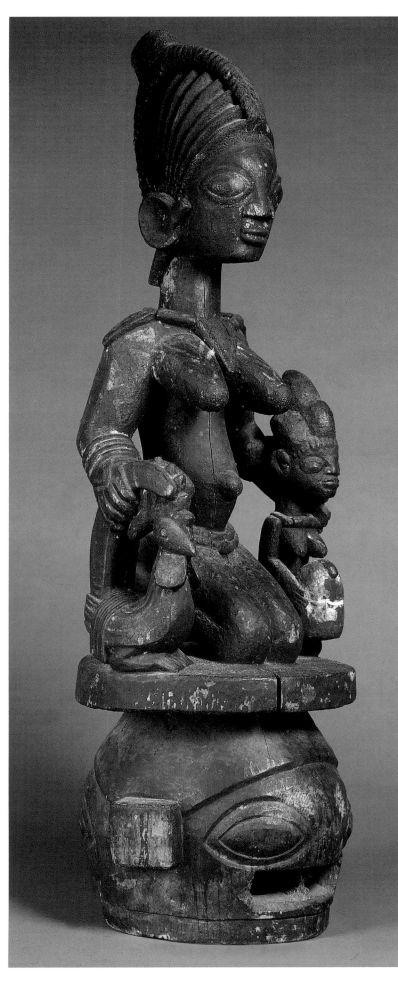

when Dogon attitudes to change have been investigated, it appears that the situation is, in fact, more complex. The tendency of the Dogon to assimilate changes rapidly into their sense of the tradition, denying that something is new once the memory of the innovation fades, suggests that numerous similar changes have occurred in the past. More interestingly, one of the key Dogon criticisms of the tourist performances is that old-fashioned and poorly decorated masks are used. Tourists have certain expectations about African tradition, informed often by a familiarity with aspects of Griaule's more accessible works, which the dancers try to cater to by using masks in the Sanga village shows that preserve the red-white-black color triad, in contrast to those for indigenous ceremonies where, Richards observed, "ink imported from Saudi Arabia, enamel paint, battery charcoal, washing blue (a bleaching agent) and coloured chalks are combined with indigenous colour preparations and contribute to a wealth of colour combinations." Rather than a one-way negative influence from external contacts to a decline in local traditions, it seems more accurate to view the process as a complex interaction, in which Dogon ideas and performances—both for indigenous and tourist audiences—are flexible and responsive in different ways to changing expectations and opportunities.

Traditions which are capable of absorbing change survive in a changing world, while those which fail to adapt are often abandoned altogether. Dancing for tourists can both promote pride in Dogon culture which is transferred to indigenous contexts and provides a new arena for young men to earn both prestige and much needed income within the village. Using new colors need not indicate that older choices no longer have relevance. During each Dama festival a mask altar called *dani*, consisting of a pole set in a clay base, is created to mark the end of mourning. Unlike the masks, this key focus for the ritual is still decorated in red, white, and black bands using indigenous pigments mixed with the blood of an animal sacrifice.

Right: A north-eastern Yoruba *epa* mask, representing a kneeling woman holding a sacrificial cockerel. The faded red, blue, and white pigment would have been repainted regularly when the mask was in use.

Christie's Images

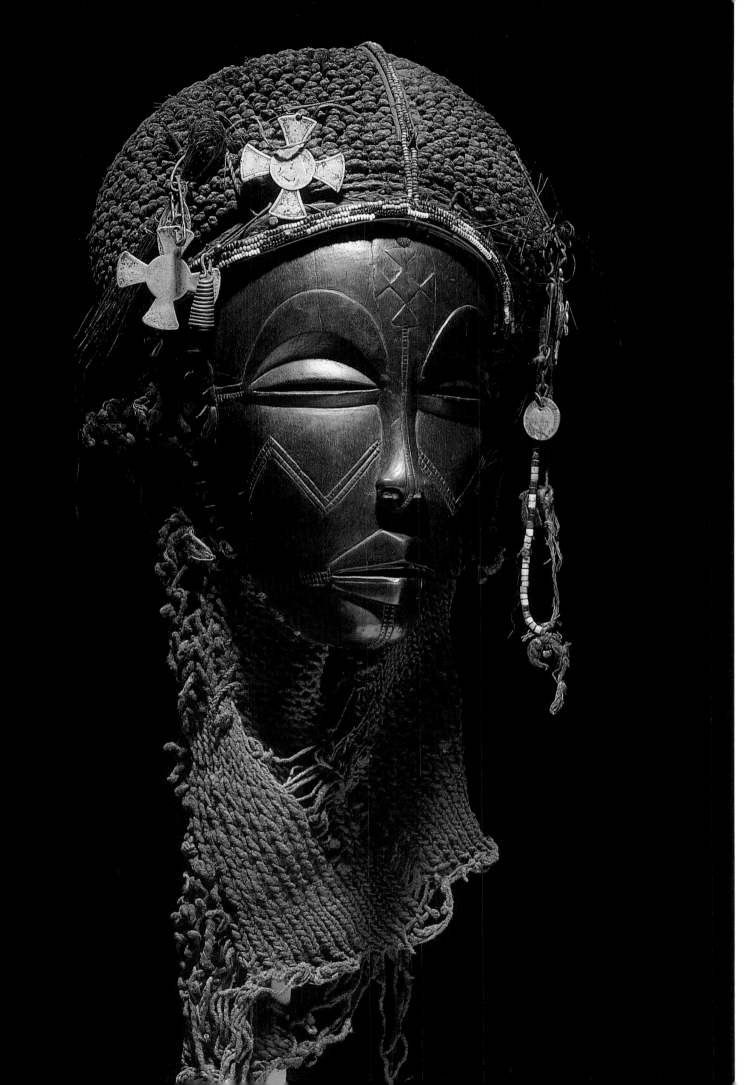

Left: A Chokwe *mwana pwo* mask representing an ideal of female beauty. Northern Angola.

Christie's Images

163

Right: A Pulloyana masquerader. This mask represents the young Fulani women of the region who are much admired by the Dogon men for their beauty.

Polly Richards

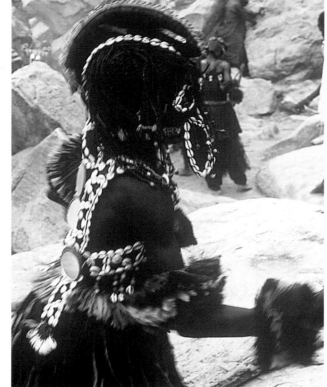

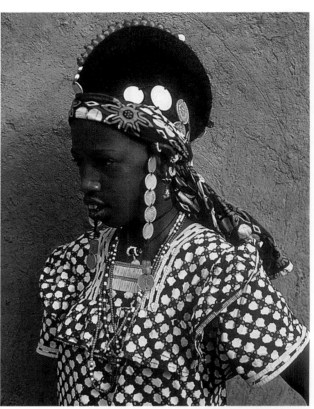

Far Right: A young Fulani woman with the crested hairstyle mimicked by the Pulloyana masks.

Polly Richards

Right: A man paints an antelope mask with chalk and imported pigments.

Polly Richards

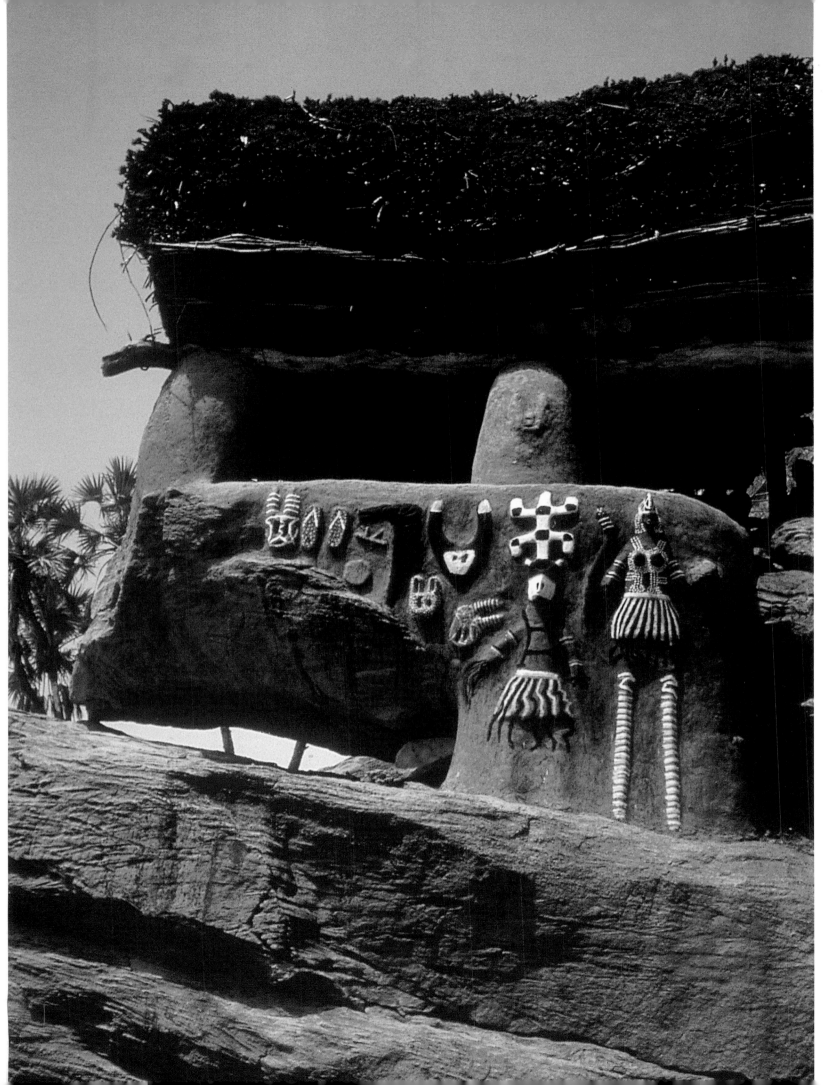

Left: A *togu-na* men's
meeting house decorated
with relief designs including
masquerades.

Polly Richards

165

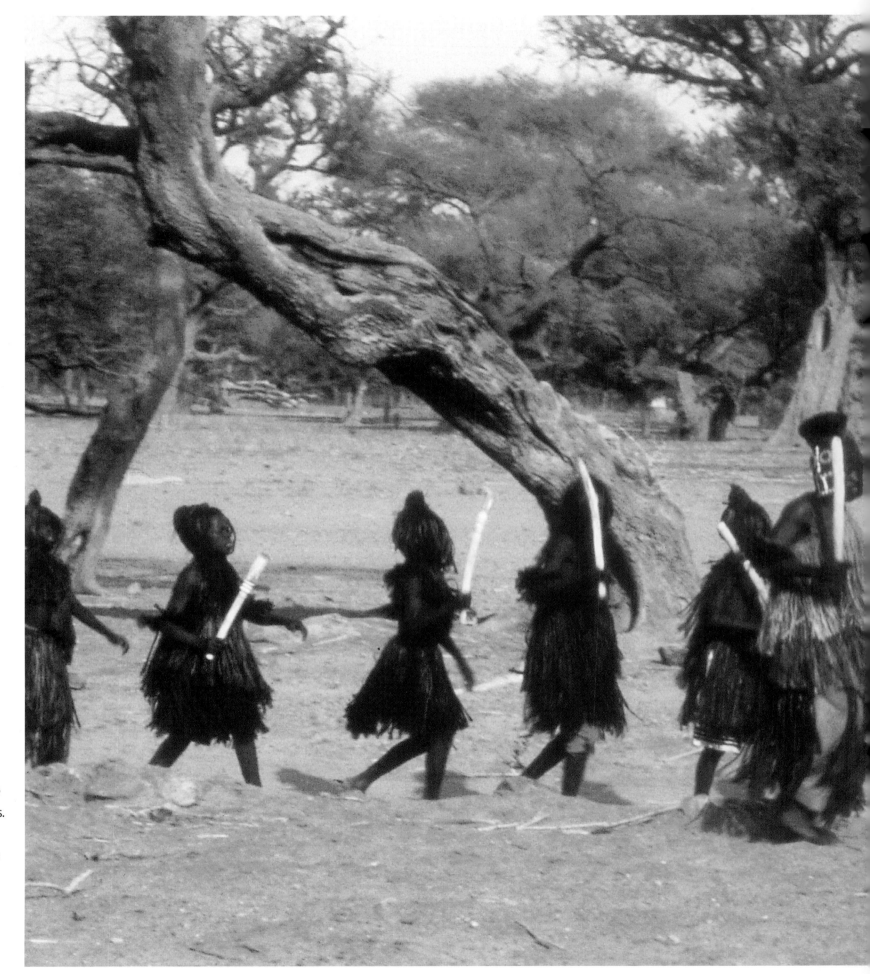

Right: New mask initiates make their first entrance from the bush to the village dressed in black mask fibers. The anthropologist Marcel Griaule noted that in Sanga the day on which these fibers are dyed red is referred to as *anam punya*—men's menses.

Polly Richards

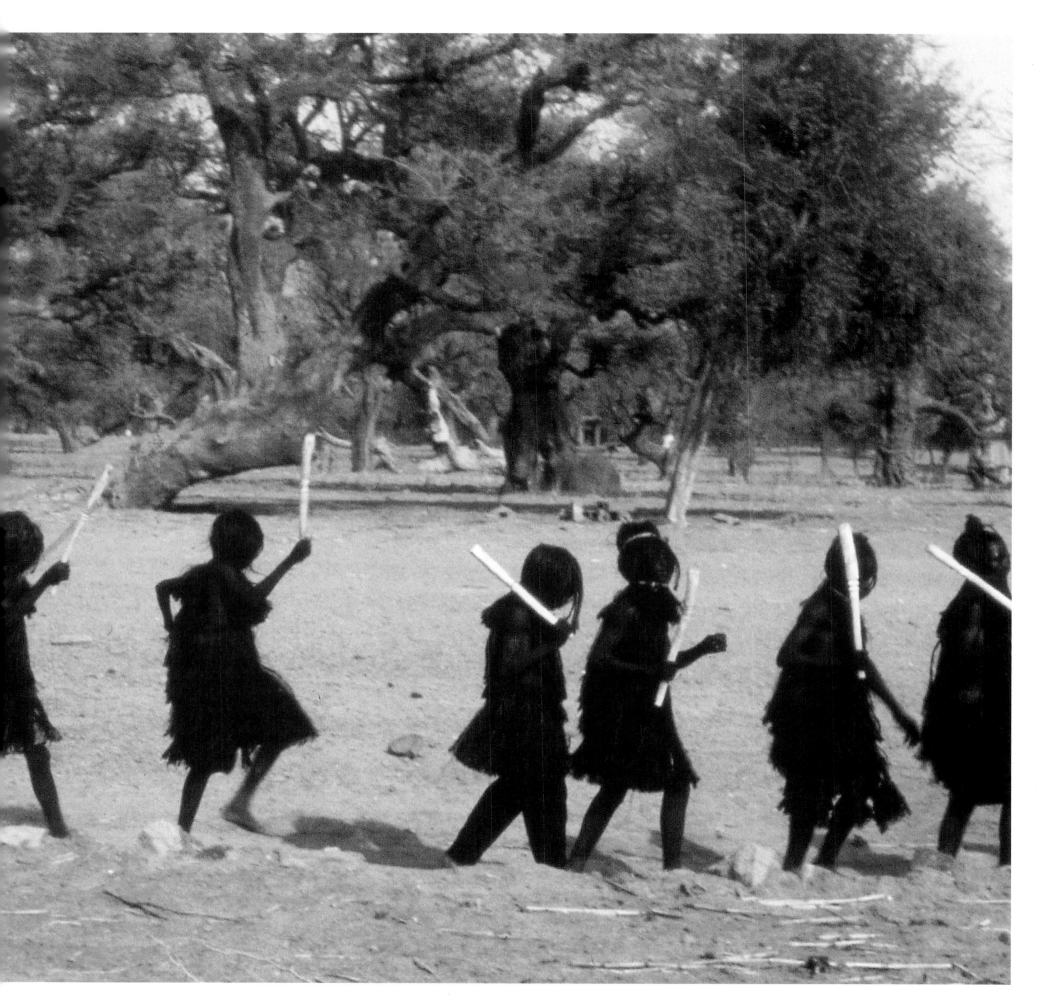

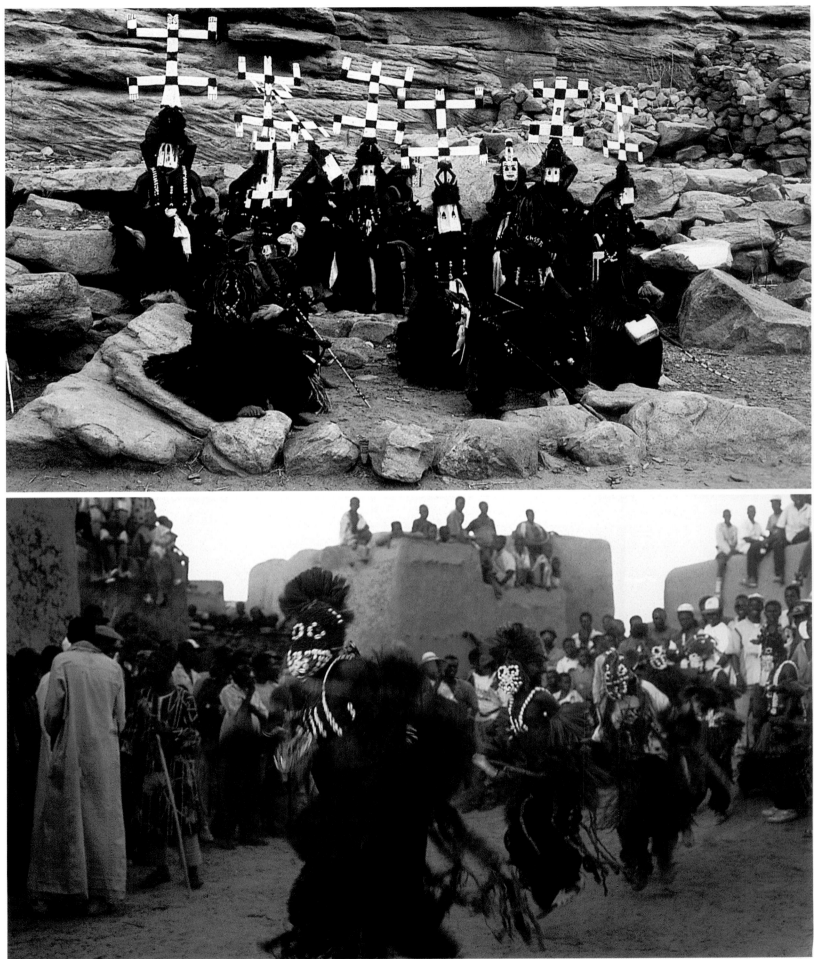

Right: A group of *kanaga* masks waiting their turn to dance. The mask is said to represent an antelope, but in some villages is also said to symbolize the creation of the world.

Polly Richards

Right: *Adagaye* masks, representing a thing of the bush, dancing at a *Dama* in Sanga village.

Polly Richards

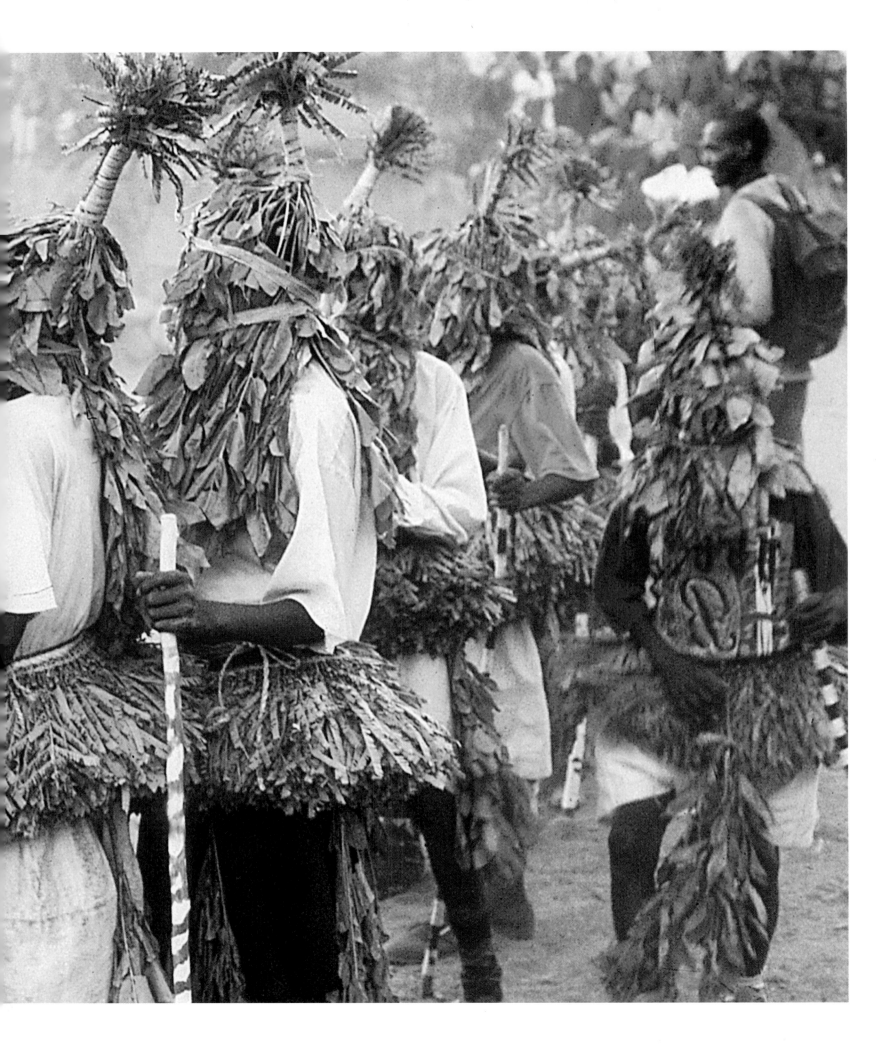

Bibliography

Aherne, T.: *Nakunte Diarra: Bogolanfini Artist of the Beledougou;* Indiana University Art Museum, 1992

Antubam, K.: *Ghana's Heritage of Culture;* Leipzig, 1963

Beckwith, C. & Van Offelen, M.: *Nomads of Niger;* Harvill, 1983

Berlin, B. & Kay, P.: *Basic Color Terms, Their Universality and Evolution;* University of California Press, 1969

Blier, S. P.: *The Anatomy of Architecture;* Chicago University Press, 1987

Brett-Smith, Sarah: *Symbolic Blood: Cloths for excised women;* Res 3, Spring 1982

Buckley, A.: *Yoruba Medicine;* Oxford University Press, 1985

Dieterlen, G.: *Masks and Mythology Among the Dogon;* African Arts XXII(3), 1989

Drewal, H. J. & Mason, J.: *Beads Body and Soul: Art and Life in the Yoruba Universe;* UCLA Fowler Museum of Cultural History, 1998

Faris, J.: *Nuba Personal Art;* Duckworth, 1972

Girshick Ben-Amos, P.: *The Art of Benin;* British Museum Press, 1995

Griaule, M.: *Conversations with Ogotemmêli;* Oxford University Press, 1965

Grossert, J. W.: *Zulu Crafts;* Schuter & Shooter, 1978

Hersak, D.: *The Kifwebe Masking Phenomenon* in *Face of the Spirits;* Tervuren, 1993

Imperato, P. & Shamir, M.: *Bokolanfini: Mud Cloth of the Bamana of Mali;* African Arts 3(4), 1970

Jacobson-Widding, A.: *Red-White-Black as a Mode of Thought;* Acta Universitatis Upsaliensis, 1979

Jolles, F.: *Traditional Zulu Beadwork of the Msinga Area;* African Arts XXVI(1), 1993

Klumpp, D. & Kratz, C.: *Aesthetics, Expertise, and Ethnicity: Okiek and Maasai Perspectives on Personal Ornament* in Spear, T. & Waller, R. eds. *Being Maasai* James Currey, 1992

Nettleton, A., Ndabambi, S. & Hammond-Tooke, D.: *The Beadwork of the Cape Nguni* in Nettleton, A. & Hammond-Tooke, D.: *Catalogue: Ten Years of Collecting;* University of Witwatersrand Art Galleries, 1989

Ofori-Ansa, K.: *Kente is More than a Cloth;* poster, 1993

Okediji, M.: *Yoruba Pidgin Chromacy* in *Orita Meta;* OAU, Ife, 1990

Olupona, J.: *Kingship, Religion and Ritual in a Nigerian Community;* Almqvist and Wiksell, 1991

Pavitt, N.: *Turkana: Kenya's Nomads of the Jade Sea;* Harvill, 1997

Pohlmann & Mchunu: *amaNdebele;* Haus der Kulturen der Welt, 1991

Rasmussen, S.: *Veiled Self, Transparent Meanings: Tuareg Headdress as Social Expression;* Ethnology 30(2), 1991

Renne, E.: *Cloth That Does Not Die;* University of Washington, 1995

Richards, P.: *Imina sangan* or *masques à la mode: contemporary masquerade in the Dogon region;* forthcoming

Schneider 1989: *Art and Communication;* in Nettleton, A. & Hammond-Tooke, D. eds.: *African Art in Southern Africa;* 1989

Schoeman, H. S.: *A preliminary report of traditional beadwork in the Mkhwanzi area of Maputuland district Zululand;* parts 1 & 2 African Studies 27, 1968

Smith, F.: *Gurensi Wall Painting;* African Arts XI(4), 1978

Stenning, D. J.: *Savannah Nomads;* Oxford University Press, 1959

Turner, V.: *Colour Classification in Ndembu Ritual;* in M. Banton ed.: *Anthropological Approaches to the Study of Religion;* SA Monograph, 1966

van Wyk, G.: *African Painted Houses;* Harry N. Abrams, 1998

Index